Photographing
Sports

RAND McNALLY & COMPANY

Chicago • New York • San Francisco

Photographing
Sports

Massimo Cappon • Italo Zannier

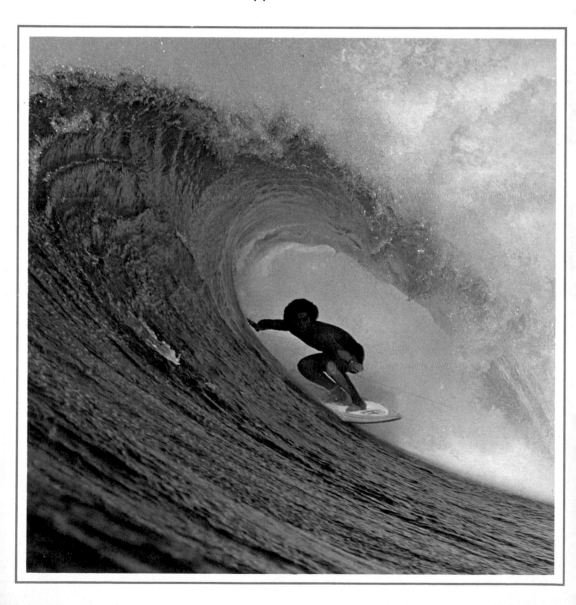

Published in U.S.A., 1981 by Rand McNally & Co., Chicago, Ill.
Copyright © 1980 by Arnoldo Mondadori Editore S.p.A., Milano
English translation copyright © 1981
by Arnoldo Mondadori Editore S.p.A., Milano
Editor: Enzo de Michele
Graphic Design: Paolo Cajelli
Translated from the Italian by Maria Piotrowski

Library of Congress Catalog Card No. 81-51336
ISBN: 0-528-81546-6

Printed and bound in Italy by Officine Grafiche di
Arnoldo Mondadori Editore, Verona, Italy

CONTENTS

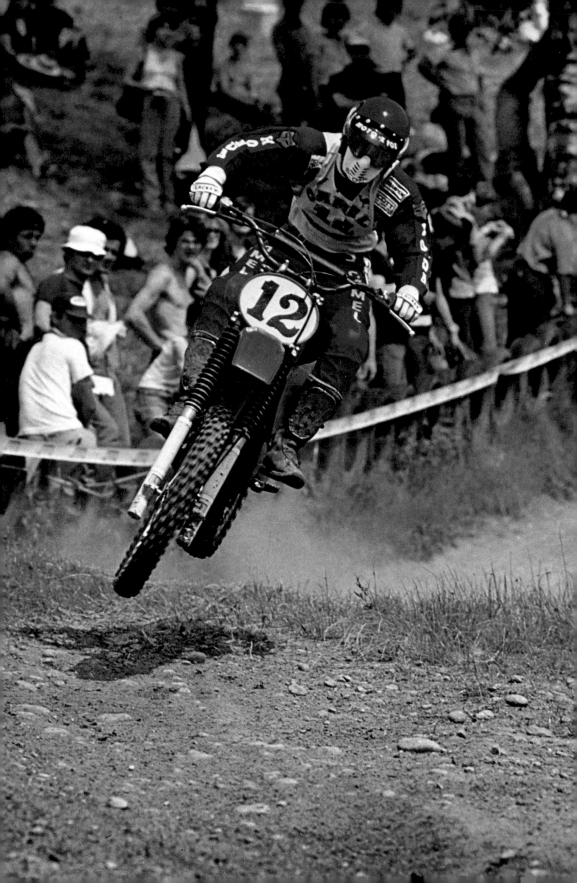

WHAT IS SPORTS PHOTOGRAPHY?

The boxer slamming home the knockout punch, the athlete hurling his body over the bar in the high jump, the sprinter breaking the tape, the slalom skier elegantly descending the slope, the ball thudding into the net behind the goalkeeper—all these magic moments in sports can be captured by the shutter in a fraction of a second, sometimes at speeds even greater than we can perceive.

Sport is competition, the striving for perfection achieved at the moment the athletes or their machines are at the peak of their potential; the will to succeed, the tantalizing hope of victory, provides the incentive to compete and may be the prime motivation for sport in the first place. In a fraction of a second, the photographer has to make a complex of decisions that culminate in the inexorable click of the shutter.

Sports photography should be considered the ultimate chapter in the ideal photographer's handbook, for it combines all the main technical, aesthetic, and structural aspects of photography in the photographer's attempt to capture in flight the decisive moment and record it forever on film. Photographing sports involves thinking about what is taking place, watching closely, always remembering that in sports every move can be anticipated to a large extent, because the participants follow rules, plans, and traditions. Sport is almost ceremonial, an expression of the tensions found in everyday life through actions and gestures that are all equally significant and that tend to be represented, as in the theatre, in the most spectacular way possible. The theatricality of sport is expressed in the athlete's physiology as he or she is tensed up to break a record, win a competition, or, more modestly, to withstand an opponent or to test his or her endurance. Photographing sports means capturing the effort, energy, and motion that come together in a fraction of a second; it means being in the right place at the right time, framing and shooting with a kind of instinctive, conditioned reflex, or, according to Cartier-Bresson, with a synchronization of the eye, the head, and the heart on the same ideal plane.

Photographing sports is not really very different from photographing everyday life, though there are in sports photography certain special problems like the dimensional and spatial relationship between the photographer and the point of action. While this is possibly one of the most obvious problems, it is one that can be overcome with the right equipment.

Sport and photography, on reflection, have a great deal in common, and one of the most important of these common features is the need for incessant training. For the photographer, this training involves learning to see, not just to look, and to make choices, often anticipating and foreseeing the most significant moments in a series of events.

It is not just the psychological strain of the situation, but the certain and instantaneous reflexes that it requires, that make the photographer's actions comparable with those of the athlete. Standing confused on the stadium steps or by the court, the photographer creates his or her own private sport, using the viewfinder to establish an ideal personal and emotional relationship with those taking part. Of course, the photographer lives the sport with a lesser degree of impassioned involvement, but that professional detachment must never lapse into indifference if he or she is to avoid the banality of stereotyped results. Behind every successful photographer there is anxiety, uncertainty, extreme solutions to problems, lost opportunities, and an unrelenting tension that frequently is not eased until the results can be finally checked on the viewer or in the black and white proofs. The photograph then arrives on some editor's desk or in some agency, to appear the following day in the newspapers, where, in the exaltation of the moment or in the frustration of the act, it captures the symbolic values of the hero, the champion, or the defeated. The amateur photographer (whose movements are usually more restricted, particularly at important events) has an advantage over the professional in that the amateur has unlimited freedom, not being tied to deadlines or formal information requirements, yet having the same technical knowledge, education, visual intelligence, and passion. In sports, as in life, the best photograph is always the one that is yet to be taken.

Opposite: A motocross champion flying through the air during a competition. The photographer has concentrated on the most significant aspects of the sport and has captured them in flight in a fraction of a second (1/500 second, using a 200mm telephoto lens).

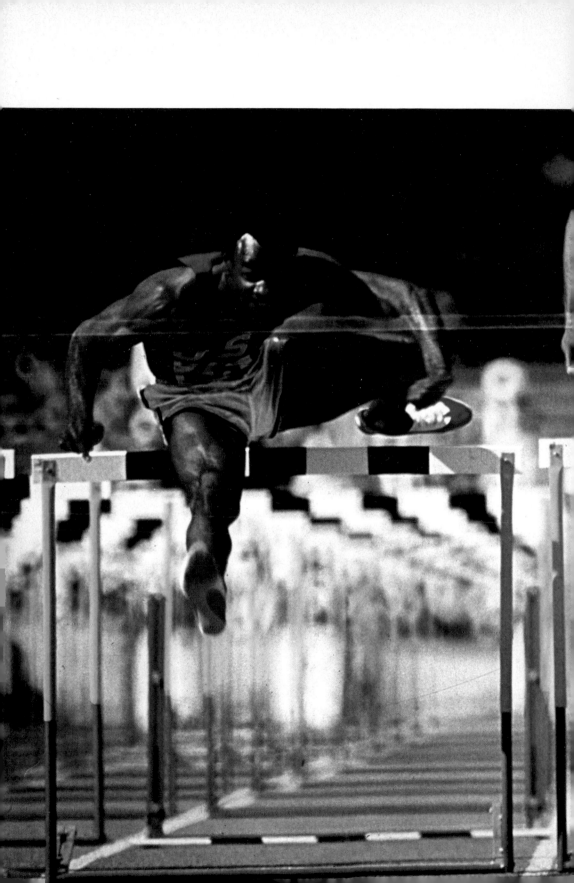

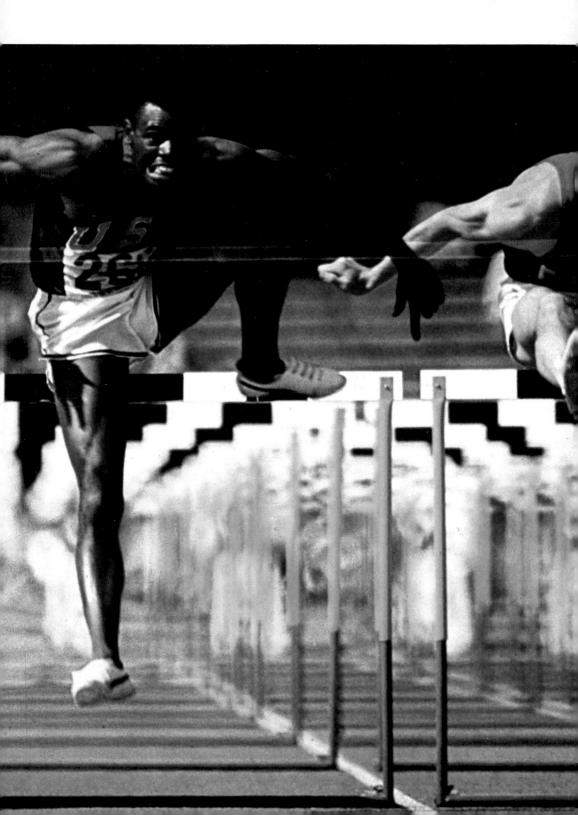

Choosing your equipment

Sports photography often presents specific technical problems that are not usually great enough to warrant the exasperation too commonly found. Any ordinary household camera, whether with fixed focal length or range finder, can quite easily meet a wide range of requirements if used with intelligence and a little imagination, as long as it has speeds up to at least 1/250 second, but its usefulness comes to an end as soon as you want to produce something out of the ordinary.

The most serious problem faced by all sports photographers (even professionals, although up to a point they are free to cross barriers closed to the public) is the distance from which they have to follow the action. It is almost impossible to capture the whole scene with a "normal" 50mm lens, so in this case, the photographer has to use a telephoto lens to pick out elements of particular interest in the confusion of the whole.

There is no question as to which format to choose: the 35mm has the advantages of a compact, manageable, light, and relatively economical system, and modern developments in film have eliminated, at least under normal conditions, the old problem of inferior picture quality on smaller frames.

The magnificent old twin-lens Rolleis still have a lot to offer, especially in sports such as mountaineering, sailing, and skin diving, where the photographer is not restricted by rules, as in sports stadiums, or by the speed of action; whereas interchangeable lens 2¼ × 2¼ inch (6cm × 6cm) cameras such as the famous Hasselblad are limited to those people who have specific professional requirements, for reasons of price as much as anything else.

Nowadays, modern interchangeable lens reflex cameras form the basis for complete, flexible photographic systems that allow the photographer to tackle any kind of situation. The fact that powerful telephoto lenses often are necessary in sports photography makes interchangeable lens systems a better choice than fixed lens rangefinder cameras,

such as the ever-popular series M Leicas. It is also better to have at least two cameras so that the focal length can be changed quickly. The choice of lens depends on what kind of sport is being photographed. A versatile lens system includes a 35mm for normal shots, a middle range telephoto lens of 100mm or 135mm for foreground and detail shots, and a 200mm or 300mm lens for close-ups. You may prefer a more powerful wide-angle lens as an alternative (24mm to 20mm, with perhaps a fisheye lens for special effects) and a simple focal length doubler to combine with the 135mm lens.

A lot of experience is needed to handle the super-telephoto lenses, the 300–1000mm "canons," but they are certainly the most useful and efficient for most sports photos. A 300mm lens with perhaps a doubler and a light, compact "mirror" lens such as the 500mm are the best in this category for nonprofessionals. To work with adequate speeds, it is important for the stop to be set at maximum aperture and to use rapid film.

The development of zoom lenses over the last few years has been significant, so their performance now is not much different from fixed lenses. The Nikon 80–200mm Nikkor, the Olympus 75–150mm and the Canon FD80–200mm lenses are the most suitable for sports photography.

Those with particular ambitions or needs will find a rapid reload winder or motor drive for sequence shots very useful. Nikon, Olympus, Canon, Pentax, Contax, and Leica all have cameras suitable for motor drive.

Essential accessories include a good tripod with a 300mm telephoto lens. Special "rifle" grips are also handy, and a good exposure meter (such as the Lunasix) is also useful for getting the right exposure, especially indoors. A lens hood, skylight filters (for color) and clear yellow filters (for black and white) that do not need diaphragm correction can be permanently attached to the lenses. A flash can come in handy at times, but it is better used as little as possible, as it tends to make the picture flat and unnatural.

As a general rule, a sports photographer's equipment should be practical and never cumbersome or excessive, so it is a good idea to plan carefully before a match or event and take only instruments and accessories that are really essential, leaving behind anything superfluous. In fact, equipment that is too heavy and sophisticated can adversely affect the finished result.

In any event, no amount of expensive equipment can make a good photographer of one who cannot "see" his subject.

Previous page: The last hurdle in the Olympic final in Mexico City (1968), where Americans Willie Davenport and Erv Hall raced elbow to elbow. The photograph was taken with a 1000mm lens and is a veritable technical masterpiece. The constant search for such effects taking advantage of the most advanced technology is one of the characteristics of sports photography.

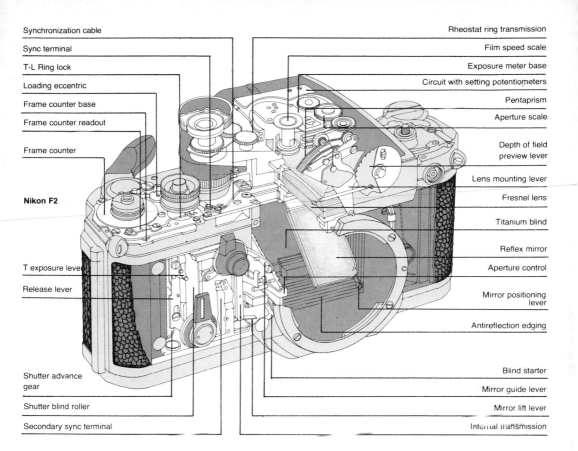

Synchronization cable
Sync terminal
T-L Ring lock
Loading eccentric
Frame counter base
Frame counter readout
Frame counter

Nikon F2

T exposure lever
Release lever

Shutter advance gear
Shutter blind roller
Secondary sync terminal

Rheostat ring transmission
Film speed scale
Exposure meter base
Circuit with setting potentiometers
Pentaprism
Aperture scale
Depth of field preview lever
Lens mounting lever
Fresnel lens
Titanium blind
Reflex mirror
Aperture control
Mirror positioning lever
Antireflection edging
Blind starter
Mirror guide lever
Mirror lift lever
Internal transmission

The reflex system

The SLR (single lens reflex) camera with interchangeable lenses is the sports photographer's basic piece of equipment. All kinds of focal depth can be used without worry because of the direct view obtained through the lens, mirror, and pentaprism of the picture to be formed on the film, and the photog-

rapher has direct control of the set values through the viewfinder. The process has been simplified even more with the introduction of automatic reflex cameras. Automatic diaphragm lenses keep the image in the viewfinder at maximum aperture, guaranteeing accurate focusing and framing. The main disadvantage of reflex cam-

eras—the fact that the image disappears from the viewfinder when the shutter is released because the mirror is retracted—is not serious in sports photography because of the high speeds usually used. The shutter is the focal-plane type and its speed, which can go down to 1/2000 second, determines the exposure. To allow

accurate focusing, particularly in poor natural light, a microprism ring or a split image focusing aid can be incorporated in the center of the ground glass screen. With powerful lenses and the consequent lack of light at maximum aperture, the center of the screen can be obscured, so a complete ground glass screen is better.

Nikon F2.

Focusing screens
The best reflex cameras offer a wide range of interchangeable focusing screens to give fast and accurate focusing even with powerful telephoto lenses. The more common systems, microprisms and stigmometers, darken when used with lenses with a maximum aperture of less than f/4.5.

1000 500 250

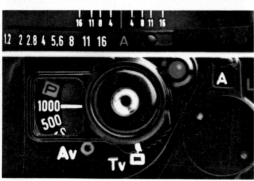

1 0 0 0 8 . 0

Checking through the viewfinder

The ability to read speed and aperture values directly on the viewfinder allows the photographer to make any necessary adjustments without having to take his eye from the frame and so be distracted.

Left: The galvanometer needle on the Nikkormat FT3 viewfinder. Below: The values are shown on the viewfinder of the Canon AI by means of a "led" display. This camera offers the possibility of a double automatic system, in that the photographer can choose between speed or aperture. The former is more suitable for sports photography, where fast speeds are often necessary.

The diagram at the bottom of the page shows the operations that should be carried out before you press the release button.

The right exposure

When using nonautomatic cameras, the following adjustments have to be made:
1) When framing, limit the field of the image in relation to the focal length selected.
2) Bring the main subject into focus using the focusing ring, the reflector viewfinder, or the rangefinder.
3) Set the exposure, using the speed selector and the diaphragm stops, selecting the combination that is most suited to the particular requirements of the shot.

The third operation can be eliminated with an automatic exposure camera, which gives the photographer the advantage of being able to concentrate exclusively on framing, focusing, and choosing the right moment to shoot.

There are two types of automatic system available:
1) automatic aperture selection, and
2) automatic speed selection.
Some particularly sophisticated reflex systems such as the Canon A1 and the Minolta XD7 offer a choice between the two.

Cameras of the first type, such as the Canon AE1, are better suited to sports photography in that the photographer can set the shutter speed accurately, but they do present problems with nonautomatic or fixed aperture lenses such as catadioptrics. The second type of system is, however, more commonly found and is used by Nikon, Olympus, Contax, Leitz, and Pentax. The shutter is electronically controlled and can close at speeds ranging from 1/1000 to a number of seconds. Nearly all automatic reflex cameras (with the exception of the Pentax ME) have a manual overrride to set the exposure, but they all have a device for setting the exposure between two limits for shots in bad or contrasting light conditions, when the "normal" reading on the photoelectric cell could be misleading.

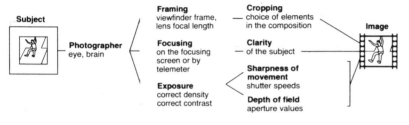

Subject

Photographer
eye, brain

Framing
viewfinder frame,
lens focal length

Focusing
on the focusing
screen or by
telemeter

Exposure
correct density
correct contrast

Cropping
— choice of elements
in the composition

Clarity
— of the subject

Sharpness of
movement
shutter speeds

Depth of field
aperture values

Image

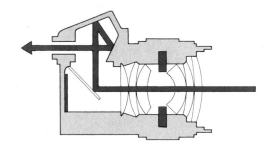

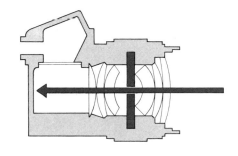

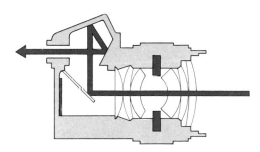

How to measure light

Different light levels determine a combination of speed and aperture values that can be read on any exposure meter scale, so the same scene can be exposed at 1/60 –f/11, 1/125–f/8, or 1/250–f/5.6. The choice of speed used depends on the speed of the subject and the stability of the machine; changing the aperture, which meters the amount of light reaching the film, also changes the depth of field of the image. Greater accuracy is achieved by a system of metering through-the-lens (TTL). When setting the speed and aperture on nonautomatic cameras, you have to align the indicator on the galvanometer with a reference point on the viewfinder, or use light signals. If an exposure meter circuit is connected with the stop-down system, the viewfinder is obscured when the diaphragm closes; but on more modern reflex cameras, a diaphragm simulator on the lens allows reading at maximum aperture, with the obvious advantage that the photographer is able to exercise more control over focusing and choice of frame.

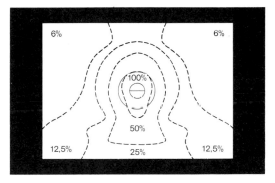

The diagrams above show the series of operations that take place when the release button is pressed on an SLR camera. The blind opens after the mirror is raised, and for a brief moment you lose vision through the viewfinder. The TTL exposure metering system memorizes the values set during exposure. The Olympus OM2 also has a direct metering system that takes place in "real time" during the brief instant that the mirror is in the raised position.

Measuring systems

The range of measurement of the cells can be "integral" (on an average value), central "spot" for making selective measurements, or "semispot" (the most common), which gives the clearest readings in the central area. When the subject has strong contrasts of brightness, inaccurate exposure values may be obtained if the reading is too selective.

Above: The dual system fitted on the Leica R3 (spot or semispot) offers either partial or overall readings.

The Hulcher 112

The Hulcher 112 is widely used by the best professional sports photographers in the United States and is every action reporter's dream camera. It is manufactured by an American company that specializes in cameras for scientific or industrial use and can take up to 60 frames per second in sequence with shutter speeds from 1/25 to 1/12,000 second. The camera is sold as a basic body, but it can use all the Nikkor lenses that have the classic bayonet coupling or any other lens with a suitable adaptor. It runs on 12V or 24V batteries and has spooling for up to 30 meters (100 feet) of roll film.

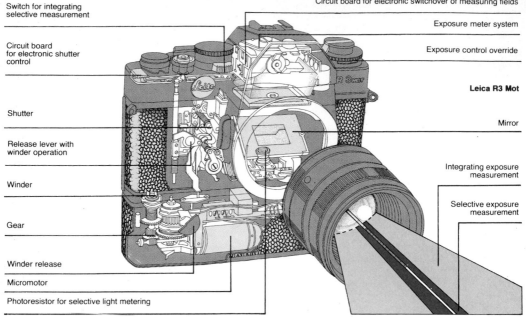

Switch for integrating
selective measurement

Circuit board for electronic switchover of measuring fields

Exposure meter system

Circuit board
for electronic shutter
control

Exposure control override

Leica R3 Mot

Shutter

Mirror

Release lever with
winder operation

Winder

Integrating exposure
measurement

Selective exposure
measurement

Gear

Winder release

Micromotor

Photoresistor for selective light metering

Motor drive

The use of a motor driven camera is by no means a luxury when undertaking sports photography. The motor enables sequence shots to be taken and the shutter to be reloaded rapidly so that the machine is ready for use at all times and the photographer can concentrate on timing the shutter release. Until a few years ago, motors were heavy and cumbersome, but now with their capabilities increased they are more than adequate, and many models have the motor directly incorporated in the body. The market currently offers a vast range of accessories, so the first decision to be made is whether to get a winder, which automatically reloads the shutter after each shot, or a true sequence motor. The rate of shots ranges from two to five frames per second (Nikon, Olympus) to a maximum of nine on the Canon High Speed. The only camera with higher speeds is the Hulcher 112.

The advantages of motor drive are obvious: with the button set to sequence, a photographer can follow the action by just pressing the button at will. Among its disadvantages, apart from price and weight, are the greater risk of mechanical failure, dependence on the state of the batteries (performance can be appreciably reduced when the batteries are low), greater delays in operating the shutter, and the enormous amount of film used (and often wasted). So that one won't run out of film suddenly, enlarged magazines that hold 250 to 750 exposures can be used with a rapid rewind system. All models should, however, have a manual rewind in case the motor malfunctions.

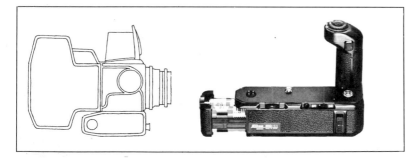

Modern motors are now simple, compact, and light, and are unlike older types, which were so cumbersome that they seriously offset their advantages for action photography. In fact many models are fitted with a specially shaped pistol grip on the battery housing, which is very useful when working freehand. Above, left: The motorized Hasselblad EI with an enlarged film chamber capable of 500 frames of 70mm film, a truly professional piece of equipment. Left: The motor on the Canon AI. Above, right: The MD-11 motor is specially designed for use with the Nikkormat FM camera and is capable of taking sequences of up to 3.5 frames per second with a capacity for rolls of 100.

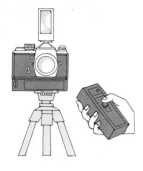

Remote control
Various systems are available to release the shutter on a camera placed in an "impossible" position, ranging from a simple cable to radio signals and infrared rays. The drawings on the right show the remote control systems available for the Olympus. Above: The Leica infrared ray system.

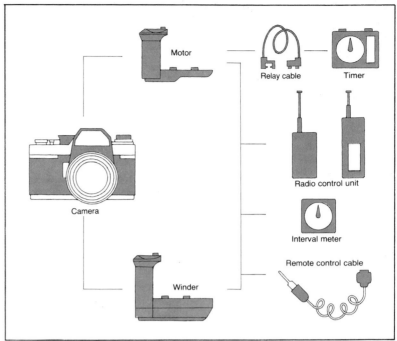

Motor

Relay cable Timer

Camera

Radio control unit

Interval meter

Remote control cable

Winder

Remote-controlled reflex systems

One of the most interesting uses of motor drive in sports photography is for controlling a camera from a distance, reloading the shutter automatically, and winding the film. This becomes essential when the photographer cannot accompany the camera at the desired viewpoint, such as in the goalmouth at a hockey match, or at the very tip of a hang glider. In these cases, the camera can be fitted with a motor set to single shutter release or with a simple winder, and the photographer can control it from a distance with an electric cable, a timer, radio transmitter, or infrared signals. The result is guaranteed to be both technical and spectacular. The camera is positioned on a clamp or a tripod and focused on the area where the action is to take place. For particularly difficult shots, a right-angle attachment can be used for the finder eyepiece to facilitate focusing and delineating the field. In most cases, the position selected in the heart of the action requires the use of a powerful wide-angle lens such as the 20mm, which also guarantees maximum depth of field. If the camera is nonautomatic, the exposure has to be preset, but if it is, then the photographer has the advantage of being able to rely on automatic correction if there are any changes in brightness. Particular attention has to be paid to protecting the camera from knocks, rain, spray, or mud. Of the various remote control systems, the most commonly used is the cable. With cables, electric relays may be necessary to maintain the voltage when the camera is over 20 meters (65.5 feet) away from the operator; but with radio signals, the camera can be operated up to two or more kilometers (a mile or more) away. Radio control is used in wildlife photography because it facilitates hidden positioning. In most cases, however, the 10 meter (32.8 foot) effective length of a normal cable connected directly to the motor is more than enough and has the advantage of giving the photographer greater control over the shutter release.

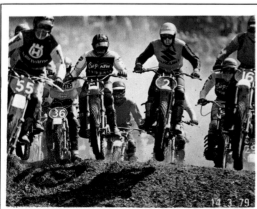

Some cameras can have a device installed by which a small internal flash prints the day, month, and year in a corner of every picture taken, useful for cataloging the photos.

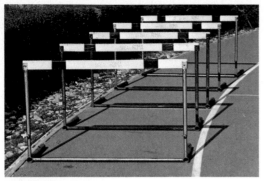

135mm f/16

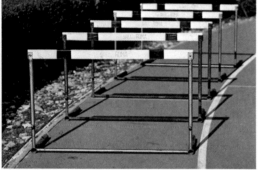

135mm f/4

Above: The line of hurdles was taken with the same lens (135mm) but with different aperture stops. Below: The limited depth of field of a 300mm lens.

Depth of field

In the past, when the size of the equipment (and consequently the focal length of the lenses) was relatively large, maximum clarity was one of the photographer's biggest problems and it was necessary to pay close attention to focus and to use extreme diaphragm stops to obtain reasonably clear pictures. But the modern small cameras like the 35mm that appeared about 1925 immediately allowed greater, though relative, depth of field, despite the lower diaphragm values.

Photo reportage and sports photography in particular benefited from this innovation, as it allows the rapid shutter speeds that are necessary to capture fast action. The "normal" lens on a 35mm camera at f/8 over a distance of 10 meters (32.8 feet) still has a significant depth of field (5 meters /16.4 feet to infinity), which allows the photographer to concentrate on other matters such as framing and shutter-release speeds.

Depth of field is now a problem mainly when using lenses with greater focal length. Depth of field is the distance between the two limits on the area in frame in which all the subjects are in focus, i.e., clear. Absolute clarity in fact is an illusion, as can easily be proved by enlarging any negative to its maximum. Within certain "normal" enlargement limits, a detail will appear clear if the eye cannot detect that it is out of focus. In fact, all pictures are not composed of groups of dots, but of numerous microscopic rings known as "circles of confusion." The clarity of the negative is determined by the diameter of these rings in the area in focus, and its definition varies according to their

300mm f/8

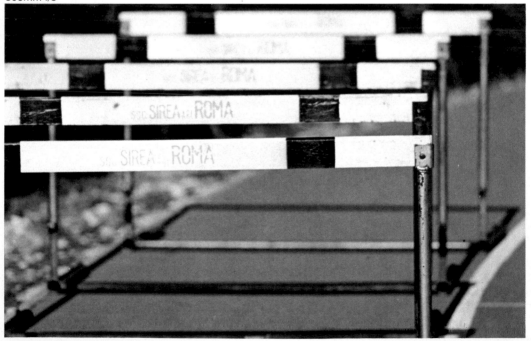

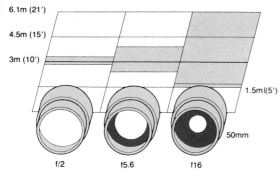

6.1m (21')
4.5m (15')
3m (10')
1.5m (5')
50mm
f/2　　f5.6　　f16

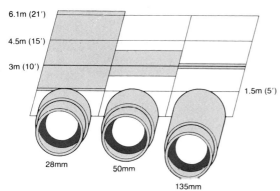

6.1m (21')
4.5m (15')
3m (10')
1.5m (5')
28mm　　50mm
135mm

Penalty area　Penalty spot
16.50m (54')
Goal area
5.50m (18')
Goalmouth
16.50m (54')
Corner
Position 1 100mm
7.32m (24')

format: on the 2¼ × 2¼ inch (6cm × 6cm) the maximum acceptable diameter of the circle of confusion has been traditionally accepted as 1/1000th of the "normal" focal length (80mm); for the 35mm, the value is higher, equal to 1/1500 of 50mm, i.e., 1/30 of a millimeter. The width of the area in focus varies as a function of the distance of the subject (increasing as the distance increases), of the diaphragm stop (increasing as the stop decreases), and of the focal length (increasing as the focal length decreases). The depth of field can be controlled on the scale designed on the lens housing, which gives the relationship between the distance and the stop with the given focal length or with the stop-down button found on certain TTL reflex models.

Hyperfocal point

The hyperfocal length is the distance beyond the point which is clear when the lens is focused on infinity; it is a function of the focal length and the diaphragm used. With the aperture set, and the lens focused on the hyperfocal point, maximum depth of field is achieved for that aperture, extending from a distance halfway between this point and the camera to infinity. The normal formula for the hyperfocal point is:

$$i = \frac{F^2}{f \times C}$$

where F is the focal length in mm, f is the diaphragm stop and C is the diameter of the circle of confusion in millimeters.

So, with a 50mm lens and aperture f/8, applying the formula for the hyperfocal point, you get:

$$i = \frac{50 \times 50}{8 \times 1/30}$$
$$= \frac{50 \times 50 \times 30}{8}$$
$$= \frac{75000}{8}$$

= approximately 10 meters (32.8 feet)

Setting this value on the focusing scale, you would have clarity from 5 meters (16.4 feet) to infinity.

Shooting with confidence

Intelligent use of depth of field can transform the camera into a "rapid-fire weapon," which the photographer can use instinctively to obtain the best results over the widest area possible without having to worry about focusing, thus being able to concentrate entirely on what is going on. Top: The variations in depth of field using different aperture stops with a 50mm lens and with different focal lengths at the same aperture. Center: The area in focus on a soccer field using a 100mm telephoto lens at f/11 set for a distance of 10 meters (33 feet).

Distance in meters (feet)	1 (3.5)	1.5 (5)	2 (6.5)	3 (10)	5 (16.5)	10 (33)	30 (98.5)	50 (164)	∞
2.8	0.99~1.01	1.48~1.52	1.97~2.03	2.93~3.08	4.79~5.23	9.18~10.98	23.55~41.34	34.29~92.41	107.32~∞
4	0.99~1.01	1.48~1.52	1.96~2.05	2.90~3.11	4.71~5.33	8.87~11.47	21.57~49.34	30.23~145.31	75.40~∞
5.6	0.99~1.01	1.47~1.53	1.94~2.06	2.86~3.16	4.60~5.48	8.48~12.18	19.39~66.52	26.11~615.55	54.00~∞
8	0.98~1.02	1.45~1.55	1.91~2.09	2.80~3.23	4.45~5.71	7.97~13.45	16.85~139.50	21.68~∞	37.89~∞
11	0.98~1.03	1.44~1.57	1.88~2.13	2.73~3.33	4.28~6.03	7.41~15.45	14.48~∞	17.89~∞	27.61~∞
16	0.97~1.04	1.41~1.60	1.84~2.20	2.63~3.50	4.01~6.66	6.63~20.57	11.73~∞	13.87~∞	19.03~∞
22	0.95~1.05	1.38~1.64	1.78~2.28	2.51~3.73	3.74~7.61	5.89~34.26	9.56~∞	10.93~∞	13.88~∞

(Leftmost column label: **F-stop**)

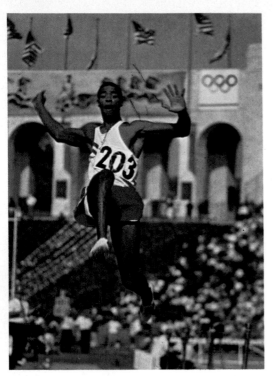

Lenses

The size of the image on the negative depends on the actual distance of the subject and the focal length of the lens used.

The *focal length* is the distance between the center of the lens and the surface of the film, with the focusing scale set to infinity. "Normal" focal length is the closest to the negative diagonal: 50mm for the 35mm format and 80mm for the 2-1/4 inch (6cm×6cm). Lenses with shorter focal length are also known as wide-angle lenses and those with long focus are telephoto lenses. The size and focal length of the image on the negative are directly proportional: an average 100mm telephoto lens produces an image double that of a 50mm lens. All lenses produce a circular image inside the camera, which is clear at the center, becoming progressively poorer in quality toward the edges. The useful area is that which is clearest and is covered by the negative. The *relative aperture* of a lens is another basic feature; it indicates the amount of light that the lens can transmit onto the film and corresponds to the focal length of the lens, divided by its diameter. The maximum aperture is very important, especially when one is working in poor light conditions with long focal lengths and fast shooting speeds, or when using very sensitive film to facilitate the use of telephoto lenses.

Field of view
The different focal lengths of lenses give different fields of view (as shown in the diagram below): the angle changes from 180° with the ultra wide-angle lenses to 2½° with a 1000mm super-telephoto lens. Above: The reduced depth of field of a powerful telephoto lens makes the figure of the jumper stand out in relief against the background. Opposite: A schematic summary of the main features of the most commonly used lenses. Long focus lenses are the sports photographer's main weapons, for they enable him to overcome the problems of distance and isolate details of the action.

It is normally better to fit the original lenses onto the camera, but there are good, cheap "universal" lenses such as the Vivitar, Tamron, and Komura, that fit onto different bodies with either a bayonet coupling or a screw fitting.

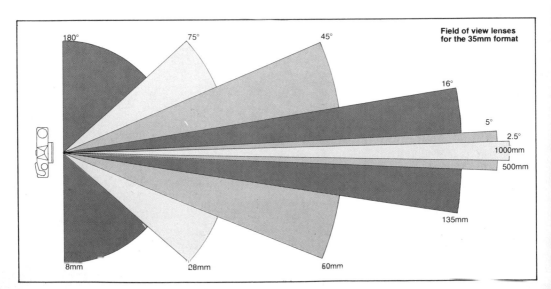

Field of view lenses for the 35mm format

180° 75° 45° 16° 5° 2.5° 1000mm 500mm 135mm 60mm 28mm 8mm

The normal lens
The 50mm is the basic lens in any photographer's kit. It is made up of six or eight elements and usually has the widest useful maximum aperture (f/2, f/1.4) for interior photography. The "normal" optic has a field of view similar to that of the human eye (46°).

The wide-angle lens
The wide-angle optic (35–76mm) greatly increases the field of view, enabling the photographer to take very involved photographs from very close distances, characterized by a more or less marked perspective deformation.

The telephoto lens
Focal lengths above the 50mm are most commonly used in sports photography. They allow the photographer to overcome the various restrictions imposed by the distance at which the events are taking place and isolate the main subject. The use of diverging elements in its construction reduces the distance between the center of the lens and the film.

Long-focus lenses
Long-focus lenses are characterized by the great distance between the optic group and the film surface. They have a relatively modest maximum aperture (f/4.5, f/5.6), but give a high resolution image.

Catadioptrics
Catadioptrics, or "reflex" or "mirror" lenses, use the effects of reflection to lengthen the internal trajectory of the light path and so reduce the distance from the film surface. They are compact and light, with their only disadvantage being that they are fixed diaphragm (f/8, f/11, or f/16).

Zoom lenses
Variable focal length, or zoom, lenses are an efficient substitute for a wide range of intermediate lenses. They have relatively small maximum aperture and are quite expensive, with a slightly inferior clarity to fixed focal length lenses. The best have a range which is not too excessive (such as the classic 80–200mm or the 75–150mm) and are a very good way of solving framing problems encountered with fast action. They are ideal for many team sports such as football and rugby.

The fisheye lens
As indicated by its name, the fisheye dilates the angle of view up to 180°, giving curiously deformed effects. The classic 8mm fisheye has an exceptional depth of field, from 30cm (1 foot) to infinity.

The doubler
Focal length multipliers are very simple optic groups that are placed between the camera body and the lens. They are a good alternative to more powerful telephoto lenses. Apart from reduced incisiveness, they have the disadvantage of needing a 2 stop diaphragm correction.

The enlargement ratio

The ability of a long focus lens to bring the subject "closer" enables you to fill the frame even when the subject is some distance away, as is normally the case with sports events. The table below gives the dimensions on the negative in relation to the distance and the focal length used.

Right and below, opposite:

The different results obtained with a normal lens and a telephoto lens. Apart from enlarging the image, the long-focus lens also compresses the different levels and reduces depth of field (which can even make the background unrecognizable). This reduces as the focal length increases and the distance and aperture decrease.

$$d = \frac{h \times f}{D}$$

d = size on the negative
h = height of the subject
f = focal length
D = distance of the subject

Focal length of lens	Distance of the subject in meters (feet)	Size in mm (inches) on the negative of a subject of 1m² (11 ft²)		Distance in meters (feet) at which a person on foot will fill the frame vertically
28mm	20 (65.5) 50 (164) 100 (328) 200 (656) 500 (1640)	2.8 1.6 0.8 0.4 0.6	(0.11) (0.06) (0.03) (0.016) (0.024)	1.4 (4.5)
50mm	20 (65.5) 50 (164) 100 (328) 200 (656) 500 (1640)	5 2 1 0.5 0.2	(0.2) (0.08) (0.04) (0.02) (0.01)	2.5 (8.2)
135mm	20 (65.5) 50 (164) 100 (328) 200 (656) 500 (1640)	13.5 5.4 2.7 1.35 0.54	(0.5) (0.21) (0.10) (0.05) (0.02)	6.8 (22.3)
200mm	20 (65.5) 50 (164) 100 (328) 200 (656) 500 (1640)	20 8 4 2 0.8	(0.8) (0.3) (0.16) (0.08) (0.03)	10 (32.8)
400mm	20 (65.5) 50 (164) 100 (328) 200 (656) 500 (1640)	40 16 8 4 1.6	(1.6) (0.6) (0.3) (0.16) (0.06)	20 (65.6)

The telephoto lens

Long-focus lenses are the sports photographer's "tools of the trade," since in most cases one can only get within a certain distance of the heart of the action. One of the main features of the telephoto lens is its depth of field, which progressively reduces compared to lenses of lower focal length. If focusing proves critical and requires greater attention, less depth of field can be put to efficient use to isolate the subject from the background and give meaning to the action. Another feature of this lens is the compression of the elements of a scene on different levels, which also lends itself to effective interpretation. The enlargement compared to a normal 50mm optic is obtained by dividing the lens focal length by this value. Telephoto lenses are very susceptible to "camera shake," and as a general rule, speeds below the focal length should not be used when cameras are hand held. But once the photographer has had practice, a 300mm or even a compact 500mm reflex could be used without a tripod.

Catadioptrics

Unlike traditional telephoto lenses, catadioptrics, or mirror lenses, are much shorter than their focal length. The light rays are actually reflected twice before they hit the film surface. The lenses are made in 500mm, 1000mm, and 2000mm sizes, they have a fixed aperture, and exposure is controlled either by the speeds used or by means of filters. One of the advantages of these "reflex" lenses over other telephoto lenses is that there are no problems of chromatic aberration in focusing. Mirror lenses do, however, give a characteristic "ringed" phenomenon outside the area sharply in focus, where the elements are out of focus.

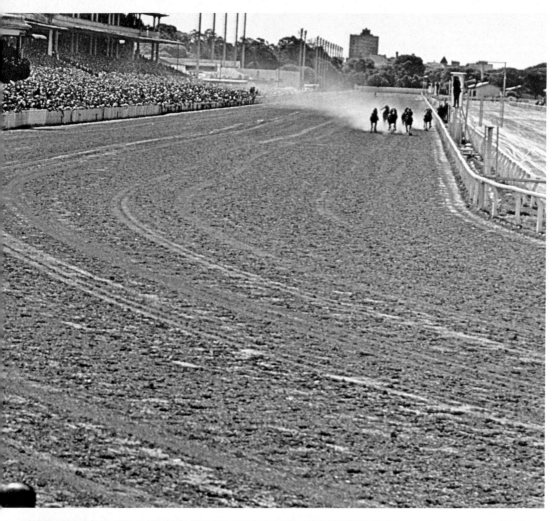

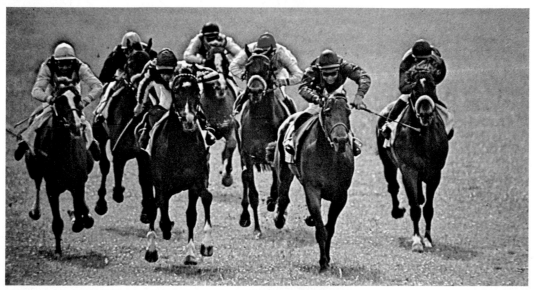

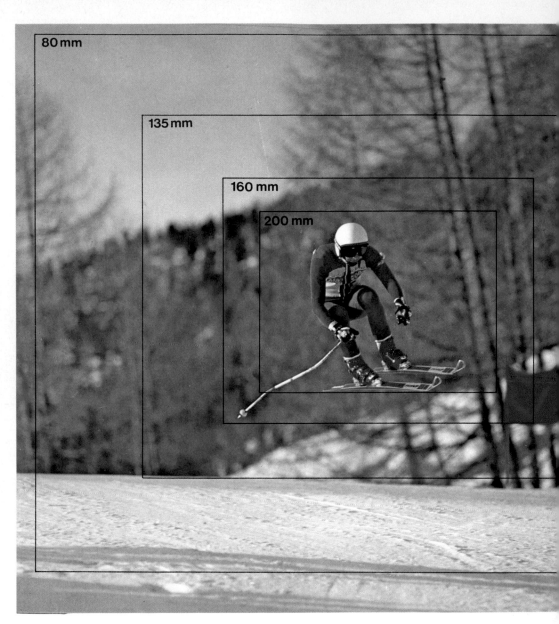

80 mm

135 mm

160 mm

200 mm

Zoom lenses
Left: The Nikkor 43–86mm zoom lens. The 80–200mm range offers the most interesting possibilities to the sports photographer. The drawing shows the depth of field scale, which obviously varies with the choice of focal length.

Above: The different areas covered by an 80–200mm zoom lens. The drawing (opposite) shows how use of the zoom ring enables you to take a sequence of the descent of a skier, without altering the frame, from 30 meters (100 feet) to 10 meters (33 feet). The advantages of a zoom lens are particularly felt when the photographer cannot select the shooting position.

The right focal length
A recurring question in the choice of additional lenses is whether to buy a variable focal length lens (a zoom lens) or a fixed optic. Up until a few years ago, the choice was largely determined by the inferior quality of zoom lenses compared to the others. Nowadays, however, there are variable focal length lenses on the market (Nikkor,

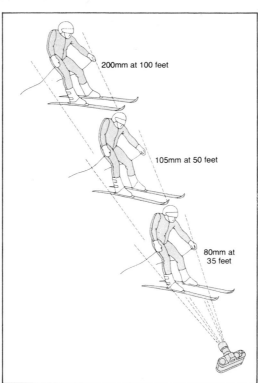

200mm at 100 feet

105mm at 50 feet

80mm at 35 feet

straight reporting shots with just one lens and moving quickly around different angles of view. The 50–300mm and the "super" 200–600mm and 360–1200mm f/11 in the Nikkor series are particularly suited to the sports photographer's needs. Those interested in special effects can use the zoom lens to create the "exploded" effects achieved by rapidly varying the focal length during exposure. The quality of zoom lenses is still slightly inferior to that of the corresponding fixed focal length lenses because of the great complexity of its optic group. *Incisiveness* is a fundamental characteristic of the lenses which is dependent on a number of factors such as optic quality and relative brightness. In general, incisiveness is greater on "normal" focal length, less on telephoto, wide-angle, and zoom lenses, and almost never corresponds to the maximum aperture of the lens. Best results are obtained by closing the aperture down a couple of stops. Perfect negative clarity also depends on the power of resolution of the film, the cleanliness of the lens, the physical stability of the camera when the shutter is released, the contrast and quality of the light, and the accuracy of focusing.

closer all the time without altering the field, such as in the descent of a skier or the arrival of a group of cyclists or horses in full gallop. Using this lens, the photographer can take more than one photo of the same subject, following it as it gets closer. The only disadvantages are that the zoom lens is relatively heavier and has a reduced maximum aperture, which is particularly felt in bad light conditions when the photographer would like to maintain the fast shutter speeds necessary to freeze the action. However, this restriction can be overcome by using high speed film. The most up-to-date zoom lenses with focal lengths from a 28mm wide-angle to a medium range telephoto lens are not essentially suited to the sports photographer, although they can be very useful for covering

Canon, or Zuiko) which are really valid alternatives to a number of lenses. The ability to vary the size of the image (keeping the focus constant) is a great advantage, particularly when dealing with sports in constant movement (such as a football game or soccer match), or when you want to take a sequence of shots of subjects that are coming

Special lenses
Lens technology has developed enormously over the last few years. The drawing shows the super-bright Canon 300mm f/2.8, which has flourite lenses to reduce light dispersion. On the same principle, Nikkon has brought out the ED series of lenses (extra low dispersion glass) from 300mm to 600mm, which incorporate correction for chromatic aberration and give excellent clarity, even at maximum aperture. The size of the lenses has also been drastically reduced by means of the system of internal focusing, which cuts down the movement of the lenses.

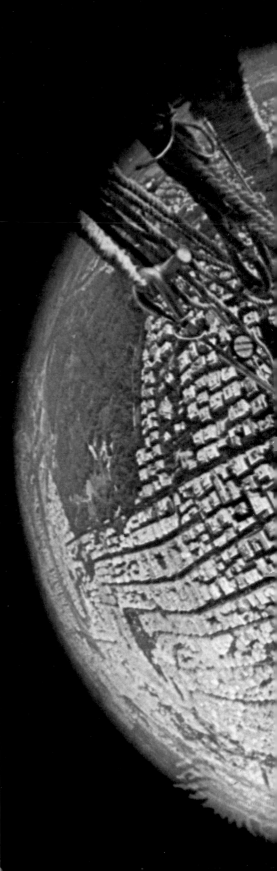

The fisheye lens

The ultra wide-angle fisheye lens creates curiously deformed, circular images on the film. The classic fisheye is the 8mm, which has a depth of field from 20cm (8 inches) to infinity (at f/11) and an angle of 180°. Even more powerful models such as the Nikkor 6mm cover an angle of 220°, enabling you literally to see behind yourself. The 16mm gives a similar effect to the fisheye but covers the whole frame.

The typical deformation of the fisheye can be used for very creative effects and is particularly useful for taking shots from a very close range.

Right: The effect obtained by fixing the camera above the basket of a balloon (above) and operating it by remote control by means of an electric cable connected to the motor. The fisheye proved to be highly effective in capturing this flight over Rome.

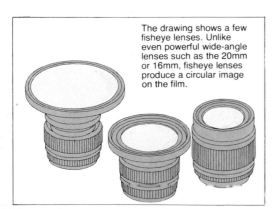

The drawing shows a few fisheye lenses. Unlike even powerful wide-angle lenses such as the 20mm or 16mm, fisheye lenses produce a circular image on the film.

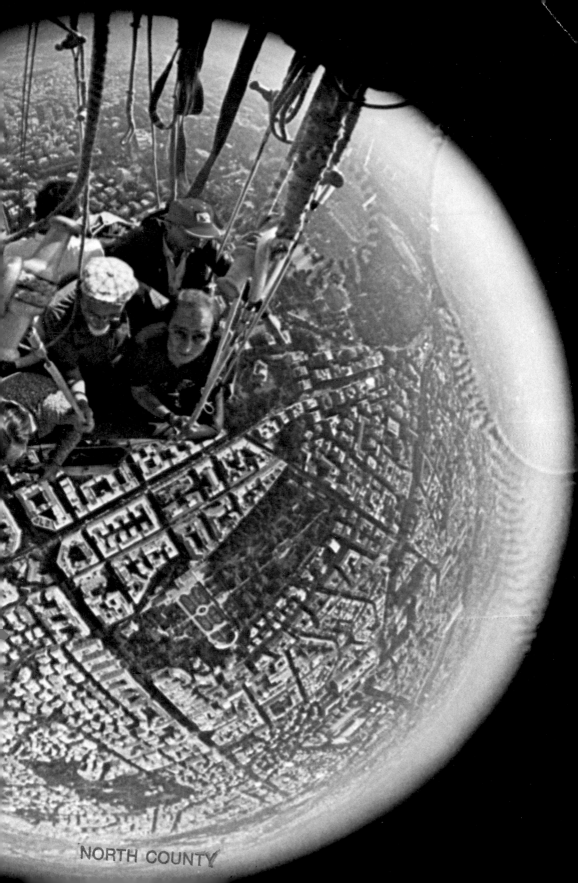

NORTH COUNTY

Degrees Kelvin	Light source	Film and filters
18,000	Blue sky, snow	Daylight film
6,000	Sky	+81A + 1/2 stop
5,800	Daylight	
5,600	(Electronic flash)	Film
5,400	Midday sun	Daylight
5,200	Blue flash	
5,000		
4,800		+82C + 1 stop
4,600		
4,400		
4,200	Dawn, dusk	+82C + 82A + 1 stop
4,000	Fluorescent light	
3,800	Clear flash light	
3,600		
3,400	Artificial light	+80B + 1 stop
3,200	Tungsten	Type B film
3,000	Floodlight	
2,800	150/200W bulb	+82C + 1 stop
2,600		+82C + 82A + 1 stop
2,400		+82C + 82C + 1-1/2 stop
2,200		
1,930	Candlelight	

Color temperature

All light sources have their own "color temperature," which is measured in degrees Kelvin. Daylight varies from 5000–6000K and candlelight is barely 1930K. Blue sky has a temperature that varies from 12000–16000K. Color films are designed for a particular range of color temperature beyond which the chromatic performance may be inaccurate; lower temperatures give dominant reddish or yellowish colors whereas higher temperatures tend toward blue. Daylight film is most accurate between 5200–5800K and electronic flash or blue lamplight fall within this range. Beyond 5800K though, to obtain perfect performance, conversion filters or temperature compensators have to be used and the exposure values corrected. Below 3200K, artificial light or Type B film is advisable. Some highly sensitive films such as the Ektachrome 400 ASA are designed for a vast range of brightness and so are suitable for both daylight and artificial light. 250–500 watt bulbs have a color temperature of 3200K and a 150 watt bulb yields 2800K. Neon lighting gives an unpleasant greenish effect over the film if it is not filtered out. A color temperature meter is advisable for accurate measurement when the lights are of various types, but in all cases, it is advisable to do a few tests.

Above: A color temperature meter to measure the color temperature of the light source. Left: A table giving the temperatures with the recommended films and conversion or compensation filters necessary.

Filters

Filters modify the reaction of the photographic emulsion to the light rays which strike it and can serve to increase the contrast, be used for chromatic correction, conversion, or other special purposes. The exposure normally has to be adjusted to cater to the absorption coefficient of the filter.

Skylight filters

These correct a dominant blue and absorb ultraviolet rays. They are advisable for all color shots and require no exposure adjustment. In fact, the slight salmon-colored hue can "warm up" lenses that are traditionally regarded as "cold," such as the Nikkor and Leitz.

UV filters

These absorb ultraviolet rays and are advisable for shots in mountains, at sea, and on snow to avoid any blurring on the film. They are also useful for reducing haze on the horizon.

Filters for black and white

Yellow and red filters are the most common to increase the contrast of the sky.

Polarizing filters

These are very useful for saturating the colors and cutting out light reflections on water or glass.

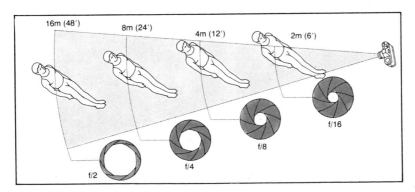

16m (48') 8m (24') 4m (12') 2m (6')

f/2 f/4 f/8 f/16

Use of flash

Every flash has its own guide numbers relating to the sensitivity of the film used. By setting the synchronization time to 1/30 second (in the case of bulbs; you would use even higher speeds with an electronic flash), the right aperture can be obtained by dividing the guide number by the distance in meters of the subject. If using a flash to supplement daylight, multiply the guide number by two and use the aperture to get the distance.

Accessories

The photographic market can offer an enormous variety of accessories, but when making a choice, the sports photographer must choose only what is essential and not overload himself or herself. Whatever is chosen must be light and practical. Of course, the real usefulness of all these accessories must also be proved, as very often they turn out to be of little or no use at all. Among the instruments that are clearly useful are a good tripod, which must be solid and light (two qualities that are difficult to find together), since one is indispensable when working with long-focus lenses. A flexible shutter release cable helps stop vibration at the camera. Remote control for the motor drive is also necessary if distance shots are to be tried, but here we're getting onto a professional level where accessories are very expensive. Good results can be obtained with a 5 or 10 meter (16.4 or 32.8 foot) cable. A screw clamp helps to hold the camera and can also be used as an emergency stand. A lens hood is recommended and is often built in on modern telephoto lenses. Small brushes and blowers are useful for cleaning the lenses, but try not to rub them unless you are very careful. A screwdriver and adhesive tape also come in handy for on-the-spot repairs. All the accessories should be kept in a strong case with appropriately shaped internal divisions.

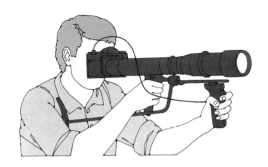

The photographic rifle
Originally designed for the photographic "hunt," this is a shoulder support that is very useful for all sport shots because it enables you to use lenses up to 500mm freehand. A special pistol grip with a spring mechanism has also been designed to facilitate focusing; rapid focusing has also been fitted on some long focus lenses such as the Novoflex. The use of a winder enables you to shoot without having to take your eyes from the viewfinder, and with an automatic camera, the shooting speed can be increased even more.
 Below: Some useful accessories for the sports photographer.

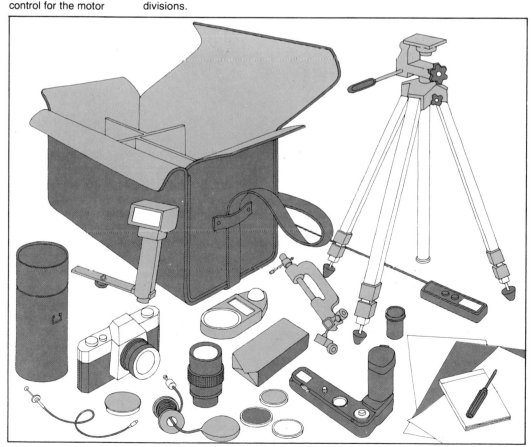

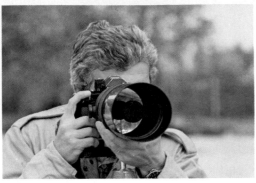

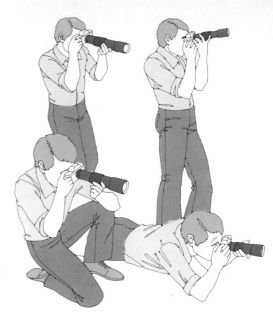

The grip
To avoid blurred effects with lenses of 100mm to 300mm, you should support the lens with one hand and keep the camera body resting firmly on your cheek. The drawings at right show some positions recommended for keeping the camera stable.

Above: With even more powerful lenses such as this 1000mm reflex, a solid tripod is essential and a cable release can be helpful when taking the shot (below). Pistol grips are available to facilitate taking the shot, particularly with motorized cameras.

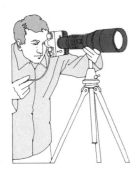

Knowing your equipment
Action photography demands instantaneous decisions that leave no room for error and that are made without second thought. For this reason, the sports photographer must have a thorough knowledge of the equipment and must be able to determine almost instinctively the best position, focal length, and exposure time, as well as to face any difficult or unforeseen situation with the most economical equipment. Training is particularly important when telephoto lenses are used.

Even with fast speeds

(not less than 1/250 second), you can still manipulate a 300mm lens by hand; the obvious advantage in mobility and speed is not available with a tripod mounted lens. The equipment case is very important when you have to change a lens or reload in a hurry: it has to be functional, practical, and all the accessories inside have to be easily accessible, so that you need not take everything out. New film should be kept in a special pocket on the outside and used film kept in another, or in a jacket pocket with a zipper. It is helpful to have all the data sheets that are usually enclosed with new lenses, as they give all the necessary information about distances and diaphragms, and so help in focusing. Before tackling any situation that will not give you a second chance, it is a good idea to try out the various shooting techniques and measure your own reaction times. Only after a great deal of

experience can you master the technique of "panning" or know for sure what speed is necessary to "freeze" a certain action. Even without a motor or winder, after a little practice you can shoot at one frame per second with an ordinary manual shutter release. Experience also helps

you to find your way through the maze of lenses and accessories available on the market and to avoid unnecessary expense. If you are working outdoors all the time, for example, it is useless to buy expensive large-aperture telephoto lenses, since you will be using only f/8 or 11.

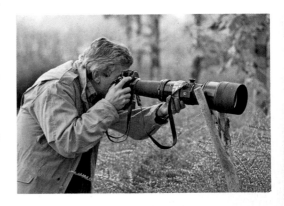

Above: Even a branch can act as an emergency support for a 400mm telephoto lens. Medium or high sensitivity film should be used even during the day to ensure the double advantages of fast shutter speeds and a

good depth of field. With 200 or 400 ASA film, you can work (in good light) at 1/500 second, f/8 or f/11; this has the advantage of allowing you to stabilize the telephoto lens freehand and arresting fast action.

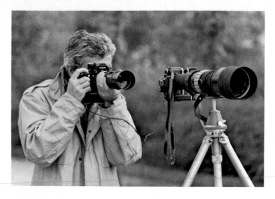

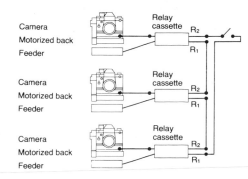

Camera	Relay cassette	
Motorized back		R_2
Feeder		R_1

Camera	Relay cassette	
Motorized back		R_2
Feeder		R_1

Camera	Relay cassette	
Motorized back		R_2
Feeder		R_1

Multiple shots

It can be interesting at times to operate more than one camera with different lenses at the same time. Above: A simple connection between one camera with a 300mm lens and another one preset with a 1000mm lens. The drawing at right shows the connections between a number of motorized cameras that require the use of relay cassettes and feeders.

Below: A simple improvised protection for use in bad weather, made of a plastic bag and a few strips of tape. The lens hood adequately protects the lens.

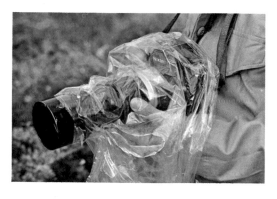

be distracted. Being prepared—psychologically as well as physically—for the unexpected helps to maintain the professional detachment that is the best guarantee of good results. Never be stingy with film: all actions that develop over a period of time, such as a team play, an accident, or a fall, are more efficiently described by a sequence of shots. Keep a mental check on the number of frames used and change film quickly, so as not to be caught unaware. Choose your position bearing in mind what is going on; a position a little further back, but from which you can get a clear view unimpeded by exuberant fans, is the best. This advice is particularly important when photographing from the stands, since spectators in front of you will likely leap up at the most exciting moments and block your view. If you want professional results, you also need serious preparation, an understanding of the game, and knowledge of the ground or competition course, as well as the advice of experts. It is also advisable to have at least two camera bodies so that you can change lenses quickly or catch a scene when one camera is out of film.

Some tricks of the trade

The skill of sports photographers is also measured by their ability to overcome obstacles and restrictions that they come across during events. Amusing stories are told by professional reporters about this or that photographer's ability to get into the right place at the right time. It is a quality that cannot be acquired without a great deal of experience, without repeated trials and mistakes. All photographers keep their own particular secrets jealously guarded, but there are certain basic rules of behavior that even the amateur will find useful. The first rule is that if the event is important and takes place quickly and suddenly (a fall, gesture, car accident), shoot straightaway and then check framing and exposure details. The results can be guaranteed if you take care to keep the exposure settings and focusing up to date. Always follow the subject in the viewfinder. In some sports such as motorcycling, boxing, and car racing, everything happens in literally fractions of a second and you cannot afford to

A little trick to make shooting more certain, particularly with powerful telephoto lenses, is to focus in advance on certain areas of the track, circuit, or field (where you know that the subjects will be) with a suitable selector, or to mark the relative positions for these different areas with a crayon or piece of tape directly on the focusing ring.

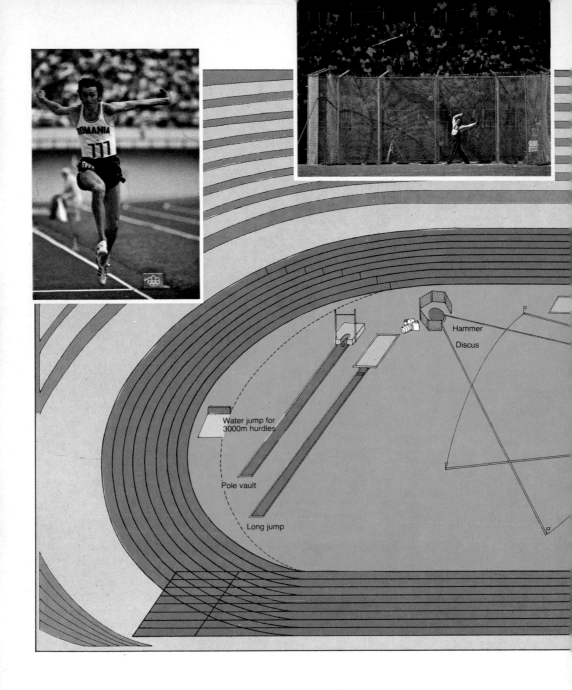

Water jump for
3000m hurdles

Pole vault

Long jump

Hammer

Discus

Position in the field
The drawing shows the
position chosen by vari-
ous photographers to get
the pictures shown on
this page: the finish at a
100 meter sprint, taken
with a 200mm lens from
a higher position; taking
off for the long jump,
taken from the front with

a 300mm lens; throwing
the hammer, also taken
with a 300mm; and the
high jump, taken with a
500mm. Accredited pro-
fessional photographers
have a great advantage
over amateurs in that
they can get down onto
the field, but they have
to stay in certain posi-

tions (something that is
generally decided by the
competition organizers
and judges), and they
also have to comply with
unwritten rules of profes-
sional etiquette and be-
havior, designed to avoid
disturbing the competi-
tors during the running of
the event.

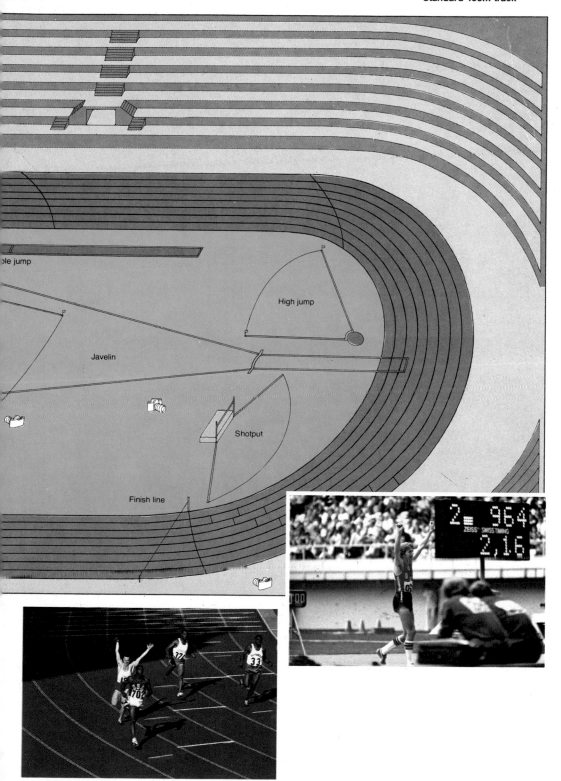

ole jump

High jump

Javelin

Shotput

Finish line

The right film for the sport

Every emulsion has a degree of light sensitivity that determines the speed –aperture combination required for correct exposure. Films are divided according to this sensitivity, expressed in ASA or DIN, into slow, medium, or fast. Other important features apart from this sensitivity are exposure latitude (which is the amount of permitted exposure error and is directly proportional to sensitivity), the power of resolution of the film (which increases as the grain is finer, consequently reducing the sensitivity of the film), and the gradation (which influences the contrast). Sports photography is by nature conditioned by the speed of its subjects in movement, so the obvious conclusion would be that the most suitable film is of the highest sensitivity, both in black and white (for example, Agfapan 400 ASA or Kodak Recording 1000/4000 ASA) and in color (such as 3M or Ektachrome 400 ASA).

However, this turns out to be an oversimplification and cannot be generally applied. As a general rule, the most suitable film for the best results is one that is less sensitive, but that is fast enough for its application. Hypersensitive material is characterized by an excellent power of resolution unheard of until a few years ago, but it tends to form grainy images that are not always acceptable for en-largement beyond certain limits. This can, of course, be used to positive effect, giving original figurative results. Medium speed film (about 100 ASA) is most commonly used under normal conditions. More sensitive film (up to 400 ASA) allows a saving of two or three stops on speed or aperture—even in shots taken outdoors and in natural light— which enables the photographer to keep high shutter speeds, even with telephoto lenses that do not have very wide apertures but which have to be used for mobility or in very fast action shots. Finally, there is slide film, which is useful when immediate publication is contemplated: all films which can be inverted with the E6 process can be developed in a few hours in a professional laboratory, enabling you to meet deadlines.

The type of event and the result desired dictate the choice of film. Above: Franz Klammer in the spectacular downhill event at Kitzbuhel. The photograph was taken with a 200mm telephoto lens, Ektachrome 64 exposed for 120 ASA at 1/500 second, f/8.

Left: A black and white low sensitivity film used indoors produced this blurred effect, which successfully conveys the dynamism of a fast judo event.

COLOR REVERSAL FILM

SENSITIVITY		TYPE	MANUFACTURER	CHROMATIC EQUILIBRIUM	TYPE OF TREATMENT
LOW	ASA DIN				
	25 15	Kodachrome 25	Kodak	Daylight	Special Kodak
	64 19	Kodachrome 64	Kodak	Daylight	Special Kodak
	40 17	Kodachrome A	Kodak	Artificial light	Special Kodak
	64 19	Ektachrome 64	Kodak	Daylight	E-6
	50 18	Agfacolor CT 18	Agfa	Daylight	Agfa
	50 18	Agfachrome 50 S	Agfa	Daylight	Agfa
	50 18	Agfachrome 50 L	Agfa	Artificial light	Agfa
MEDIUM	100 21	Agfacolor CT 21	Agfa	Daylight	Agfa
	100 21	3 M Color Slide 100	3 M	Daylight	E-6
	100 21	Fujichrome R-100	Fuji	Daylight	E-6
	100 21	Sakuracolor R-100	Konishiroku	Daylight	E-6
HIGH	160 23	Ektachrome 160T ET	Kodak	Artificial light	E-6
	200 24	Ektachrome 200 ED	Kodak	Daylight	E-6
	400 27	3 M Color Slide 400	3 M	Daylight	E-6
	400 27	Fujichrome 400	Fuji	Daylight	E-6
	400 27	Ektachrome 400 EL	Kodak	Daylight	E-6

Color or black and white?
If, regardless of any other consideration, we demanded maximum information possible from a photograph, color would be the natural choice. But photography is not just a technique of "reproduction," so among the various choices a photographer must make is whether to use color or black and white film. Unlike color, which has a richer and more immediate "code" of symbols, the power of suggestion of black and white film lies in just the perspective and the contrast, so it is much more difficult to master. When used indoors, black and white can play on geometric designs, for which its greater sensitivity is very useful. It is interesting to experiment with the different results obtained by taking the same subject with the two types of film.

BLACK AND WHITE FILM

SENSITIVITY		TYPE	MANUFACTURER
LOW	ASA DIN		
	25 15	Agfapan 25	Agfa
	32 16	Panatomic-X	Kodak
	50 18	Pan F	Ilford
MEDIUM	80 20	3 M 80	3 M
	100 21	Agfapan 100	Agfa
	125 22	Plus-X	Kodak
	125 22	FP-4	Ilford
HIGH	200 24	3 M 200	3 M
	200 24	Agfapan 200	Agfa
	400 27	Agfapan 400	Agfa
	400 27	Neopan	Fuji
	400 27	HP-4	Ilford
	400 27	HP-5	Ilford
	400 27	Tri-X	Kodak
VERY HIGH	1000 31		
	4000 37	Recording 2475	Kodak
	1250 32	Royal-X Pan	Kodak

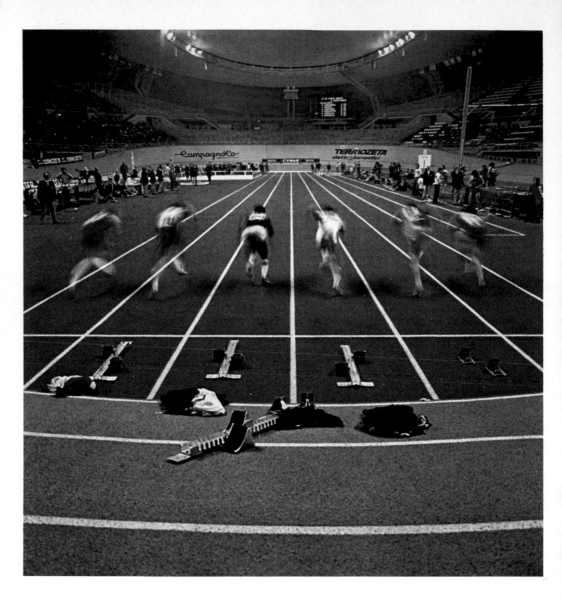

Above: The start of the 80 meter sprint in the Palasport in Milan. The rather slow time of 1/30 second was used with a high sensitivity film to obtain an effective sensation of dynamism. In this case, the small aperture extended the depth of field to its maximum, reaching from the foreground to the spectators' area in the background.

Indoor photography
Until a few years ago, indoor photography was limited to black and white film, but the improved sensitivity of modern color film has increased its range of application enormously. Regardless of any other consideration, color reversal film gives the greatest flexibility; the slides give excellent results and can be made up into prints, produced in black and white, copied and easily printed in

the newspapers. High sensitivity film (such as Ektachrome 400 ASA) is balanced for a wide range of color temperatures and gives very good results both outdoors and in artificial light, and a lightly dominant red is preferable to the colder tones of a type B film. The nominal sensitivity of this kind of film can be "pushed" one or two stops up to an effective 1200 ASA simply by telling the laboratory to increase the

developing time. The only disadvantage here is a slight reduction in exposure latitude, which requires you to choose subjects with not too much contrast and set the exposure very carefully. Even indoors, the degree of brightness in a covered stadium or gymnasium is usually quite high for the benefit of the athletes and the spectators, but in special circumstances, or when there are television cameras present, the lighting

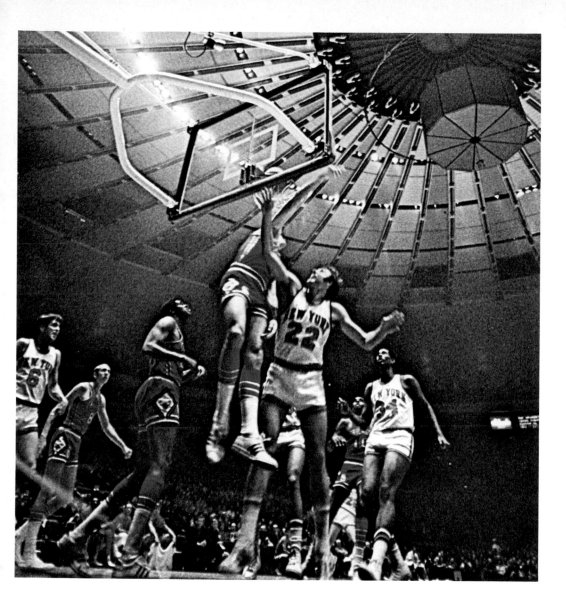

is even better. Daylight film gives excellent results even when natural light is mixed with electric reflectors and flash, whereas artificial-light or type B film (such as Agfachrome 50 L or Ektachrome 160 ET) is designed for tungsten light sources of about 3400K. It is better not to use conversion filters since they cut out a lot of valuable light with fast shutter speeds, and the lens aperture is particularly important in these cases, especially with medium range telephoto lenses. The dead point of a move can be used to freeze fast action in critical brightness conditions, and flash lighting may be used as an alternative, although portable flashes are usually not bright enough and moreover are often forbidden; portable flashes often yield unpleasant "night effects" when used close up, so they are better as an auxiliary or complementary light source. In certain conditions, the limitations can be used to advantage, emphasizing the action by the blurring achieved with slower shutter speeds. Great care must be taken when reading the exposure meter not to point it directly at any light source or reflectors, for this will drastically affect the accuracy on your reading. The combination of speed and aperture should be chosen according to the action and the desired effect.

When insufficient light prevents the use of fast shutter speeds, the only alternative available to freeze movement without the use of an unnatural flash is to take advantage of the "dead point" of the action, as in this classic shot of a basketball match "frozen" at 1/60 second.

Picture analysis

The photographer makes the first important decision simply by looking through the viewfinder and deciding on the frame. Above all else, good photography requires the ability to see and isolate those elements which capture the feel of an event or situation out of a confusing, involved, dynamic reality. The photographer composes a meaningful picture by bringing all the important details into the frame and cutting out anything that is unnecessary or distracting. The photograph on the right was taken in Sardinia during a windsurfing exhibition by the Hawaiian champion Robby Naish, and is an excellent example of meaningful composition: the spray emphasizes the movement; the tension of the athlete and the sails show the power of the wind; cropping on the diagonal suggests the continuity of the action. With the board almost completely lifted out of the water, the moment captured is certainly most spectacular and the focal length used (1000mm) enables the picture to be compressed against the uniform blue background of the sea.

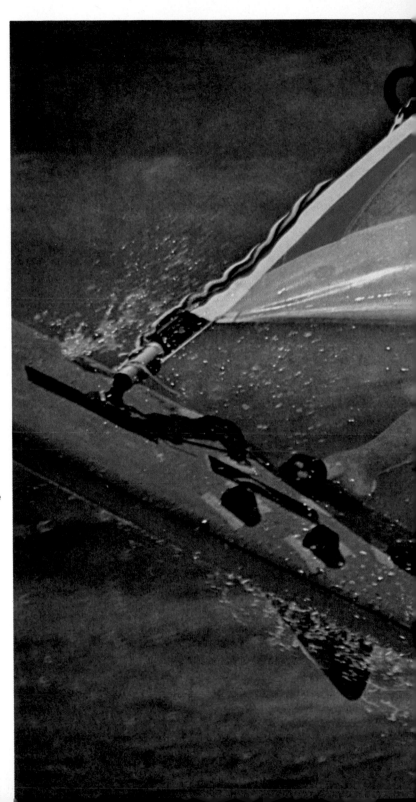

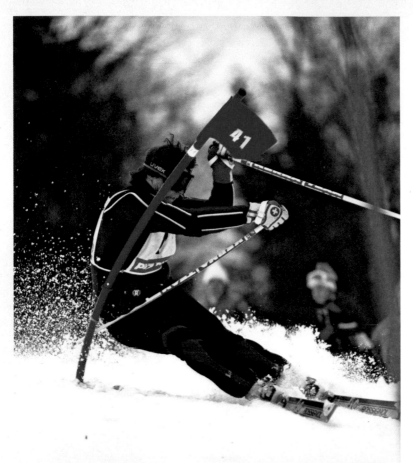

Elements of composition

Photography is generally considered an objective means of representing reality, even though reality is three-dimensional, dynamic, and full of sound and color, whereas photography can only show two dimensions, is static, silent, and often in black and white. The reason that photographs are taken as objectively real is that we subconsciously interpret and elaborate certain symbols, such as the image left on film by an object we instinctively consider to be moving. In order to recreate the most lifelike and meaningful illusion of reality, the photographer must be able to use all these symbols and devices in the photographic "language."

Even though sports photography requires almost lightninglike reflexes during composition, it is not exempt from these rules. For a photograph to be meaningful, that is, rich in technical information and full of emotion, the photographer has to make a series of choices: the lens to be used, the line of the frame, the depth of field, the balance of the different layers, and the particular moment to be captured on releasing the shutter are the elements of the composition, which if closely attended to can make the difference between an ordinary and a great picture. In all sports, the elegance of the movements and rhythms and the geometry of single or collective actions determine the relationship between the composite signs and structure in a kaleidoscope of images that form and disappear in an instant, and the photographer has to be able to pick them out and capture them on film. It is an instinctive job of selection, in which the aesthetic element always has to be subordinate to the technical information to be conveyed and clarity of the photograph. In order for the photograph to be successful, its literal and objective representation must be screened by the photographer's intelligence and sensitivity. Nevertheless, the making of a good photograph also requires an aesthetic or expressive dimension, and the photographer must not be unaware of the artistic potential of each scene.

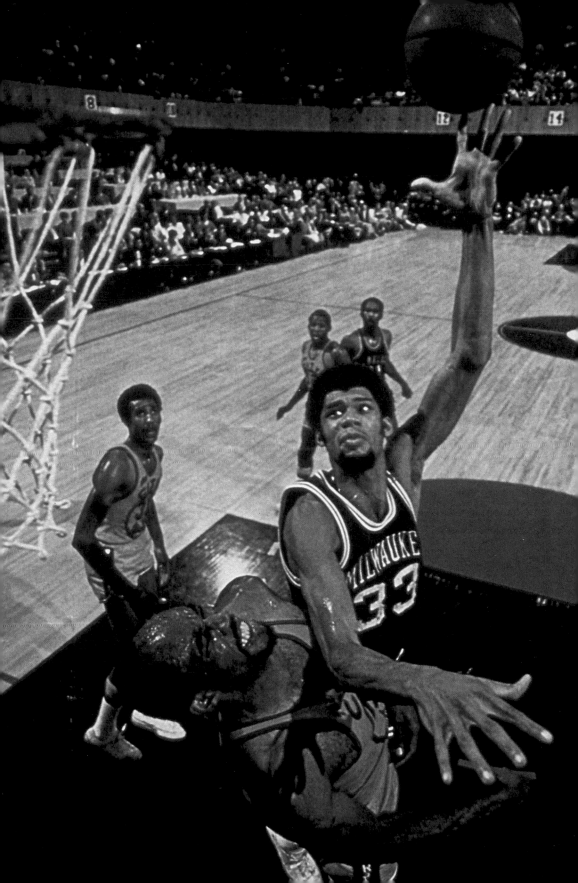

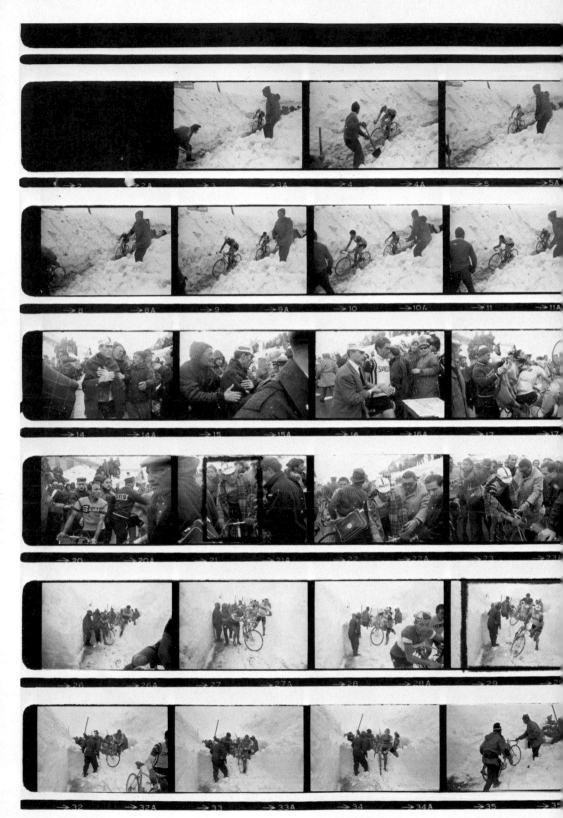

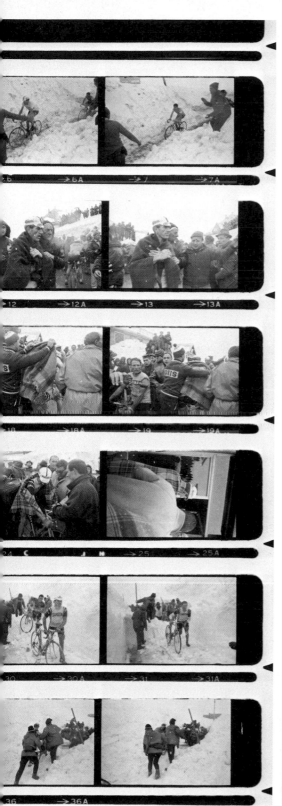

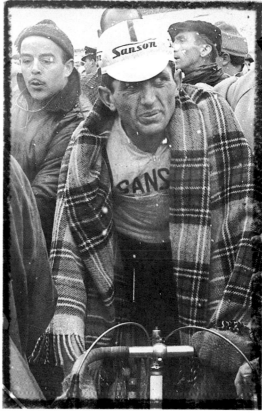

Choosing from the proofs

A very valuable rule to follow for getting good sports photographs is not to be afraid of using up film; in fact, many variables come into play and often just a detail out of place, some distracting element, or even a simple mistake or technical fault, can ruin the whole thing. The final choice should be made from the black and white contact prints or through a viewer; the more stringent the selection process, the greater the resulting quality of the photographs. The photographs on these pages show the two photos that were chosen out of a whole roll of film taken during a difficult stage of the Giro d'Italia.

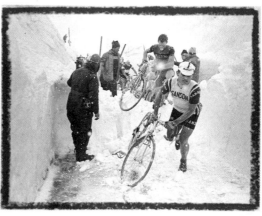

The importance of cropping

As a general rule, the photographer must be conscious of cropping the photograph at the time the picture is taken, but this is not always possible and is, in fact, often extremely difficult when working within the constraints on speeds and timing in sports photography. At the development stage, of course, cropping is only possible with color or black and white negatives and enables one to vastly improve the print. It can quite easily happen that at the crucial moment, the right focal length is not available, or that the photographer is not careful enough with the line of the horizon, or even that unnecessary elements such as the head or hand of an excited fan on the field have to be cut off the edge of the photograph. In all these cases, efficient cropping can correct the composition of the photograph.

Enlarging a detail from a negative brings out the potential of a photograph to the full by isolating its most significant elements. The sections to be cropped or enlarged can be marked straight onto the proofs by crayon so that the laboratory knows which area to enlarge into print, but more care is needed with slides, which cannot be corrected.

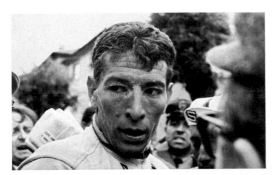

Cropping the photograph during the printing stage can have a decided effect on its power of expression.
Left: A good close-up shot of the Italian cyclist Gimondi, taken at the end of a particularly difficult stage of the Giro d'Italia; but it is the enlarged detail of his eyes (below) that truly shows the stress and fatigue of the rider after having been tried to the limits of his endurance.

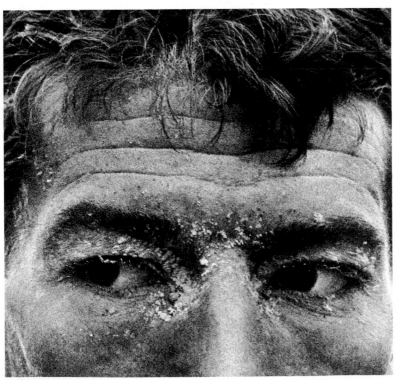

Enlargement during printing

When the action is fast and unpredictable, it is a good idea to take shots when the opportunity arises and worry about the framing later at the printing stage. Bear in mind that the "point of force" hardly ever corresponds to the center of the photograph.

Right and above: The simple process of partial enlargement overcomes the problems of using a focal length that is not really suited to the job. The drawing opposite shows an enlarger for printing black and white and color negatives on paper.

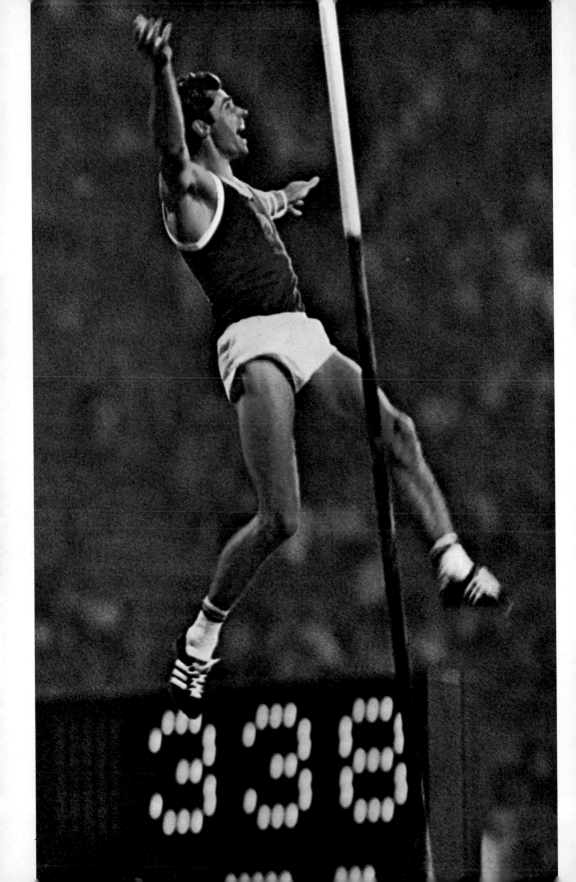

The moment that counts

The camera can register faithfully things that the eye cannot see and can break down the action into mere fractions of a second. For this reason, two photographs taken successively of the same action are never quite the same. The photographs on these pages show the difference between pictures taken with only the briefest interval between them.

Opposite: The jubilation of a pole vaulter who has just cleared the bar at 5.50 meters (18 feet), photographed by John Zimmerman. A fraction of a second sooner or later would have produced the "flat" photograph you see below. Another example can be seen above and right: The first shows a jumper "frozen" in midair and looking rather awkward; the second was taken at just the right moment, on completion of the move.

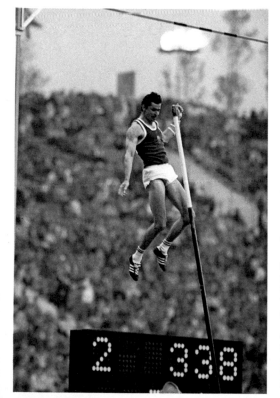

Knowing when to shoot

Important moments in sports are never repeated, and very often the best photographs are lost because the photographer was distracted, or was inexperienced in focusing or setting the speed and aperture, or was just not ready. Two photographs taken within seconds of each other are never the same: when the action is taking place very rapidly, as in a sports event, you never know what will be on film until the very last moment, and details such as an unnatural position or gesture can make the difference between a good photograph and a wasted one. It is a good idea to concentrate on the action and anticipate how it is going to develop and never to be taken by surprise, so that you can shoot at exactly the right moment. This can sometimes be at the climax of a move (as in the pole vault) or at its completion (as in the long jump), but at other times, you have to be guided by your intuition; for example, after a goal, it can be better to wait a second or so to capture the players' contrasting emotions in front of the net. The right moment often is also the crucial moment in a game, a moment that characterizes the sport itself. But it takes a lot of experience to know for sure when this is, so you also need to understand the game you are photographing. This will enable you to recognize its rhythms and pauses, its most intense and spectacular moments, as well as be aware of those occurrences that can influence the game's outcome.

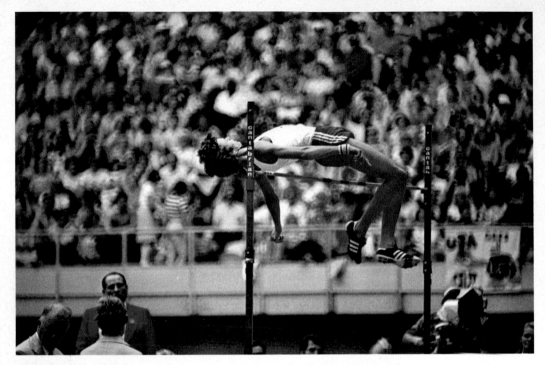

How to choose the best position

The choice of position is essential for the best results. The photographs show the high jump taken from three different viewpoints. Left: This is the worst of the photographs, as the background is distracting and the raised position squashes the perspective. Above: This is a good photograph taken with a powerful telephoto lens (500mm), which has isolated the high jumper from the public. Opposite: The use of a wide-angle lens from below the action has produced this exciting picture. Below: The drawing shows the different positions chosen by the three photographers.

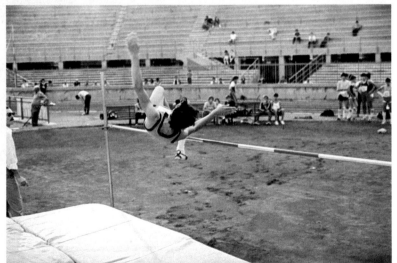

The viewpoint

Every professional reporter knows how frustrating it is to be confined to the positions allocated to photographers during important sporting events, since the choice of viewpoint is one of the principal creative elements of photography. All sports offer an infinite variety of possible angles on the chosen focal length, and in order to orient yourself, you must have advance knowledge of the ground. If you are looking for new or original perspectives, it is better to do so before the actual competition at less important events or friendly matches in which you can rely on the cooperation of the participants.

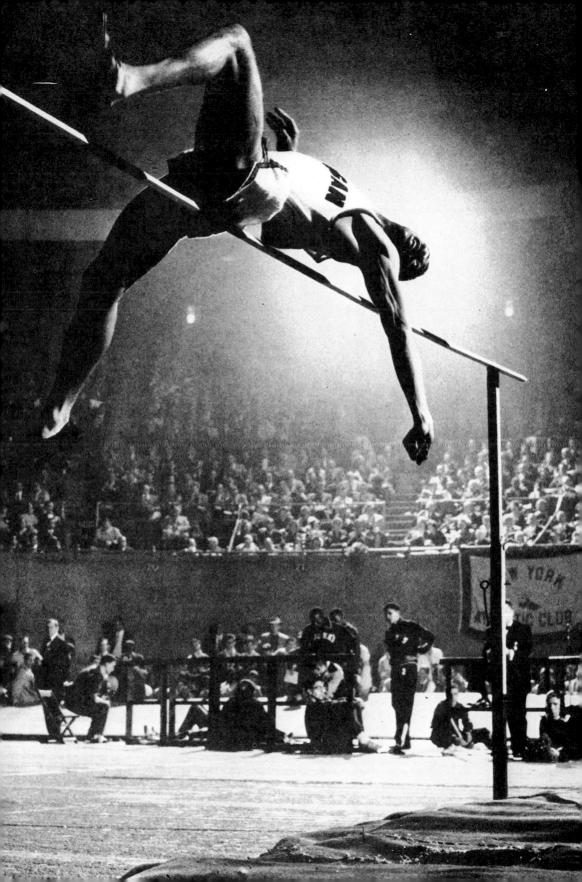

Speed and movement

By its very nature, photography can capture on film moments that are indistinguishable to the human eye (which is not sensitive to changes that occur in less than 1/10 of a second) and freeze them in time. Sport is characterized by its movement and speed, and it has only been possible to photograph it successfully since the development of emulsions and shutter speeds capable of arresting movement in fractions of a second. But not all the best results are obtained by freezing the energy of an action and running the risk of making it unreal. The photograph on the right is a good example. The photographer, Ernst Haas, followed the exciting development of a football game and used a longer shutter speed (1/10 second), moving the camera from side to side during exposure to obtain this vivid picture in which the blurred effect and the bands of color depict all the tension of the game very effectively indeed.

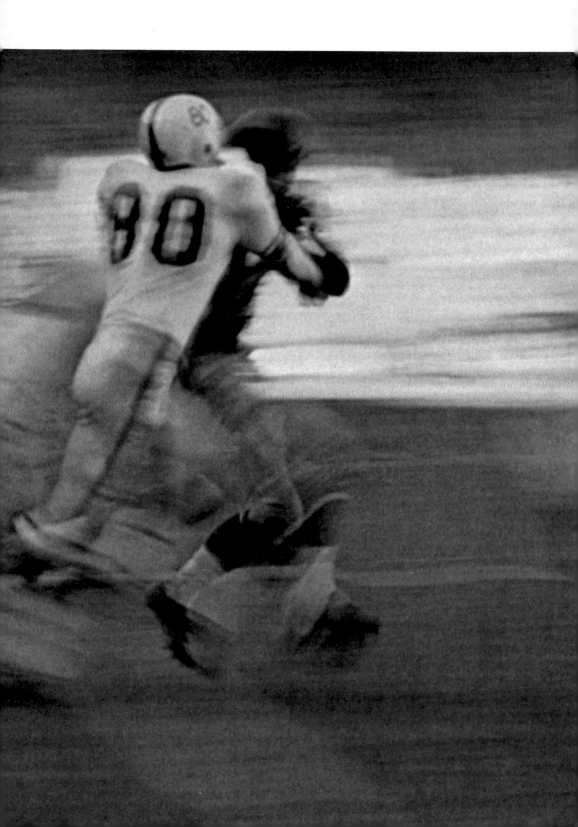

A famous sequence

Right: Four pictures of a horse under gallop taken by E. Muybridge in 1878. They are from a famous sequence which came about as a result of a bet and which proved that in certain stages of the race, the horses lifted all four hooves off the ground at the same time. Muybridge concocted an elaborate device to obtain these photographs, using twelve cameras that were positioned along the edge of the track and that were operated by cables that the horses broke as they passed. Wet collodion was used for the photos, which were taken with a shutter speed of 1/1000 second, which was exceptional for that time. Below: The boxers, another study by Muybridge. Opposite page, center: A "chronophotograph" of birds in flight taken by Etienne Marey in 1882 with his "photographic rifle" (below). The images were imprinted on a rotating circular plate, which was exposed at a speed of barely 1/700 second.

Capturing the instant

The movements and gestures making up any sport are available to us through photography, as the camera can instantly "memorize" and show what our eyes are physically incapable of seeing.

When Daguerre pointed his very basic camera at the crowed Boulevard des Italiens in Paris in 1839 and exposed his silver-coated copper plate for half an hour, the only trace of any living beings recorded was that of a shoe-shine boy who had stood at the corner of the street. Since the invention of photography, many attempts have been made to arrest movement and continual research has enabled us to progress over the last century and a half from the eight hours exposure time necessary for Niepce to obtain the first faint photograph ever, to the millionths of a second of modern electronic technology. Nineteenth century manuals contained long chapters dedicated to rapid photography, explaining how to capture the fleeting moment and cut down exposure times, even if only by a fraction, by using more sensitive emulsions, wider aperture lenses, and more functional shutters.

The most important contribution to this research was made by the progenitors of photography themselves, Talbot and Daguerre, who unknown to each other, discovered the magic of the latent image. From that moment on, exposure times were

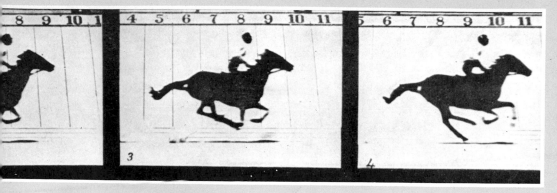

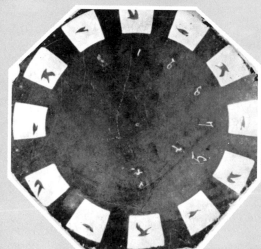

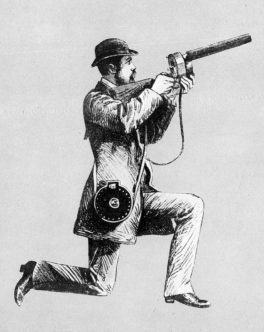

drastically reduced by subjecting the calotypes and daguerrotype plates to various chemical processes. The record time of one minute was soon reached, but it was still too long to record movement.

Research then moved to the negative/positive system devised by Talbot, and in 1851, calotype paper was replaced by glass plates coated with an albumin emulsion that needed about ten seconds in the open air in full sunlight. The discovery of wet collodion, a derivative of gun cotton, then made it possible to work with exposures of less than a second, a feat that had previously been thought impossible. In 1872, the Société Française de Photographie offered a prize of 500 francs to anyone discovering a dry emulsion that would make it possible to photograph a street full of moving traffic. True movement (not the tableaux vivants with models posing as if moving) was actually recorded in 1878, using a silver bromide gelatin. The time required (up to 1/25 of a second) made it possible to photograph sport action, particularly when photographers realized that they could time the shutter release to coincide with the dead point of an action, "freezing" the subject in midair.

This victory over the instant was assisted by the constant improvement of lenses, which developed from the simple converging lens to the achromatic double lens, and then on to ever more complex and light lenses such as the one designed by J. Petzval in 1841, with a relative aperture of f/3.5. Then came the triple and wide-angle lenses of Dallmeyer (1865), the aplanatics and double astigmatics of Goerz-Dagor, and Scott's lead silicate glass lens (1880) followed by the legendary Heliar or Tessar lenses, which came out in 1902. The development of cameras also followed this logical pattern, as they became an increasingly versatile means of representation available to the general public. In the latter half of the century, the weight of a "jumella" was barely 2 kilos (4.5 lbs), as compared with the 50 kilos (110 lbs) of a daguerrotype machine. Then in 1888,

George Eastman brought out the economical Kodak Number 1, a camera which could take one hundred 6cm (2½ inch) diameter round pictures.

It was then but a short step from the "detective" cameras, which could be hidden under a man's waistcoat, to the "Velocigraph" and the "Cents Vues," to the Leica, which was designed by the engineer Leitz Oskar Barnak and put on sale in 1925, in step with the development of journalism, which used spontaneous, dynamic pictures.

The shutter also underwent rapid development from a simple cover that was placed by hand in front of the lens to more accurate mechanisms such as the "guillotine" shutter used until the 1840s and then gradually perfected by the use of springs and elastic to produce the lateral shutters of Londe and Dessoudeix (1885). These were followed by the central straight line shutters of Thury and Amey, formed by placing two plates between the lens glass; Dallmeyer's "multiple blade" shutter (1887), which was the forerunner of the modern iris type shutters; and finally the blind shutters designed in 1893 by Viscount Ponton d' Amécourt. By the end of last century, Guido Sigristo's focal place shutter was having a great deal of success since, used in front of the chamber, it made very fast shutter speeds of 1/40–1/5000 of a second possible. In the 1900s, the most popular types of shutter have been the

A virtuoso of the 1800s
Above: This photo was taken in 1885 by Count Esterhazy, showing his friend Count Rinsky executing an athletic leap. The picture is decidedly advanced for its time, given the low speeds of the emulsions, but the photographer obtained the result by capturing the dead point of the movement. Below: "The fencer," a chronophotograph taken by Etienne Marey in 1885. Note the trace left on the plate between the two poses of the subject.

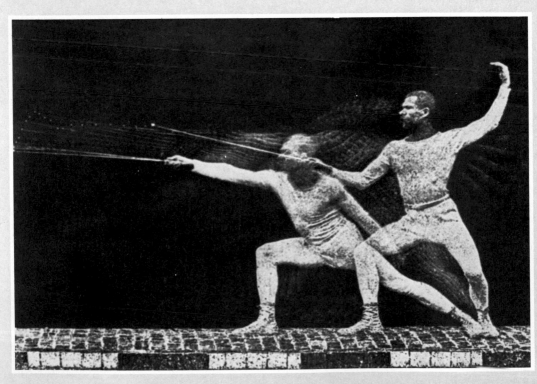

The age of the pioneers
Left: The strange "photographic carriage" on which the American Gustav Haertwig travelled throughout the United States around 1874. At that time, a photographer's equipment weighed about 400 pounds, what with the camera, tripod, glass plates, and the various chemical reagents necessary. This obviously made it very difficult to try action photography. Below: A piece of apparatus for "calling cards," which took four portraits on a single plate. The "photographic card" was invented in 1854 by the Frenchman André Disderi and rapidly became very fashionable. The demand for equipment that was smaller, brighter, and easier to handle for taking photographs of action "in flight" led very quickly to the development of modern systems with fast shutters and highly sensitive film.

between-the-lens bladed shutter such as the compour and the blind type used in the Leica.

Shutter mechanics soon outstripped the capacities of film emulsions and this prevented full use being made of the shutter speeds available. All photographers could do at the time was increase the lighting on the subject by means of artificial light. Fox-Talbot was one of the pioneers in this field and in 1851, he photographed a *Times* rotary press in operation, "arresting it" with an electric spark. Another pioneer was Felix Nadar, who used the light of a bunsen burner to reduce the collodion exposure time to just 60 seconds in the catacombs of Paris. Magnesium powder was used for the first time in 1859, and the technique was perfected in 1883 with the flash lighting system: potassium chlorate was added to the magnesium and the mixture was encapsulated in glass bulbs.

In their zeal to meet the challenge posed by speed, photographers managed to break down the elements of movement, using the technique of "chronophotography," or motion analysis. In 1878, Edward Muybridge achieved the first sequence shots of a horse under gallop, which he took with a battery of twelve cameras on which the shutters were electrically released by trip wires broken by the horse as it passed along the track. Each photograph was taken at intervals of 68cm (2.25 feet) on collodion plates at a shutter speed of 1/1000 of a second. Muybridge's sequence was followed by countless other studies into human and animal movement and he proved that at a certain point in the gallop, the horse raised all four hooves off the ground. The whole episode was brought about by a bet made by the rich American breeder Leland Stanford, who won the $25,000 stake thanks to Muybridge. Muybridge's experiments were followed by those of the Prussian Ottomar Anschütz and the French scientist Etienne Marey, who used a "photographic rifle" in 1882, which he had based on the "revolver" used by the astronomer Janssen to photograph the various phases of Venus passing in front of the sun. The rifle barrel was very large and contained the lens, while a very sensitive clockwork system controlled the rotating shutter and a photo-

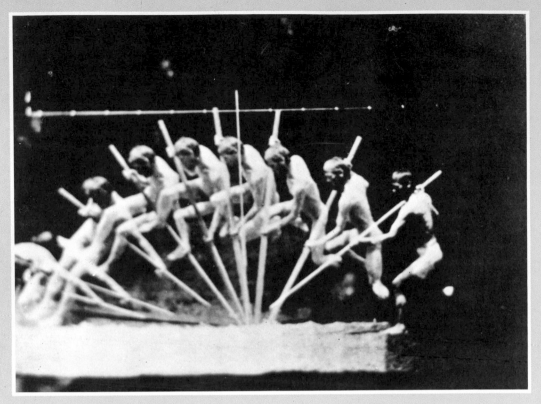

Phases of movement
Above: This photograph of a pole vaulter was taken by the painter-photographer Thomas Eakins in 1884 by means of a perforated disc, which was placed before the camera lens. By rotating the disc quickly, he could break down the movement and freeze it onto one single collodion plate. Below: a

very famous stroboscopic photograph taken by the American Harold Edgerton in 1935. It shows a golfer in action, illuminated by a succession of 100 flashes per second. For this kind of photo, the lens must remain open and the picture should be taken in the dark so that only the light of the flash registers on the film.

sensitive plate that revolved around it. Using this device, he could take twelve images per second. Marey used the equipment mainly to study the flight of birds, and his observations had a great influence on the development of aerodynamics.

In 1884, the American painter Thomas Eakins dedicated himself to "strobophotography," which consisted of showing the various phases of movement of a body on one plate instead of in sequence. Instead of the twelve or twenty-four cameras used by Muybridge and Anschütz, or the circular photosensitive rotating plate used by Janssen and Marey, Eakins used a single camera plate on which only certain phases of the subject's movements were registered by means of a disc perforated with holes in the shape of a Maltese Cross revolving in front of the lens. By this means, he could follow an action and break it down systematically.

In the first decades of the 1900s, new documentary and expressive possibilities were found to attend the advent of electronics. In 1933, at the Massachusetts Institute of Technology, Harold Edgerton and Kenneth Germeschausen obtained their first extraordinary photographs using a stroboscopic flash in dark surroundings, illuminating the subject at a rate of 100 flashes per second, and opened new horizons in the visual aspects of reality.

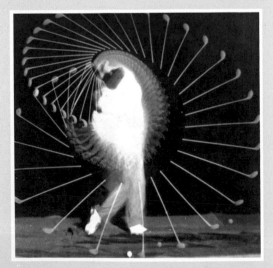

Stroboscopic photography

Right: A stroboscopic photograph of a pole vaulter in action, taken in Boston in 1963 by Edgerton. The method of multiple exposure was used with seven electronic flashlights operated from a control box. Edgerton began his experiments in 1933 at the Massachusetts Institute of Technology, where he examined the most sophisticated shutter release systems available (timers, remote control, photoelectric cells) and used them with batteries of flashes of increasing speeds, which could even "freeze" a bullet in a millionth of a second. Below: The drawing shows a stroboscopic flash capable of twenty flashes per second. Bottom: A 100 meter sprinter on takeoff, broken down by J. Babout, who used five 1/1000 second flashes at 1/50 second intervals. The whole move—the separate stages of which are not detectable by the human eye—lasts only a tenth of a second.

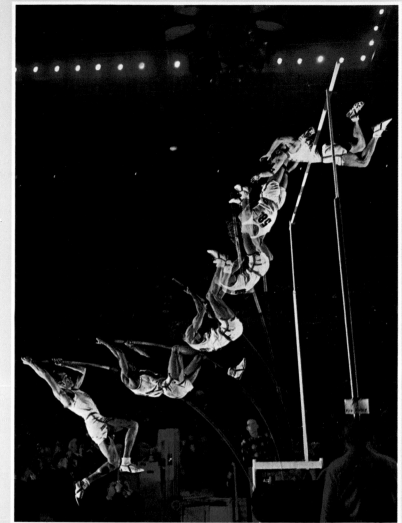

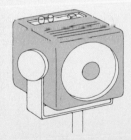

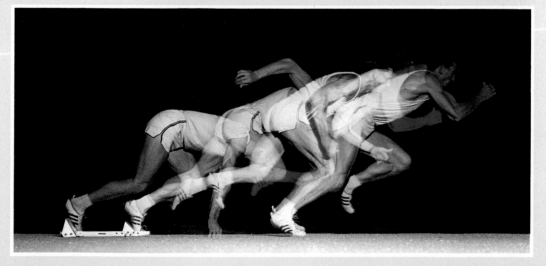

Techniques for capturing movement

Very often, a photograph taken with a very fast shutter speed loses the dynamism and tension of the sporting movement that it shoud capture. The first rule to follow with very fast speeds is to arrest an important moment of the action in which the athlete is at the peak of his or her force, but there are other graphic symbols that can be used: cropping on the diagonal immediately suggests movement, even if the subject is stationary, so composition along diagonal lines stimulates the imagination through its sense of indecision between the horizontal and vertical planes and is natural in many sporting sequences (say, a horse clearing a fence or a diver in motion). In some cases, when the reference point of the horizon is missing, or if the background is not in focus or is blurred, you can use this for deliberate emphasis. The dynamism of an action can be brought out through suspense: looking at a photo of a soccer player with leg raised to shoot at the goal and the goalkeeper diving in the direction of the anticipated shot, you automatically wonder what the outcome was. It does not take a great deal of imagination to associate the idea of speed with a picture of a skier in between the slalom poles, with skis cutting into the snow and throwing up a flurry of white. This is a classic picture in which the symbol of speed is the snow being thrown up. Other similar effects can be achieved by photographing the turbulent wake behind a speeding motorboat, or the dust around a galloping horse. In all these cases, the snow, the water, and dust emphasize that the action was caught in full movement. Dynamism in a photograph also is achieved by selective use of depth of field for the sense of three-dimensionality, deliberate blurring of the subject or the background, and the special effects obtained with wide-angle or fisheye lenses. With telephoto lenses, the limited depth of field allows the photographer to scan the image at various levels, and putting the foreground out of focus often makes an effective frame.

TYPE OF MOVEMENT		DISTANCE OF THE SUBJECT		
		7.5m (25')	15m (50')	30m (100')
Running, swimming	(8kmph/5mph)	1/125	1/60	1/30
Long distance, jumping, trotting, canoeing	(15kmph/10mph)	1/200	1/125	1/60
Sprinting, team sports	(30kmph/20mph)	1/400	1/250	1/125
Skating, horseback riding, cycling	(45kmph/28mph)	1/500	1/400	1/250
Skiing, motocross, rallying	(90kmph/56mph)	—	1/1000	1/500
Motor racing, motorcycle racing	(over 100kmph/60mph)	—	—	1/1000

The table on the left shows the recommended shutter speeds necessary to freeze certain subjects in movement, with the direction of motion parallel to the film surface and the camera still. As a general rule, when the distance is halved, the speeds should be halved accordingly, and, of course, the use of focal lengths other than a normal 50mm will affect the values given, as they vary the distance of the subject.

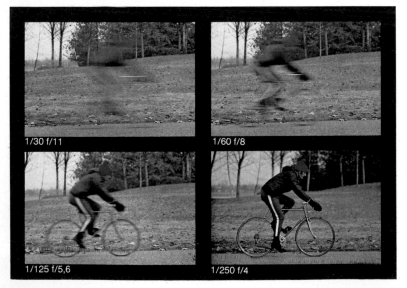

1/30 f/11
1/60 f/8
1/125 f/5,6
1/250 f/4

Times and speeds
A moving subject appears frozen when the trace it leaves on the film does not exceed the power of resolution of the human eye. Absolute clarity is, in reality, just an illusion.
Left: The cyclist was taken with four different shutter speeds. It is easy to underestimate the distance covered by an object moving at speed, particularly in the early stages, so this is a common cause of error and the effect is compounded by involuntary movement of the camera, especially with long focus lenses. The blurring can, however, be used to positive effect in describing the movement, as can be seen in the two examples on the opposite page.

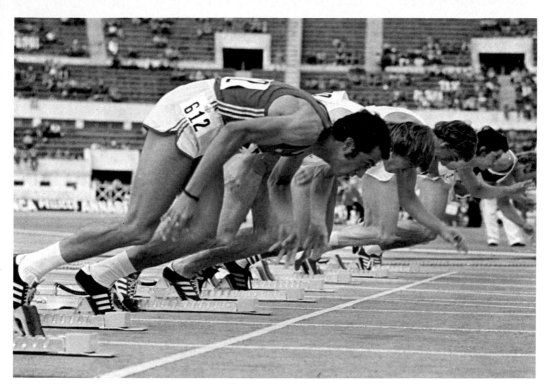

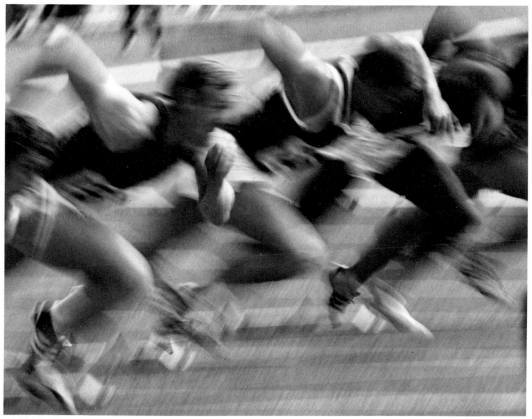

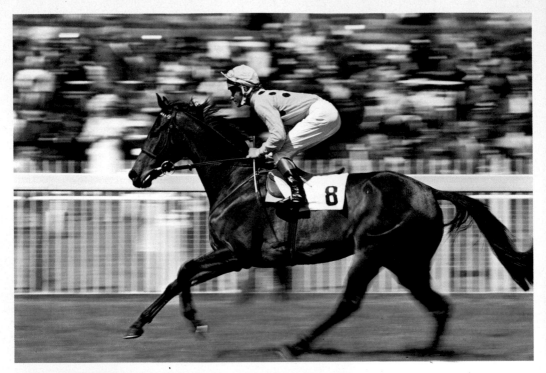

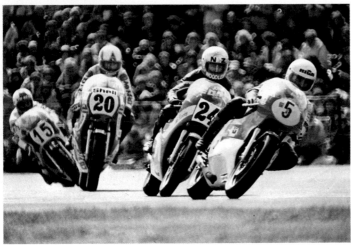

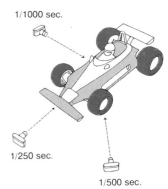

1/1000 sec.

1/250 sec.

1/500 sec.

The direction of motion

To establish the shutter speed needed to arrest a particular action, the subject's angular speed with respect to the film surface is more important than its actual speed, and knowing this will enable you to photograph high speed action that would otherwise be impossible to take. To photograph a fast-moving two- or four-wheeled vehicle going in a straight line past the stands, for example, you would need high shutter speed of up to 1/2000, which is the maximum on reflex cameras currently on the market. The secret lies in taking the photograph from a position as much in front of or at an angle to the action as possible to reduce the subject's relative movement against the film. The different angular speeds of the various elements in a move, analyzed at their various points, as in a tennis player's smash, for example, can be used to emphasize the sense of movement, which is an effect that can be obtained by photographing any complex move, such as athletes running or horses galloping.

The drawing above gives an example of how you can reduce the exposure time by varying the angle of the shot. Left: Despite the speed of the bikes, their relative movement is minimal. Top: The horse and jockey were photographed in the most difficult conditions, but the problem was overcome by following them with the viewfinder during exposure. Opposite: A very suggestive picture taken by Erich Baumann with a telephoto lens at 1/60 second. The different angular speeds of the cars is evident on the turn.

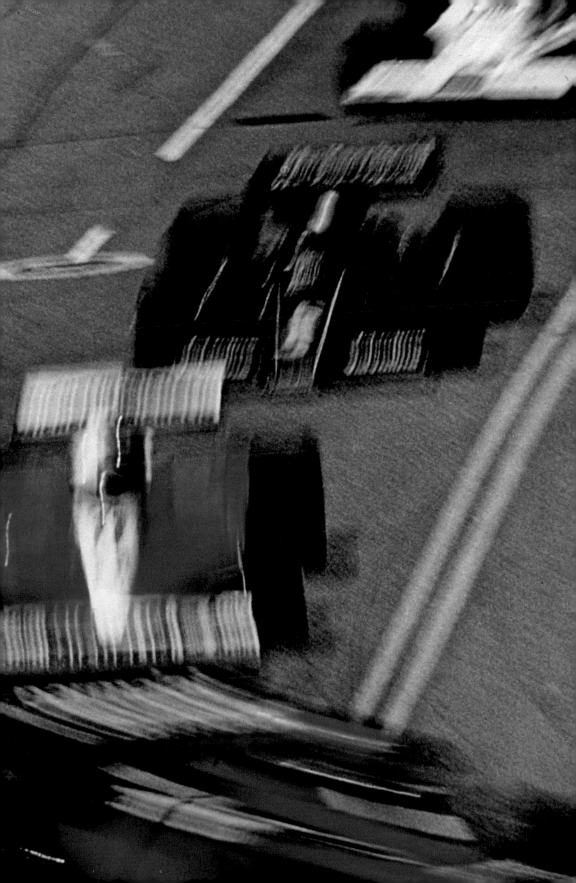

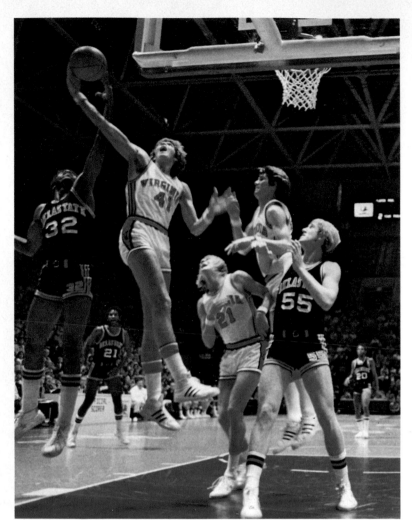

Always anticipate
The drawing below shows that even relatively slow shutter speeds can be used to photograph a basketball player at the peak of the leap. Left: An actual example. The two players off the ground are almost motionless. A fraction of a second later and they would already be coming back down, so the photograph would be blurred, or at least less effective. For the best results in this kind of shot you have to evaluate your reaction speeds and that of the camera so that you know when to release the shutter slightly ahead of time.

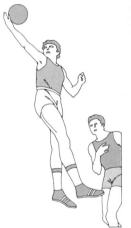

The crucial moment
In the exciting stages of a basketball game, there is a moment, a fraction of a second, in which the player who is about to shoot the ball is almost motionless in midair. If you manage to catch this particular moment, the photograph will be successful: it is the key point of the action, the moment when all the energy is about to be unleashed. Every rhythmic movement has such "dead points" that can be photographed even with relatively long shutter speeds. A high jumper stretched out in an arc over the crossbar, a golfer about to swing the club, a tennis player about to return the ball: these moments of pause all offer excellent shots and are, paradoxically, the moments that express all the vitality of the action. The ability to use slower shutter speeds can be very useful indoors where you are restricted by the ambient light; in fact, the first sport photographs of the 1800s, when 1/25 of a second was the maximum speed, were taken using this critical point of the action. The exact timing of the shot is essential to the success of the photograph, for it is very easy to get a blurred image or to lose the expressiveness and sense of concentrated energy that the photograph should capture. A thorough knowledge of the sport is required rather than quick reflexes, and you particularly need to be able to evaluate exactly your own speed of reaction and that of the camera. You also need to be able to use to the full that very brief moment of anticipation that is the only guarantee of perfect timing in the shot. It compensates for the time it takes your brain to send its signal to your finger on the button or the release lever (about 1/10 second), and the inherent inertia of the shutter control mechanism (about 1/20 second). To ensure success in this kind of shot, constant practice is essential. The degree of anticipation needed depends on the speed of the action taking place in the frame: it is greater when the speed of the subjects is higher, for this usually means that the critical action will occupy a shorter span of time.

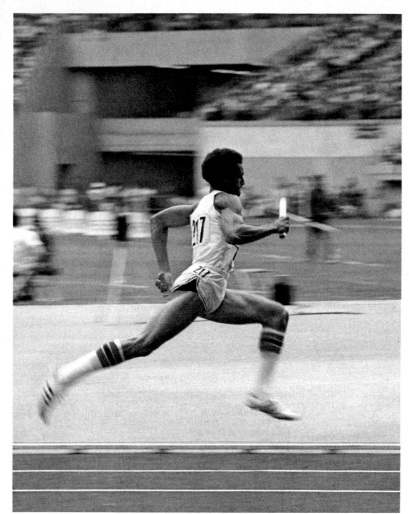

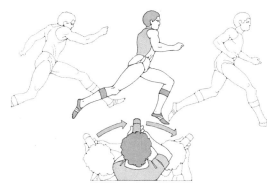

Panning

Left: The light, powerful stride of the Cuban runner Juantoreña, taken at the Montreal Olympics during the finals of the relay with a 180mm at 1/125 second. The slight blurring of the legs (due to their different speed of movement relative to the trunk) emphasizes the dynamism of the movement, which is also suggested by the background. The drawing below shows how panning is done. Movement of the camera should be smooth and uniform so as to keep the subject as still as possible in the frame. It is often difficult to be able to tell exactly what the result will be like. To avoid unnecessary elements appearing in the shot, it is better to vary the position and speed a few times.

Deliberate use of blurring

There are two ways to get the good effects of blurring on film: either make no attempt to freeze the moving subject and use a longer exposure time, or follow the subject in the viewfinder while taking the shot, so as to have a sharp foreground and a blurred background. The first method loses almost all detail on the subject, sometimes making it unrecognizable; for example, a car racing by will appear as a colored strip on the track. But the effect can be interesting

and it is worth trying various different shot speeds, as long as you keep the background steady. A completely blurred photograph is not really the desired effect and is usually the result of a mistake, but if you want to hold attention on the subject and keep the documentary efficiency of the photograph, it is usually better to use the technique of panning. This technique is recommended for all actions moving predictably in a straight line: all you have to do is set a speed between 1/30 and 1/125, focus on a fixed point,

wait for the subject, and shoot, keeping it in frame. It is easier with a medium range telephoto lens, and the best graphic effects are obtained

with a blurred background in which the individual elements of the scene appear as horizontal streaks or uniform bands of color.

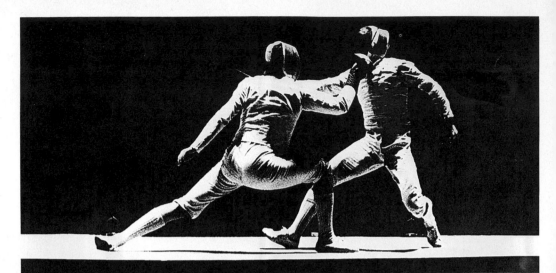

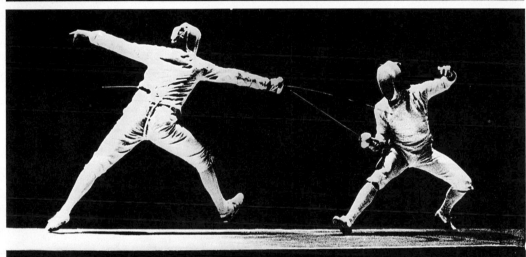

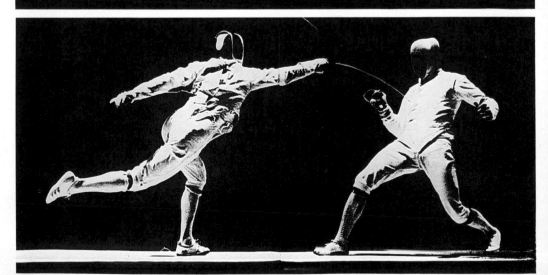

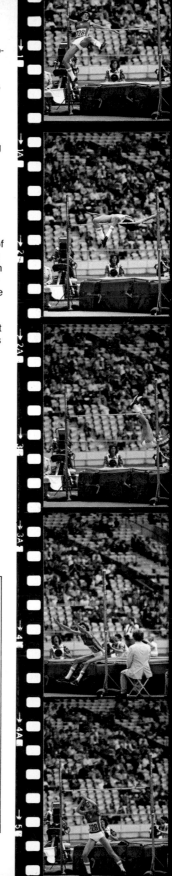

Opposite: An effective series of pictures taken with a motorized camera.

Right: A full sequence taken in Montreal in 1976 showing the jump with which Sara Simeoni won the gold medal. The use of a motor to produce a sequence of pictures at speeds varying from two to five frames per second is very useful for capturing the entire development of the action, but it is not as effective when you want to take a specific moment. For that, it is better to rely on your own reflexes.

Sequence of images

Some of the most exciting documentary photographs of sporting action are not made up of single images, but of complete sequences. A motorized camera that can take up to five frames per second is a great help in this kind of photography, as long as you know how to use it properly. Taking volleys of photographs with the motor set to sequence is often just a waste of film and results in your finding yourself out of film at the worst possible moment. Even four or five frames per second will not cover all the moves in an acrobatic display, a jump, or the track of a car taking a bend. Whenever the crucial point of an action happens at a specific moment, it is better to rely on your own reflexes and have the motor set to a single shot and use it just for fast reloading, so as to have the subject constantly under control. The final burst in a cycle race can be taken at up to 70 kph (43.5 mph) which is the equivalent of 20m/second (65.5 feet/second). Using a volley of shots will take a picture every 4–5 meters (13–16 feet), too great a margin to be sure of getting the exact moment when the leader's front wheel crosses the finishing line; and the same applies at the end of a 100 meter sprint. Using motor-driven sequence is useful, however, when the action takes some time to complete (as in a pole vault) or where timing a fraction of a second earlier or later will not miss anything in the description (as in a goal shot in soccer or a scrum in rugby). A full sequence of photographs, showing the various stages of a dive or a team move, can say a lot more than a single picture. Apart from the disadvantages already discussed, you have to remember that there is a constant risk of the mechanism jamming and a very slight delay in operating the shutter release. The most effective use of sequence shots lies in photographing very complex moves that the eye generally misses because of their very speed, but which the lens can record and bring out on film with an effect similar to a slow-motion replay. The high jump, pole vault, a dive, a trampoline jump, a skier's descent, or a high hurdle are all actions that benefit from sequence shots, as they can bring out all the hidden harmony of the move.

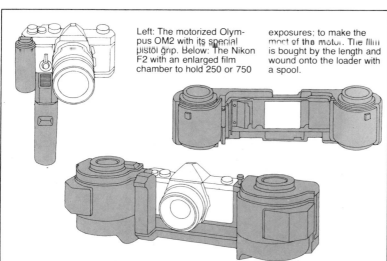

Left: The motorized Olympus OM2 with its special pistol grip. Below: The Nikon F2 with an enlarged film chamber to hold 250 or 750 exposures; to make the most of the motor. The film is bought by the length and wound onto the loader with a spool.

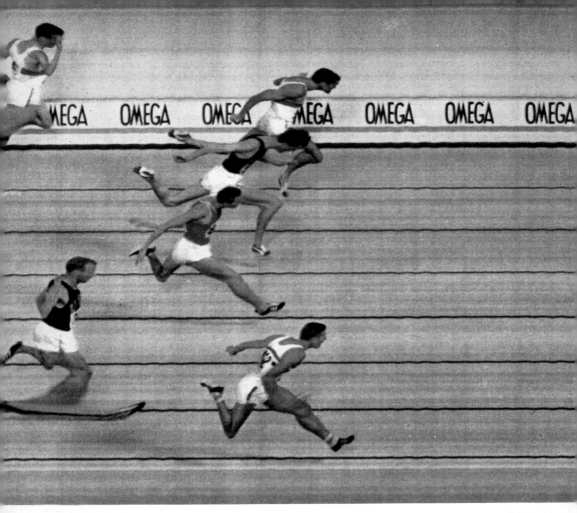

The photo finish

The accuracy and objectivity of photography have been used for some time on race tracks to show unquestionably what was the exact order of finish. At horse tracks, where the horses battle nose to nose right up to the finish, a photograph of the finish is often the only way of deciding the winner. The camera used has a special slit shutter (lined up with the finishing post) behind which the film is driven by a motor. The mechanism is activated while the racers are a few meters away from the line and the speed of the film is pre-set in relation to the speed of the subjects, the distance of the shot, and the focal length used. Only the moving subjects appear on film, taken at the exact moment they all cross over the finishing line. The technique used to cover a photo finish has also stimulated the imagination of many photographers; by varying the running speed of the film, for example, curiously deformed effects can be obtained.

Top: The finish at the 400 meter hurdles final in the 1968 Olympics, taken with a special photofinish camera. Above: A classic shot taken during a trotting race at the San Siro track. The horses crossed the finish line at about 55 kmph (35mph) and the film speed was 9 cm per second (3½ inches per second). The white line is drawn in at the printing stage. Right: The photographer Neil Leifer used a special motorized Nikon with a 0.1mm slit shutter to obtain this dynamic photo of Billy Kidd at Val Gardena in 1970, showing how the photo finish technique can be used for creative effects.

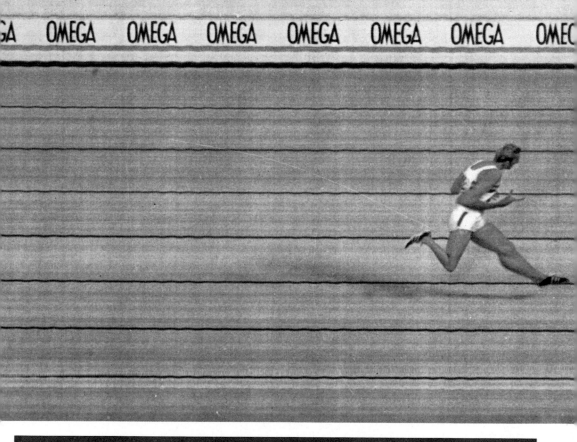

The decisive moment

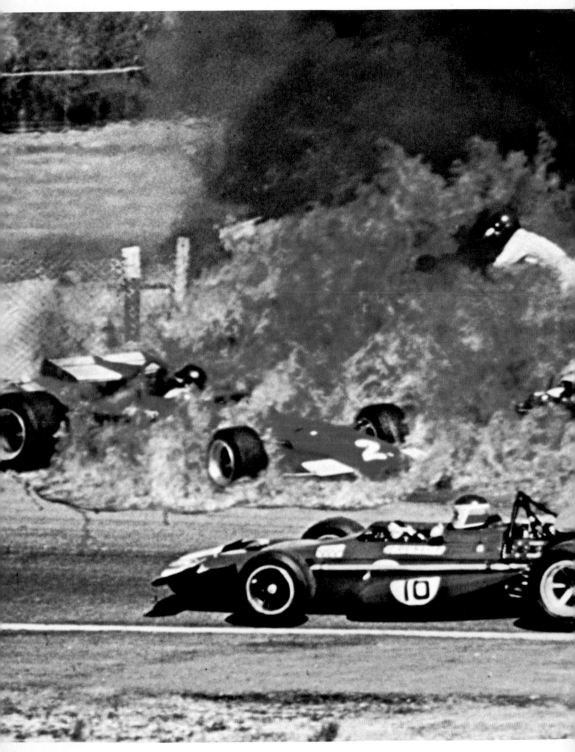

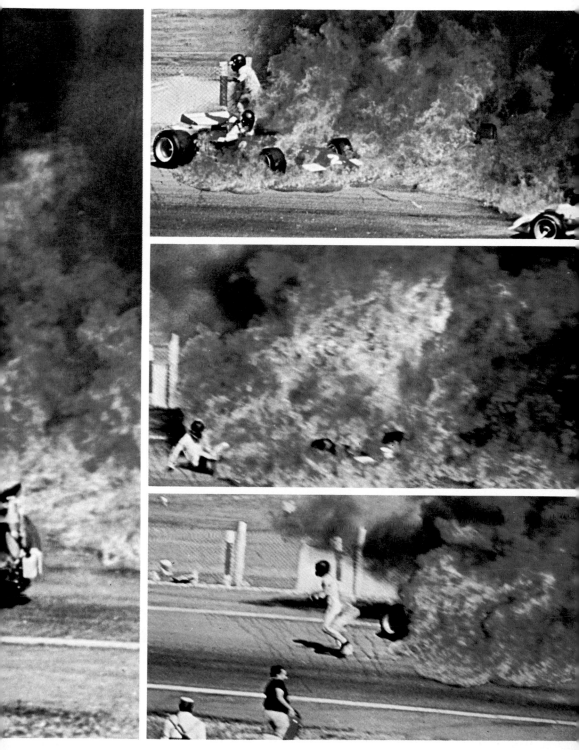

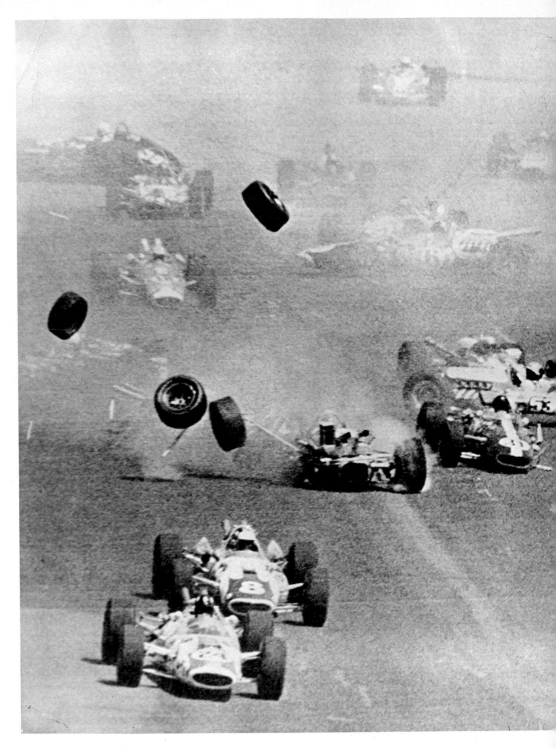

Previous page: A dramatic documentation of the terrible blaze which engulfed the cars of Ickx and Oliver in the Spanish Formula 1 Grand Prix in 1970. Fortunately, the drivers managed to come out without any serious injuries.

Above: Another spectacular accident, which incredibly managed to avoid causing any serious injuries at the chaotic start of the Indianapolis 500 in 1966.

Opposite: Villeneuve's Ferrari "taking off" from the Mount Fuji track.

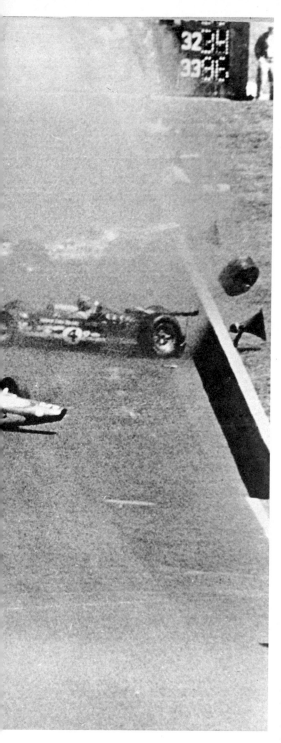

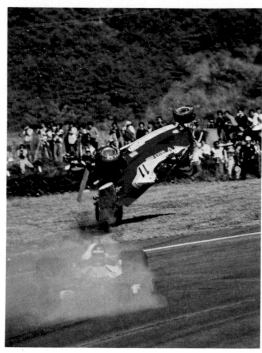

Fractions of a second

Sudden or unexpected things such as a knock-out, a fall, a fight between players, or an accident of some sort can happen in any sport. In fact they often dictate which way the competition will turn; so if you can catch these amusing or dramatic but always decisive events, the photograph automatically acquires a documentary value, independent of its technical quality, because it has recorded a moment that will never be repeated. Every sports photographer has to face the constant, stimulating, and sometimes frustrating challenge of the unexpected in this world of perpetual tension where no distractions are allowed. The best photographs are often the ones taken in those exciting and confused moments when the outcome can never be predicted, even though the feat may be possible or the player may be taking a calculated risk. The type of incident depends mainly on what sport is being photographed: a fall at a horse trial can give rise to some amusing pictures because of the contrast between the rider's elegant attire and the ungainly fall to earth. Any incident happening in a car race, where the drivers can be travelling at up to 300 kph (186 mph), is automatically dramatic, and in sports such as boxing, everything happens in literally fractions of a second, so one second later is indeed too late. Through its documentary value and the undisputable evidence of its content, photography can bring out details that may have been missed in the confusion of the incident, pointing out where responsibility lies, or testifying to the fairness of a penalty, or even reconstructing the fatal chain of events leading up to a tragedy.

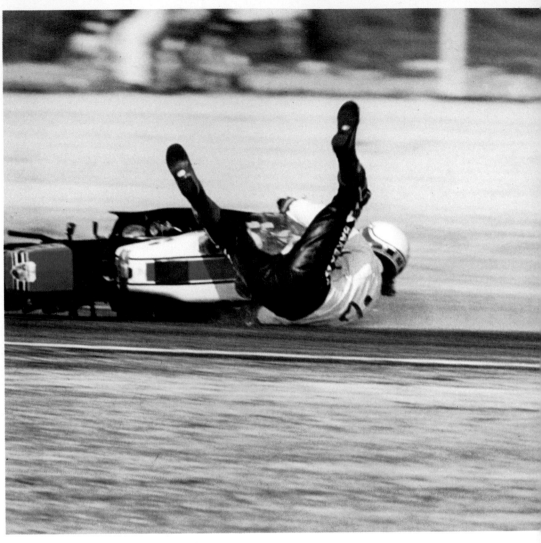

Action film

In all sports characterized by high speed action, such as car or motorcycle racing, skiing or bobsledding, where there is always the possibility that the driver will lose control of the machine, a motor driven camera can be very useful for taking a "movie" of the event with a full sequence of photographs. The results can be spectacular, particularly in sequences involving a fall since, although the unfortunate participant may be unharmed in the incident, it often ruins all chances of success. In these cases, only a full sequence of shots will effectively show the full range of emotions undergone. The fall or accident is almost always caused by some technical error on the part of the driver or athlete, and the sequence of photographs can show where the mistake was made (as in a television replay). But it must be said that, unlike motion picture film, photographs cannot give a continuous view, so it is very difficult to get complete sequences of photographs of any sudden or unforeseeable event; in fact, when it does happen, it is usually by accident. No matter how fast he or she is, the photographer can only begin taking pictures upon the realization that something unusual is going on, and this naturally involves a moment's delay. Nearly all photographic sequences of a fall, for example, miss the initial, precipitating event, which is often the most interesting. It is not necessary to have an ultra-fast motor to take sequence shots, as they have the disadvantage of burning up film so quickly that you risk running out at the best moment. Good results can be obtained with a winder, or simply by learning to operate the manual reload lever quickly and without taking your eye from the viewfinder. By doing so, you can take up to one frame per second and always have the situation under control. In fact, in certain circumstances, such as in a boat race, taking pictures at a slower rate is better than shooting in volleys.

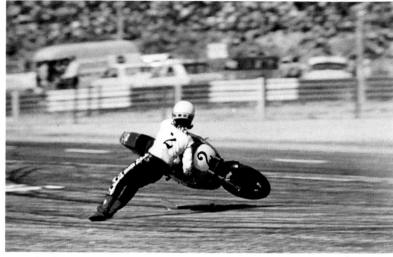

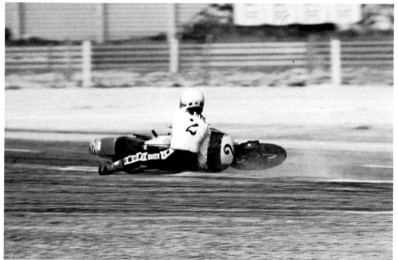

A fall in slow motion
The pirouette of Steve Baker, who came off his Yamaha at Daytona in 1977. The use of a motorized camera enabled the photographer to register the full sequence as if in slow motion. The photographs bring out clearly the dangerous but instinctive re-action of the rider in clinging to the handlebars of his bike throughout the incident instead of letting the machine go.

Preparing for the unexpected

When Von Trip's car careered off the track into the public at Monza in 1961, the only photographs of the incident were taken by an amateur and the cars appear blurred, out of focus and far away, but those photographs now form part of car racing history, as well as the history of sports photography to a certain extent. Photographic documentation is not the privilege of just experts and professionals: an amateur can also find the right opportunities if he or she has quick reflexes and the necessary calm and coolness. There are a few more tips which, if nothing else, will help you find the best position to catch these moments when they happen, as long as you remember the first rule for a good sports photographer: always be ready for the unexpected. It is important never to be distracted. Always follow the action in the viewfinder, even if you have no intention of shooting, and make sure you always have sufficient film in reserve. Many professionals at sporting events deliberately change the roll with still another four or five frames to go, so as to

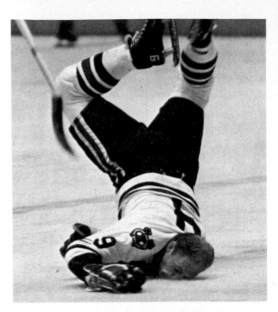

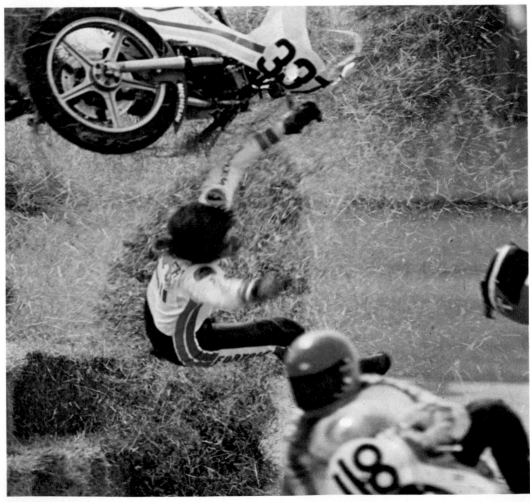

A photographer's strategy and tactics
To avoid the risk of missing the most exciting or dramatic moments of a sports event, you have to follow certain tactical and strategic rules, prepare yourself psychologically and technically for the unexpected, choose a position where the probability that something eventful will happen is the highest, and never allow yourself to be distracted. The photographs on these two pages show examples of unexpected situations that were taken with perfect timing by various photographers.

Opposite page, top: A bad landing on the ice by a hockey player. Bottom: The flight of a motorcycle rider at the edge of the track. Left: A clear foul in the midst of a soccer match. Below: A tangle of players in the penalty area.

cut down to a minimum the possibility of running out of film. It is also a good idea to have at least two camera bodies ready with different focal lengths. Always reload the shutter immediately after taking a photograph, and keep checking the exposure settings, maintaining the high speeds. Checking the depth of field in advance guarantees good results even when you are working by instinct, and an automatic camera can help avoid exposure problems. Having practiced focusing quickly is a great advantage when you have no time to lose; it helps to remember which way to turn the dial when the distance changes. The last rule worth noting is to find out which is the most dangerous bend, who is the most nervous driver, which slalom stretch is the trickiest, and where a mistake can capsize the boat. There are professionals who can "smell" what is going to happen because they know the athletes, how fit they are, what strain they are under

because of their general classification, and their style of play. On this basis, you can choose a strategic position from which you can predict the unpredictable, giving up a good spot with limited vision for a more panoramic view. Sometimes it is impossible to see the whole area, as in a grand prix circuit. In circumstances such as this, it is a good idea to keep in touch with the other photographers ranged along the track.

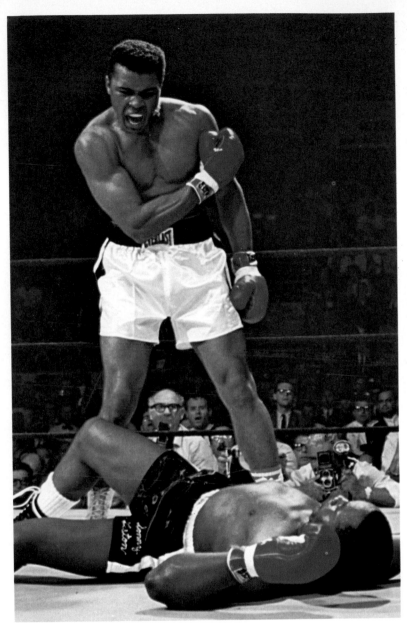

There is no room for weakness in a boxing ring, and with its crude reflector lighting and the merciless determination with which the contenders exchange blows, there is very little breathing space for the photographers. The speeds are often so great that when you expect to see a blow land, it is already over. No other sport demands such a degree of instinct and intuition as boxing, for the photographer has to be able to anticipate the punches up to a

Recording the story of a knockout

It was one of the fastest and most dramatic knockouts in the history of boxing: At Lewiston in 1965, the young, arrogant Cassius Clay floored the favorite Sonny Liston halfway through the first round. The punch was so fast and unexpected that it even took the photographers at the ringside by surprise, but not Neil Leifer, who had prepared himself with an incredible arrangement of equipment. He had

placed a motorized, remote-controlled Nikon with an 8mm fisheye lens above the ring so that he could include the spectators, and supplemented the lighting in the hall with a battery of 40 electronic flashes fitted on the ceiling. He had to choose his moments very carefully, as it took 30 seconds for the flashes to recharge after each shot, but his timing proved perfect. In between taking a number of close-up shots of the winner (above) he operated the remote control to obtain the overhead photograph on the right, which has captured all the drama of the knockout.

Opposite page, top: The frightening effect of a blow on the face of Joe Walcott, frozen by the split second light of a flash. In fact, the speeds of modern electronic flashes, ranging from 1/10,000 to 1/50,000 second, can freeze moments that happen so quickly they cannot be seen by the human eye.

point, and to do so, it is an advantage to know the contenders' character and style. One photographer who has been at many of Nino Benvenuti's matches said that the first few times he was so disorientated that he missed all the important punches, but then after a while, he managed to get into the action so much that he could see the punches before they had even been thrown. The problems are aggravated by the lighting, so you have to use fast film or a flash in order to be able to use the high shutter speeds necessary. The speed of an electronic flash (up to 1/50,000 second) is often the only way of arresting the devastating effects of a punch landing so heavily on the opponent's face that it physically distorts. The history of sports photography offers an impressive collection of similar pictures taken either by chance or through instinct by the photographers who were ranged around the ringside.

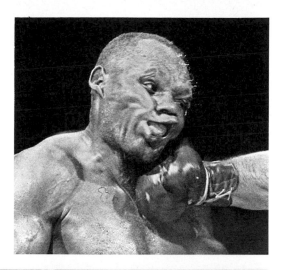

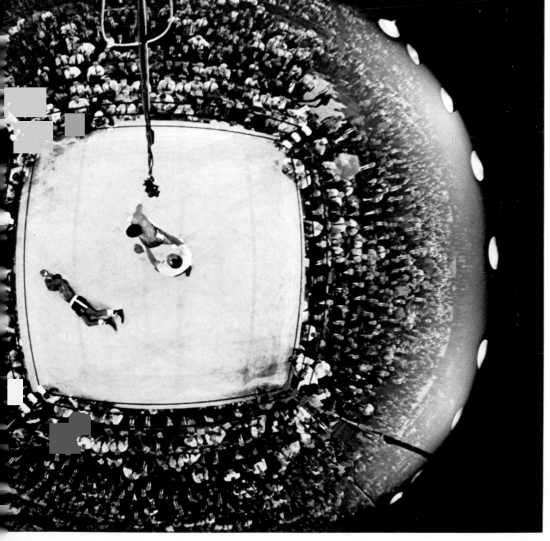

Light and shade in the ring

The "noble art" of boxing is more than just a savage fight between two men. There are rules and a code to follow, so the photographer must not focus only on the brute force of the punches. The photograph on the right shows a different angle: The fight is over and the winner walks off into the darkness toward the applause of a public that cannot be seen but is clearly imagined; the loser is on the floor with his arms wide, almost in a gesture of surrender, while above him is the referee, giving the fateful count. There is no real action in this photograph, but it shows an important part of the ritual of boxing. The light gives the photo, taken with a medium range telephoto lens on high sensitivity black and white film, a suggestive, tangible quality, and its symbolic value pushes its documentary significance (Nino Benvenuti's knockout of Mozzinghi in 1965) into the background.

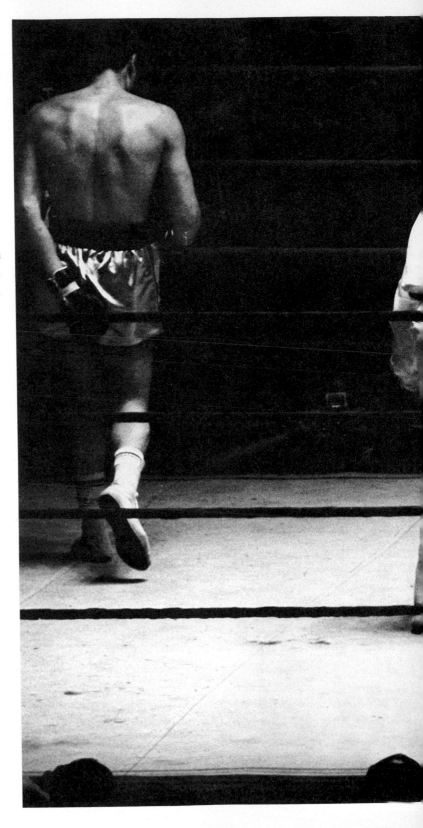

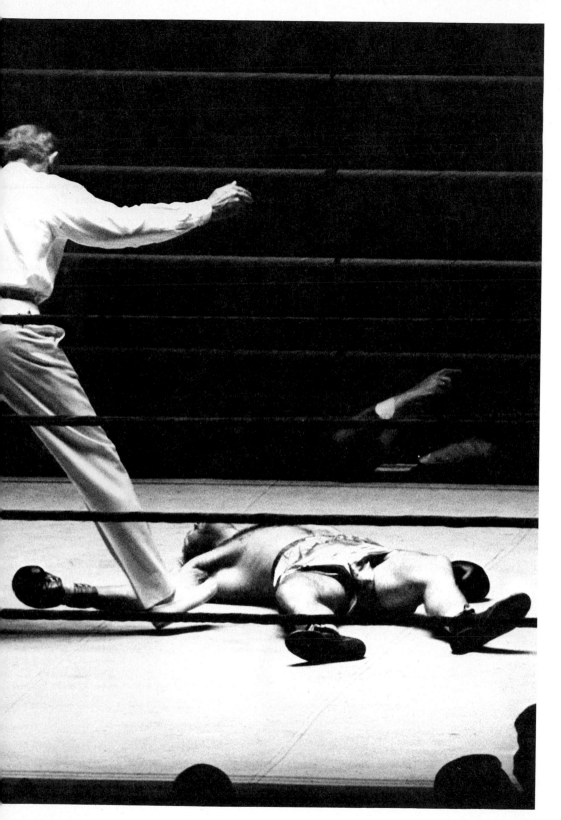

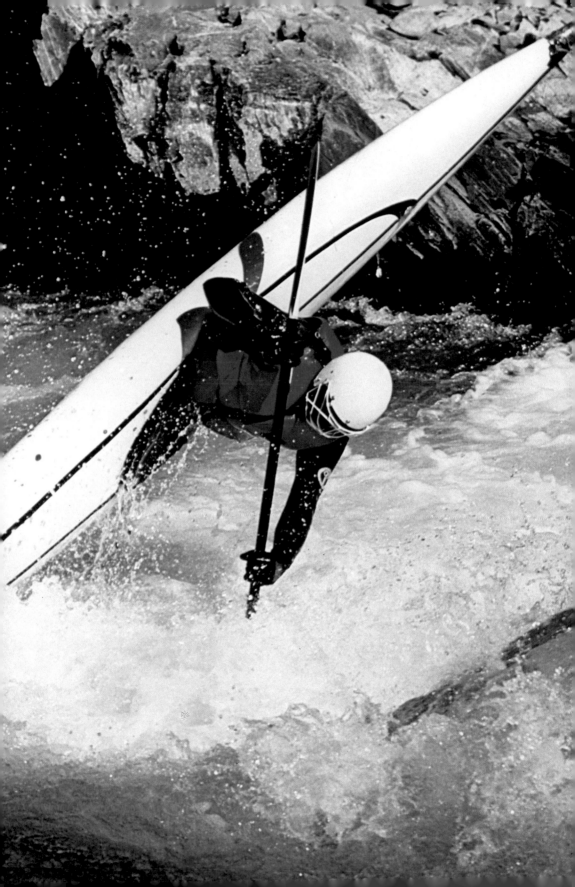

A revealing zoom shot
Opposite: The spectacular spin of a kayaker in the cold waters of the Adige. Right and below: The furious disappointment of a competitor hung up in the Taro Marathon. This amusing scene was enlarged during printing to show his expression better and give the photo a zoom effect.

Drama and comedy

The photographer sat on the banks of the Taro River, ready to photograph the canoes as they went past on the gruelling marathon. It was no accident that he was in that particular spot, for on the previous day, he had found out from an expert that the current at that point, the shallow water, and a few large rocks hidden under water could all change the course of the brightly colored canoes. He had already been at the spectacular start of the race and had quickly gone on ahead, following the river with his camera until he arrived at the point where something out of the ordinary would probably happen. His patience and serious preparation were rewarded; the photographer had the pick of amusing frames of canoeists caught in this tricky spot (as above). There were no technical problems, as the light was good and the distance so short that he could easily use a 105mm lens. The important factors, though, were that he had familiarized himself with the course, taken the advice of an expert, and thoroughly prepared to be in the right place at the right time, which is the real secret of sports photography. There are no rules or general regulations to achieve this result; every photographer has to act according to intuition and call upon experience to cut down to a minimum any risk in the shot.

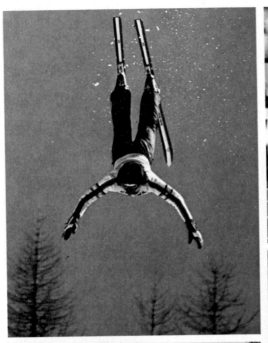

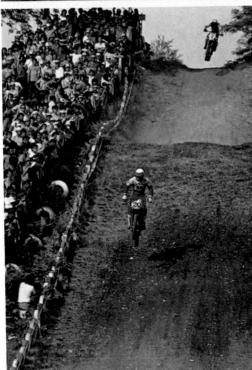

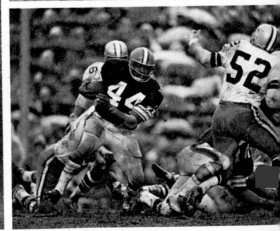

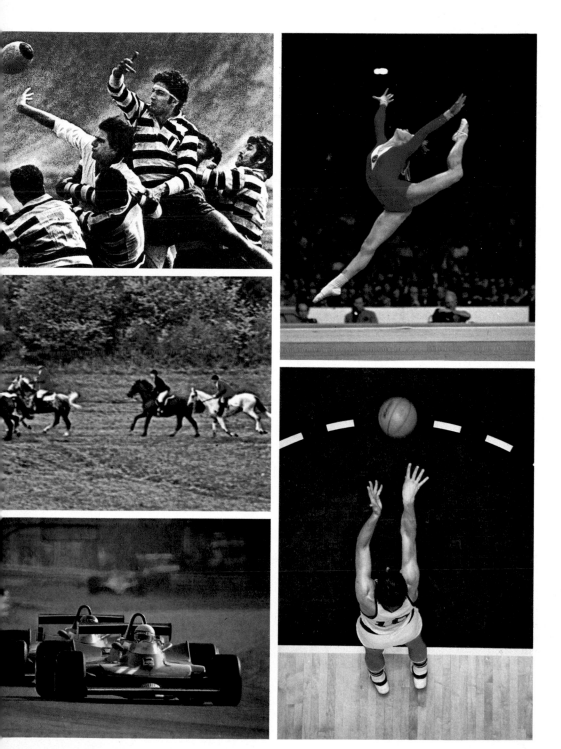

The first rule: know the game

Sports events generally follow rules and traditions that rarely change, so both the spectators and the photographer know in advance what actions and sequences to expect from the game. A runner clearing a hurdle or a quarterback attempting an end run are both to a certain extent taking programmed action along lines determined by the game. The position of other participants or the equipment and machinery within certain areas in the field or along the track will also affect the course of events, so you have to follow the action with one eye on the viewfinder and the other on what is going on around you. If something happens, you are ready to release the shutter, which is preset to cover any situation that may arise. A faked pass, an attempt at overtaking a competitor, the proud but painful struggle against a strong opponent, all combine to make up the "rules of the game," and are, in fact, often the very stuff of which the game is made. To be successful, you have to know, or better still feel, the game and its particular rules and surprises. The most popular types of sport can be divided into four major categories: athletics, team games, motorized racing, and sports taking place in natural surroundings. The photographer who knows the rules and systems governing the action can plan the work in advance, beginning with the choice of functional and portable equipment. It is also important to pick out a good observation point, since once you have chosen your position at an important event you are more or less stuck there, whether you are an amateur or a professional. Accredited professional reporters naturally have more freedom to move around (as long as they do not disturb the athletes), but if you are gaining entrance to an event by ticket which reserves a particular seat, that position has to be suitable for the photographs you intend taking. Keeping your particular equipment in mind, as well as all the inevitable logistic and technical restrictions of the grounds, have a look around the day before, and that may make it easier to pick the best spot.

Athletic events take place either in a stadium or a gymnasium: in the first case, the photographer is generally not allowed onto the sports area and must try to get as close to the athletes as possible, though the most favorable position with respect to the field is not always in the numbered seats in the central stands. The view has to be unimpeded by support pillars or protective nets, but in a pinch, trained use of depth of field or a telephoto lens can make the mesh of a net disappear. It is easier in a gymnasium, where you can get closer to the action and use the contrast of a darker background, or alternatively choose a higher position and photograph the athletes against the uniform background of the floor.

The same applies with team sports, except that in those you usually want photographs of certain actions only, so it is wiser to position yourself near the basket or the goalposts in order to capture the rhythmically repeated moments of intense action. In a stadium where you are surrounded by a large, noisy public, it is a good idea to be able to control whatever is in front of you: fans do tend to leap to their feet at key points in the game. Yet even professional photographers on the field have to make their choices; crouching motionless far downfield near the goal line, they wait for the long pass and the diving catch, a shot which has almost become stereotypical. There are many sorts of decisive moments in a game; a clear winner crossing the finish line can be photographically very uninspiring, while other, perhaps less crucial moments, such as an accident in a car race, may be much more meaningful. Technical ability is just as important when photographing sport in natural surroundings, for the events take place over a very large area that is difficult to control: whether the location is by a stream, among rocks, or at sea, professionals and amateurs alike have the same opportunities and must rely only on individual preparation and ability.

Previous page: A mosaic of sports photographs that shows the four main categories of sporting activities— individual sports, team sports, speed competitions on tracks, and sport in nature.
Opposite: A hockey match taken from above, emphasizing the organization of the game in a limited geometric area, which the photographer must know how to control by the choices he or she makes.

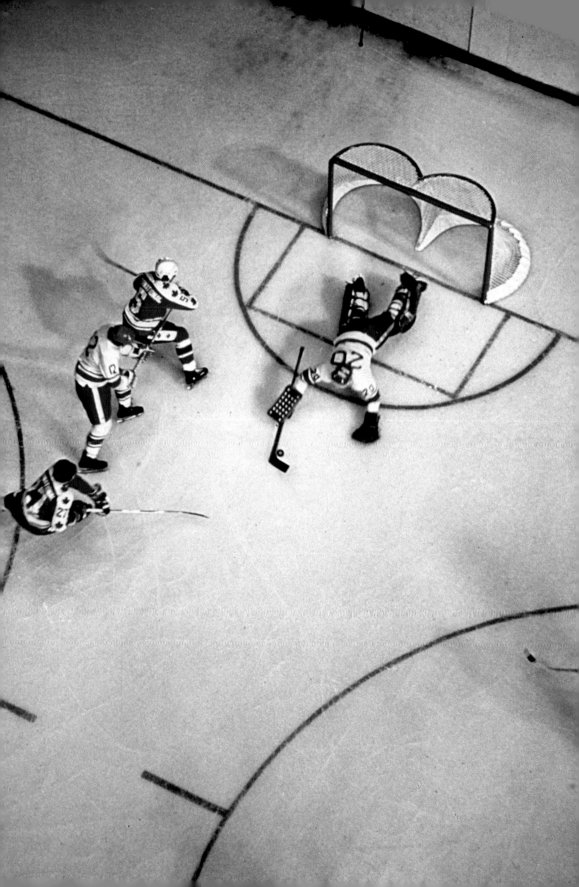

The human machine

An athlete is like a machine, built to a design that makes the most of the energy potential of his or her muscular and nervous structure. A series of actions and reactions both physical and psychological allow the athlete to attain "maximum output" and sometimes produce new records. In individual sports where there is no team to consider, athletes can express their personalities to the full and can win only by using all of their intelligence and strength— these are the elements which bring out their greatest efforts and lead them to victory. The culmination of this effort can take place in such a brief moment that the eye cannot actually see what happened, but the photographer can capture it all in a photograph, such as the one here showing Sara Simeoni giving her best in her specialty, the high jump; in 1978, her jump, measured at 2.01 meters (6.6 feet) set a world record.

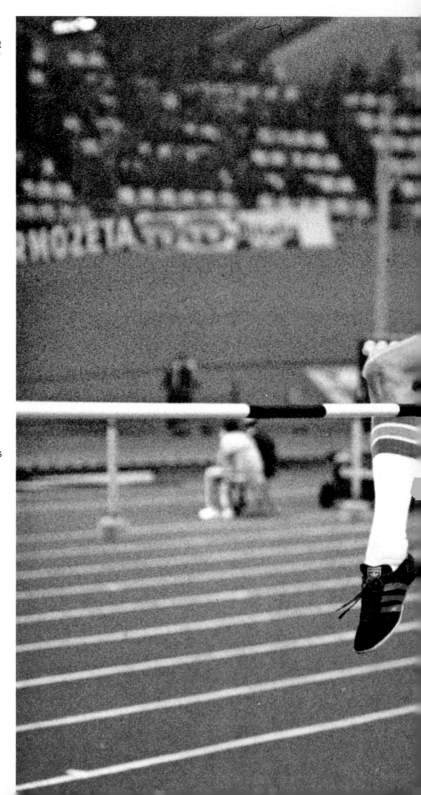

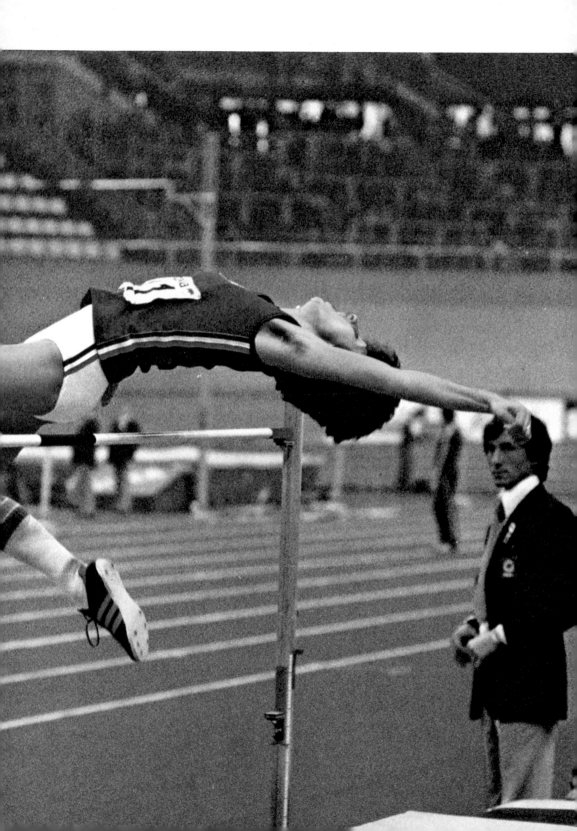

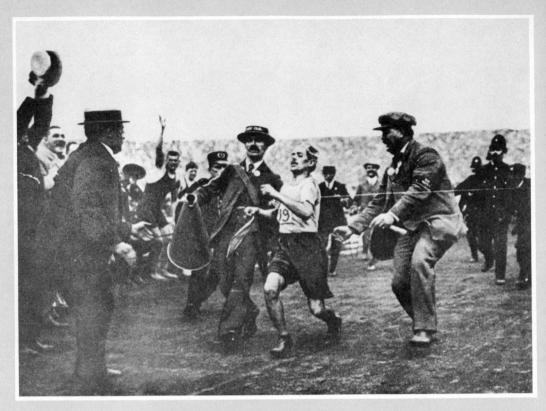

Above: One of the most dramatic and exciting moments in the history of the Olympics, followed at every instant by the numerous photographers present. It took place in London in 1908 at the end of the gruelling marathon, when the Italian Dorando Pietri entered the stadium. He fell many times but got up and continued on, though he had to be supported over the finish line. The public was behind him all the way, but he was disqualified and the American Johnny Hayes was given the gold. Right: Another bitter moment in Italian sports: gymnast Fausto Menichelli, who had won the gold medal in Tokyo, lies in pain on the ground at the Mexico Olympics (1968), betrayed by a torn tendon.

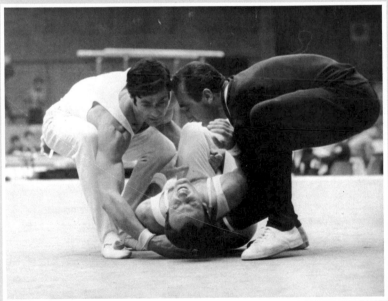

Photographs taken just 100 years ago show a world and a concept of sport that is completely different from the high pressure professionalism of today. Left: A poster advertising the world athletics championship of 1895. Below: The timid beginnings of women's involvement in sport: the French tennis champion Broquedis (1912). Bottom: The start of a 100 meter race in 1933. The athletes' dress and techniques may make us smile, but their dedication and competitive spirit were just as great as those of their modern counterparts.

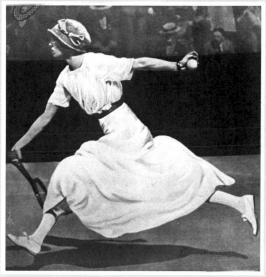

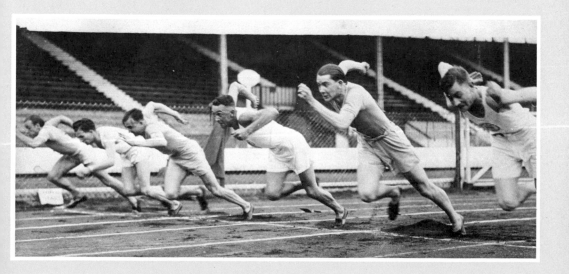

Running, the purest of all sports

On all running tracks, the competitors' hearts are set on the magical goal at the end of the 100, 200, 400, or 3000 meters, so all photographs of running, the purest of all the sports, must capture this effort. It is found in races from the 100 meter sprint to the 10,000 meters or the marathon. The special concentration needed for these events can form the basis for original photographic reports; with a 200mm lens, you can take anything from expressions and gestures to warming up and preparation. To avoid "television"-type perspectives, you must get as close to the field as possible, but in general only accredited professional reporters can get within the inner circle at important events, and even they are bound by fixed rules of position. This problem does not arise at less important events where amateur photographers will find ideal conditions in which to move and where they can rival even the greatest sports photographers, despite the fact that there are no great stars present. Even if you are not permitted to get down onto the field, you should not be discouraged, for it is still possible to take many excellent photographs from a viewpoint in the front rows of the spectators. Standing at ground level and using a 200mm or 300mm, you will be able to photograph the athletes against a neutral background and at the same time have an opportunity to measure your own timing and reflexes and test your pow-

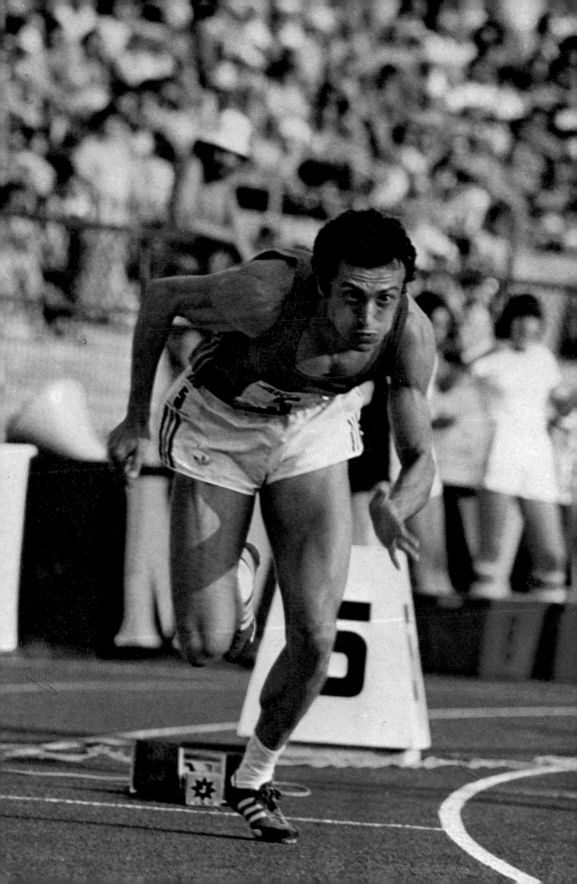

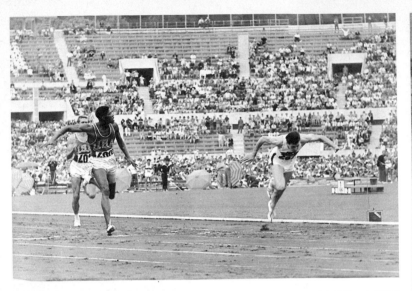

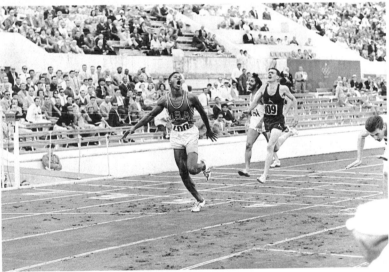

Choice of position

The photographs on these two pages are the same shot of an arrival at the finish line taken from three different positions at 1/500 second (see diagram). A comparison between the three photographs shows how widely the result can vary just by changing the perspective by a few yards. This exceptional series of pictures was taken during the final of the men's 400 meters at the Rome Olympics in 1960. The large photo is possibly the most "descriptive" and was, in fact, published in the sports papers. Despite Carl Kaufmann's desperate attempt to throw himself through the line, he was beaten by a whisker by David Otis, who

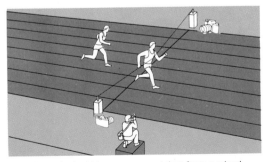

is turning to look at him. Both men had the same time: 44:9, which constituted a new world record. Unlike the other two photographs, which were taken from the side of the track with a 50mm lens, the large photo

was taken from a raised position with a 200mm telephoto lens. Note the quick reflexes of the three photographers, who all managed to freeze almost the same moment as the runners crossed the finish line.

ers of composition.

It is useless to try to get impossible close-ups without powerful telephoto lenses from the top of the stands, which is notoriously the "worst" position for a photographer, but you can get very satisfactory results with a 200mm or 135mm, composing the figures of the athletes against the linear and geometric track area, framed perhaps within the lines of hurdles. In pure speed events, the start is possibly the most intense mo-

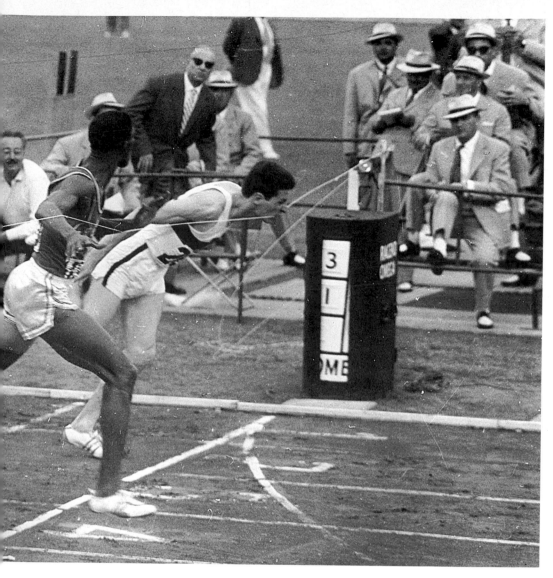

ment, being the time when all the athletes' energy is unleashed. In the 100m and 200m sprint, only two moments really count: the start and the finish. Standing on the sidelines with a 300mm or more telephoto lens to give you good shots over a distance, you can compress the athletes into the photograph and capture their expressions of concentration, using speeds of 1/500 or (better still) 1/1000 second. The best results are obtained by releasing the shutter as soon as you hear the starting pistol, as this captures the athletes out of their starting blocks and just as their formation is about to break up into a frenetic flurry of arms and legs. This kind of angled shot does give problems with reduced depth of field, but it can be extended using maximum aperture (with fast film in order to be able to use the high speeds necessary) on less "critical" telephoto lenses such as the 135/200mm, or by focusing on just one plane, such as on the leading athlete or on one athlete in particular. It can be quite interesting to follow the starting points with a rapid sequence motor getting 3 to 5 frames per second, but even fast manual reload is enough to get a sequence of the three classic positions of the athletes: kneeling on the ground on their marks, raised and set, and thrown out of the blocks on "go." The finish is just as interesting and spec- tacular, very often with only the slightest margin between the athletes as they vie for position. Us- ing a 50mm or 30mm lens from the sidelines, with speeds of 1/500 second, you can get good documentary pho- tographs that show the expressions and effort of the athletes, but it is then essential to have perfect timing and not shoot a moment too soon or too late, when the tape has been broken. With a powerful telephoto lens, you can photograph the

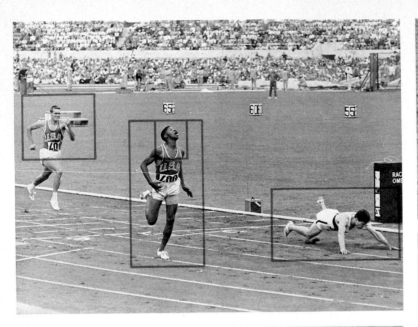

Analysis of a finish

Also taken at the final of the men's 400 meters in Rome, the photo above was taken immediately after the leaders had crossed the finish line and lends itself well to breaking down into different levels. Kaufmann's dive in his vain attempt to gain that extra centimeter that could have earned him the gold medal ended in a disastrous fall. David Otis's face expresses his relief at having come to the end of his tremendous effort before registering his satisfaction with his victory. As for the other American in the race, Earl Young, seen in the background and opposite, the race is not yet over: He finished in sixth place.

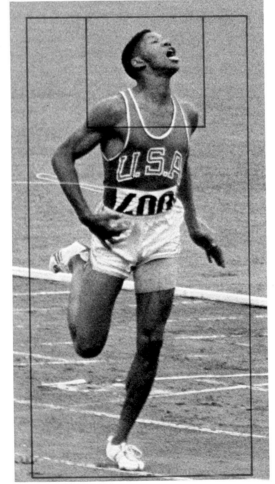

competitors head-on, as long as you are far enough away not to get in their way when they slow down, although this kind of photograph does not give as good an idea of the distances between the leaders. Long distance races over 1500, 5000, or 10,000 meters give the photographer many more opportunities, particularly in the first few laps when the runners are still bunched together and fighting elbow to elbow for position. With a medium range telephoto lens or a 300mm, which compresses the field of the picture, you can wait for them coming out of a bend, positioning yourself in front, slightly at an

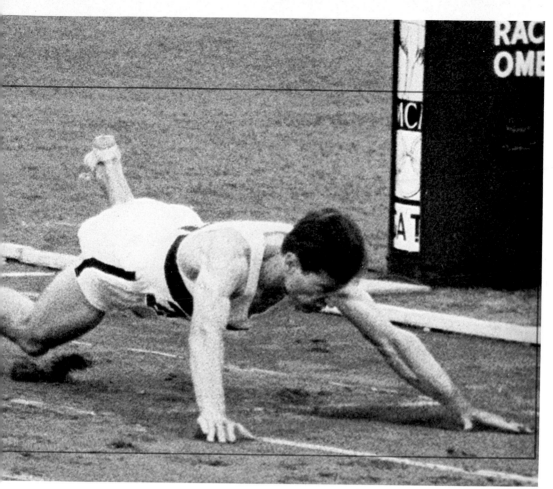

angle, and preferably on the inside; having focused on a preset point makes it easier to shoot quickly. A medium range telephoto lens of 135mm is good for getting interesting shots in sequence while the group is passing by, again having focused on a chosen line and using release times of not more than 1/125 second and not less than 1/30 second in order to keep the pictures sharp. If you take the shots kneeling down, you can get a uniform background with no distracting elements.

The different speeds of the athletes can give some quite interesting effects, as can the different relative speeds of

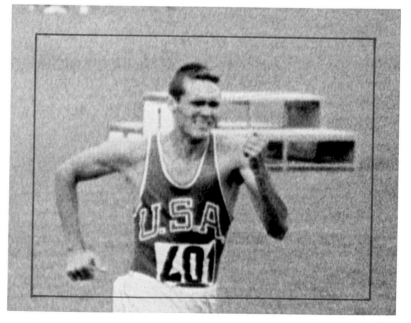

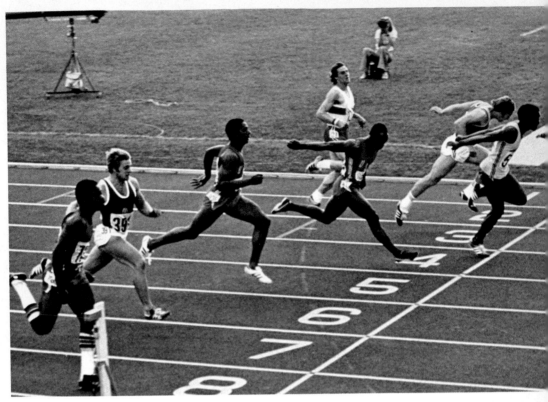

the arms and legs compared with the rest of the body. For really "sharp" pictures, it is better to use speeds of at least 1/500 second, but even so it is often necessary to follow the movement of athletes in the viewfinder while taking the shot, especially when close up, for it is wiser never to underestimate speed. Using speeds that are too high can arrest the action at the wrong moment (the stride should be at full extension), thus not representing the speed effectively. The finish in a long distance race is hardly ever important (unless you want to capture the winner's moment of triumph), since all that happens is that the winner breaks the tape, but in record-breaking races, the athletes generally strain at the finish, and there is usually more competition for second and third place. The 4 × 100 or 4 × 400 meter relay is maximally interesting on the changeover, in which the athletes have 20 meters to hand over the baton; the picture should be taken at this point, when the athletes have also slowed a bit. In the 3000 meter hurdles, there is a water jump, which is 4 meters (13 feet) wide, that immediately follows a 90cm (3 foot) hurdle, and this part of the race is certainly the most spectacular. But too close a position with a normal or wide-angle lens can also be the wettest, so it is better to position yourself in front, with the focus preset, and release the shutter when the leaders are already landing in the water, throwing up splashes of water, while the rest of the group behind them is still climbing the hurdle. If

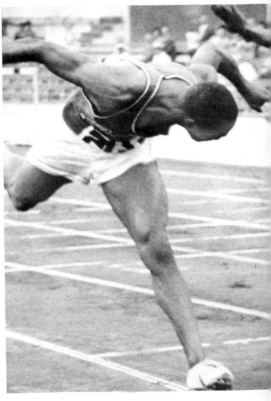

A feeling of power

Races over short distances bring out the power of the athletes, whereas long distance and middle distance races emphasize their agility and endurance.

Left: The finish in a 100 meter sprint, taken from the classic photo-finish position, which enables the photographer to describe the finishing order exactly, even from the front of the stands using a medium range telephoto lens, so that the times and distances can be measured. The shot is nevertheless cold and impersonal. Below, left: The duel on the finishing line at the final of the 100 meter hurdles in the 1960 Olympics between Leo Calhoun and Willie May; the chosen frame is very emotive. Right: The power of Jim Hines in full stride. Below, right: Bob Hayes ("the world's fastest human" at Tokyo in 1964, when he had a time of 10.0 flat) coming out of the starting blocks. The lens used clearly shows the muscles of these veritable supermen of the pure speed events.

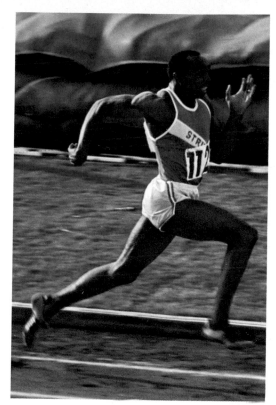

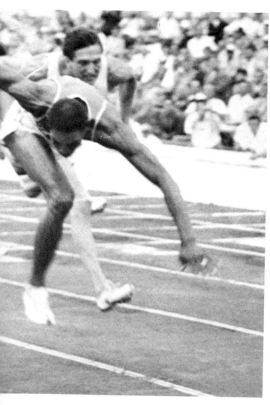

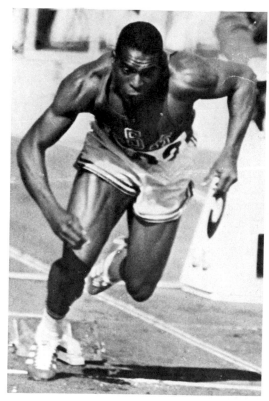

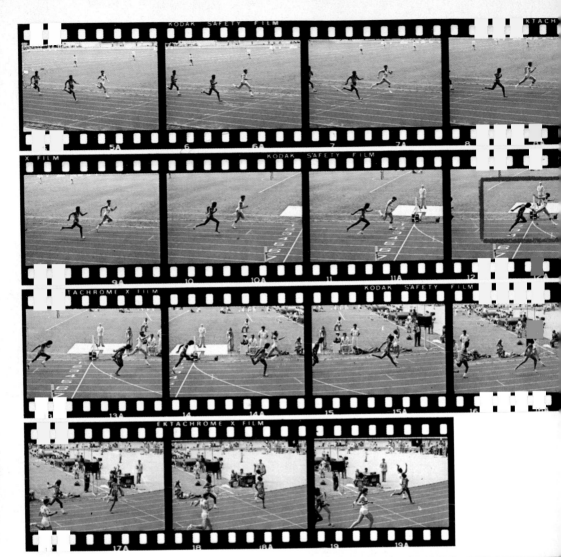

The film of a race

The Cuban Juantoreña, seen above in a sequence taken at the 400 meters final in the Montreal Olympics in 1976, is gifted with agility, power, speed, and class. The sequence shown covers the arrival at the finish line, taken with a 35mm lens from an angled position up in the stands, from where the photographer could follow the sprinters against the background of the track. Instead of using his own reflexes to take only the moment of crossing the finish line, he chose to set the motor to sequence and obtain a "film" of the event. Right: An enlargement taken from one of the shots shows Juantoreña's victorious arrival. The sequence does demonstrate, however, the fact that even with a fast motor (3 frames per second in this case), you have no guarantee of capturing the exact moment when the winner crosses the finish line. If you want to get just this moment, it is better to rely on your own reflexes and shoot slightly ahead of time.

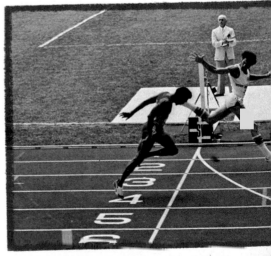

there is more distance between the runners, you can photograph an athlete arriving at the hurdle and about to make the jump. The effort on the faces of the athletes in this murderous specialty makes it worth taking head-on shots with a good telephoto lens such as a 300mm. All races, especially over longer distances where more sustained effort is made, offer good opportunities for very interesting and meaningful close-up shots. The 135mm is perhaps the quickest and most manageable lens for taking photographs of a friendly embrace between two of the contestants, or a contorted face beaded with sweat, but remember to respect the athlete's privacy. Hurdle races over distances of 110 to 400 meters give you time to pick your spot carefully (in front at an angle) and get your

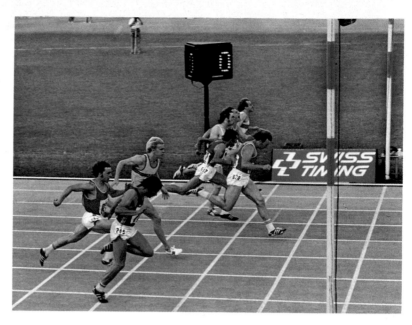

focus. You can also isolate just one athlete with a 300mm lens, or take the whole group with a 100mm, always using fast speeds. It is better to shoot while the athlete is actually crossing the hurdle, and a front view from a distance, using a 400, 500, or 1000mm telephoto lens can give some interesting pictures of the final hurdle. A distance shot of the athletes stretched out along

At the tape
Above and below: The same exciting finish in the final of the 100 meters of the 1974 World Championships in Rome, taken from two different positions. The Italian Pietro Mennea was beaten by a whisker by the great Russian Valeri Borzov.

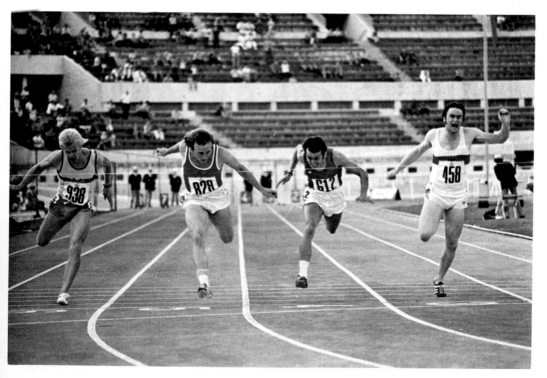

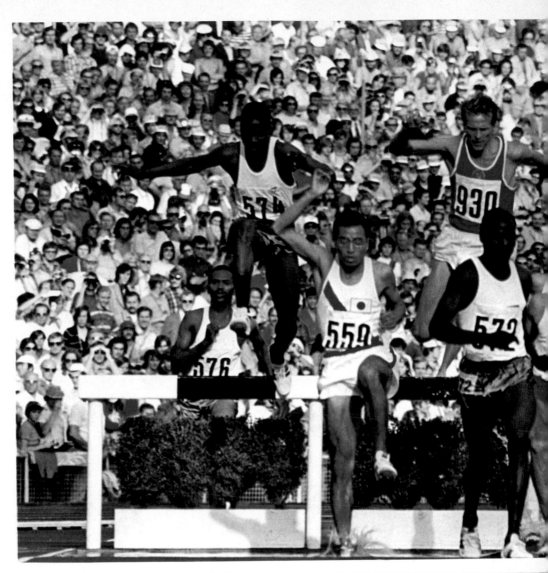

the finishing line, compressing the whole competition area into the space of the photograph, can be just as interesting. In many cases, you can set the focus on a fixed point of the track and play a waiting game with the camera ready on a tripod, using a shutter release cable, but it is also very important to be able to work freehand and change the focus whenever you want, so that you can take a number of photographs from a position facing the runners as they approach. Your control must be instinctive, for if you stop to think, it is highly likely that you will lose the frame and have to wait for the next lap. This applies particularly to professionals, as they cannot allow themselves the mistakes and excuses an amateur can. But regardless of who you are, if you choose to work in sports photography, even if only as an amateur, you should always respond to its challenge by giving only of your best.

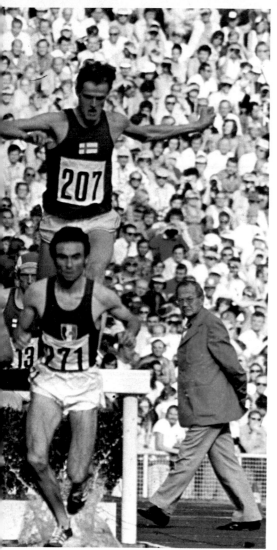

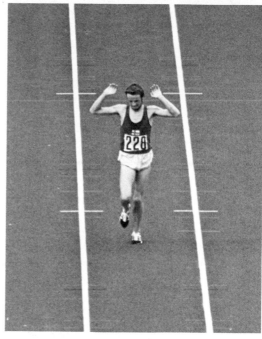

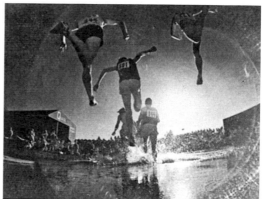

Endurance tests

Long distance races—from the 800 to the 10,000 meters and the walking marathon—offer the photographer themes and subjects quite different from those of the pure speed events. The race develops its own story of racers overtaking, battling for position, and breaking away. The most interesting shots are taken as the competitors come out of a bend.

Left: The technique of panning enables you to take good pictures even when the athletes pass directly in front of you. Above: Crossing the water jump, a ditch full of water in the 3000 meter hurdles. For this kind of photograph, it is better to focus accurately in advance,

then shoot when the runners are on the hurdle. Top right: The solitary arrival of Lasse Viren in the final of the 10,000 meters at Montreal. Normally, the finish of a long distance race offers little in the way of emotion.

The drawing on the right shows an intelligent solution for photographing the racers clearing the water jump from an original angle. The camera was fitted with a fisheye lens and a motor for winding on the film and was then positioned directly below the hurdle where it was operated by cable. Above the drawing is the resulting photograph. The very close range requires a fisheye lens or a very powerful wide-angle lens in this type of shot.

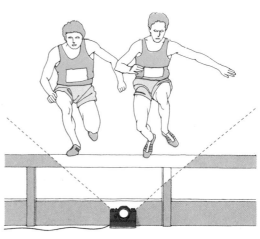

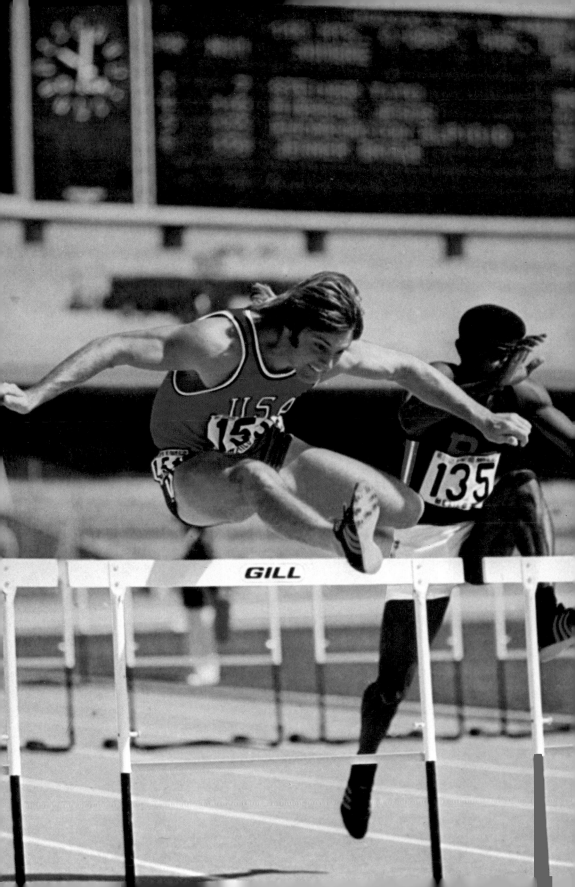

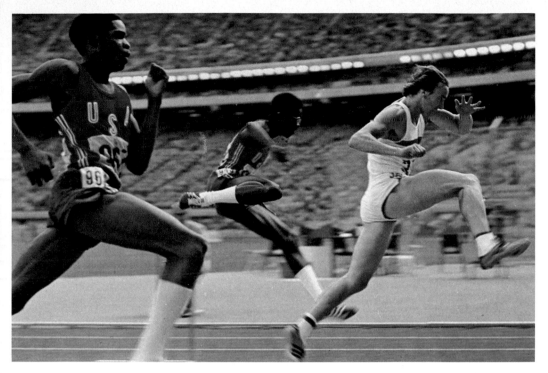

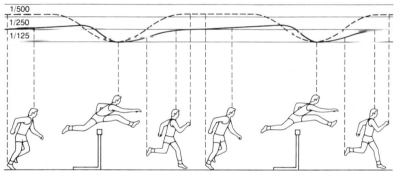

Shutter speeds

The legs, arms, and body of an athlete move at different speeds during a race and so break the forward movement into a series of rhythmic actions. The eye of the camera can register these different speeds better than the human eye because the subjects leave a different trace on the film when the shutter speeds are below certain limits. The drawing shows the minimum speeds necessary to freeze the movement of the arms, legs, and body of an athlete during a hurdle race. The lowest speeds refer to the "dead point" of the jump when the various speeds level out to move forward at the same speed.

Opposite: A frontal shot at the right moment enables the photographer to arrest the athlete even at 1/250 second. Above: This shot was taken at the same speed, but panning.

Left: A correct but ordinary shot, taken at 1/500 second.

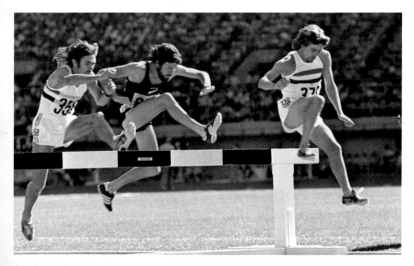

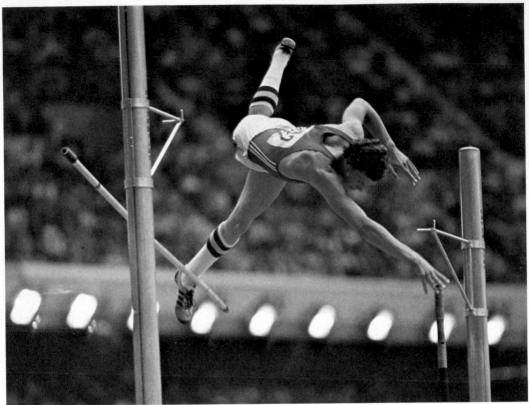

The jump

In the various jumping events, which are among the most fascinating athletic specialties, the photographer has a subject that carries out fixed, predictable moves, but there still is the problem of arresting the action at its climax. To make a full sequence and bring out the elegance of a move normally hidden by its speed, you really need a motor driven camera, but as you have a certain degree of freedom of movement, a 135mm or 200mm is perfectly adequate to pick out the athlete against the background at the point he or she clears the bar. The best positions are chosen with the different styles of the athletes in mind. The almost universal adoption of the "Fosbury flop" among high jumpers has put an end to any possibility of inter-esting shots from below, even with a powerful wide-angle lens. But in the pole vault, the photographer's position is particularly important so as to give a good idea of the height involved; it is often possible to do this better when the camera is lower and a shorter focal length is used.

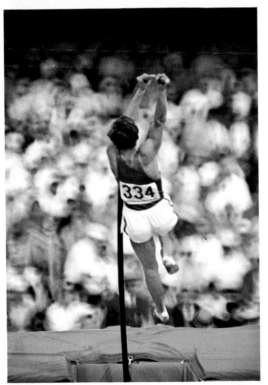

Opposite: The photographer used just the right shutter speed to arrest the athlete as he cleared the bar. The blurred background emphasizes the height of the jump. Above: An unsuccessful attempt. Left: Takeoff. A 500mm mirror lens has blurred the background with the typical ring effect.

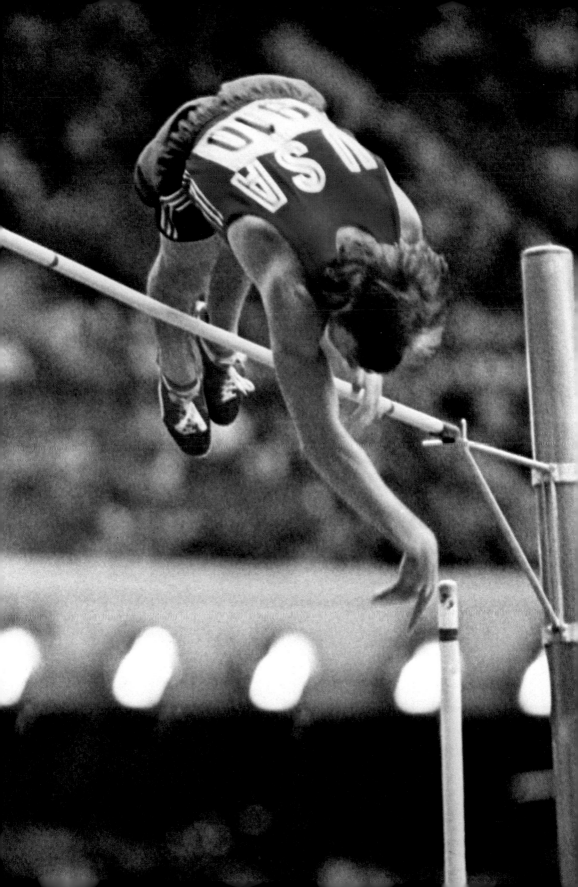

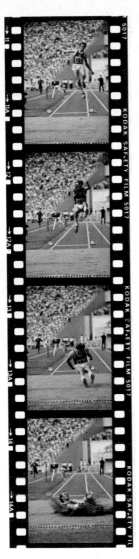

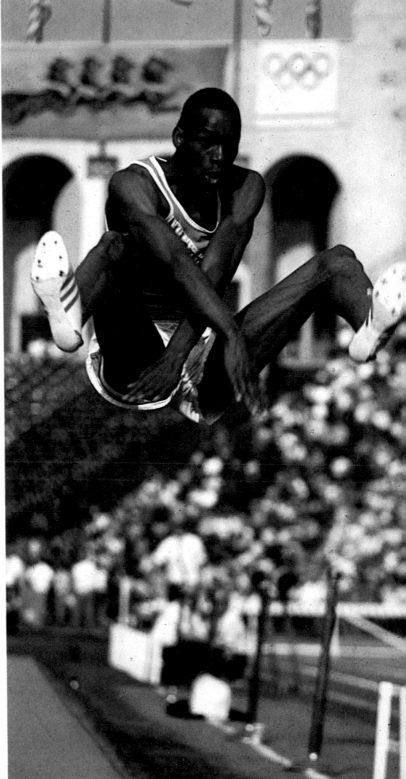

The long jump
The long jump should be photographed from the front with at least a 200mm telephoto lens to pick out the athlete clearly against the background, adjusting the focus to suit the varying distances of the subject. The most photogenic moments are at the jumper's maximum height off the ground and landing. Above: A sequence showing the finish of a jump. Right: Bob Beamon in flight on his way to a record distance of 8.90 meters (29.2 feet), taken frontally using a 400mm telephoto lens.

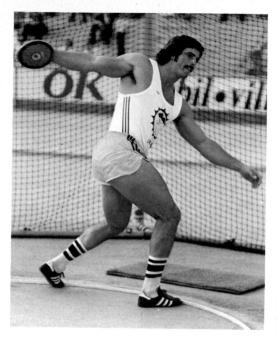

over, or during trials, even a medium range short distance telephoto lens is sufficient to bring out the intense concentration and effort required in these events.

Left: The classic discipline of the discus lends itself to interesting studies of the athlete's movement. Below: An unusual moment captured by the photographer outside the competition. Bot-

tom: With the effort clearly evident on his face, shotputter Al Feuerbach unleashes all his impressive power on putting the shot. It is attention to details such as these that demonstrates the originality and intelligence of a good sports photographer, who knows when it is time to move away from the common type of frame.

Attention to detail

The "fixed focus" technique, which allows the photographer to concentrate exclusively on the right moment to shoot, is useful in all sports where the most intense action takes place at a fixed point such as in throwing the discus, the hammer, and the javelin, or shot-

putting. The movements in these events all follow fixed patterns, even if each athlete has particular speeds and rhythms, so the photographer can devote all his or her attention to getting the right moment and frame. It is difficult to get close to the athletes during the competitions, but when the event is

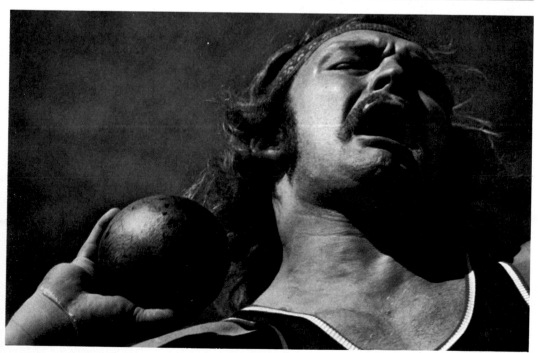

Indoor events

Wrestling, boxing, and weightlifting are sports in which the power and strength of the contenders is shown in all its brutality and are hence most successfully captured in close-ups. On the other hand, gymnastics, judo, and the martial arts are full of elegance, skill, and style. But all these sports have one thing in common: they normally take place indoors in a gym or stadium where the artificial lighting gives the photographer the usual problems. The photographer has to choose the right film, use filters and backup lighting to correct any dominant shades; nor at times can one use powerful telephoto lenses, because they are not very bright. As a result, the choice of position is of paramount importance.

Right: A photograph taken from the ringside, showing the tremendous power of Muhammad Ali. Perfect alignment of the flash has emphasized the impact of the blow on Foreman's face.

Below: Wrestling. Opposite, top: The angle of the shot underlines Menichelli's elegance on the rings. Opposite, bottom: The Russian man-mountain Alexei Vassili, the "strongest man in the world," at the Montreal Olympics. Weightlifting gives the photographer excellent opportunities for taking very effective shots of facial expressions.

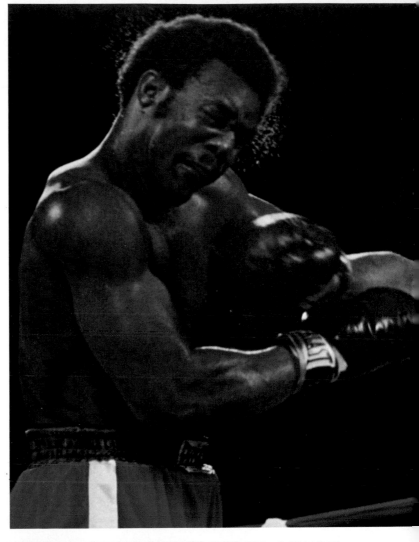

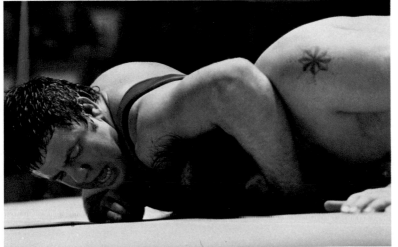

Artificial lighting

Direct flash makes the atmosphere look unnatural, and its use is prohibited in many cases because it disturbs the athletes. What is more, the guide numbers on portable flashes are often too low and are therefore almost useless over 4 or 5 meters (13 to 16 feet), so in bad lighting, it is better to use powerful electronic flash lamps to back up existing light. The drawing shows the arrangement of the flash lamps to cover a boxing match, where both photographers chose to have overhead illumination. In special cases, a number of flash lamps can be used simultaneously. Relatively low shutter speeds should be used to avoid ghosting on the film.

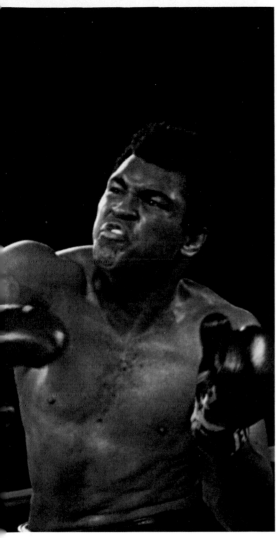

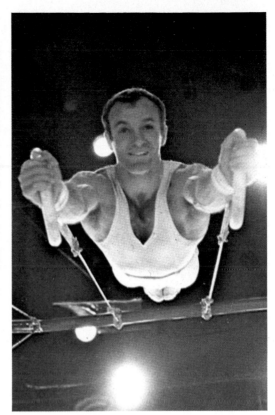

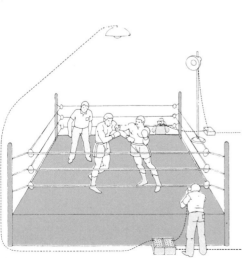

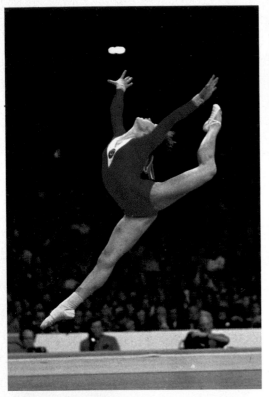

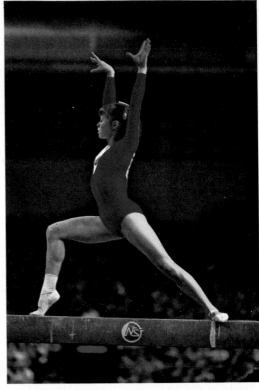

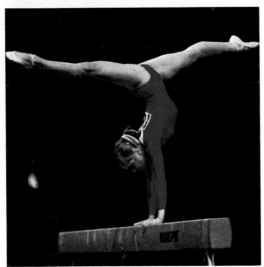

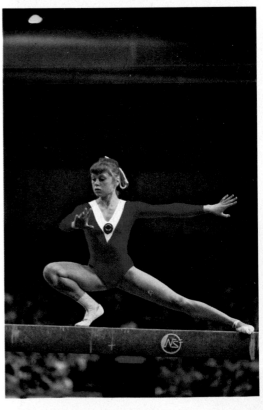

The "figures" of a gymnast

Gymnasts perform elegant, fleeting figures in the air with the grace, harmony, and coordination of classical dancers; and the photographer has to know all these to be able to take advantage of the dead points of the various exercises. A very bright medium-range tele-photo lens (80/100mm) is the ideal lens, though the film must also often be pushed to its maximum. The poor ambient light can be used positively for good blurred effects, as long as these effects are functional. In any case, some part of the subject or an element in the background should be kept sharply in focus.

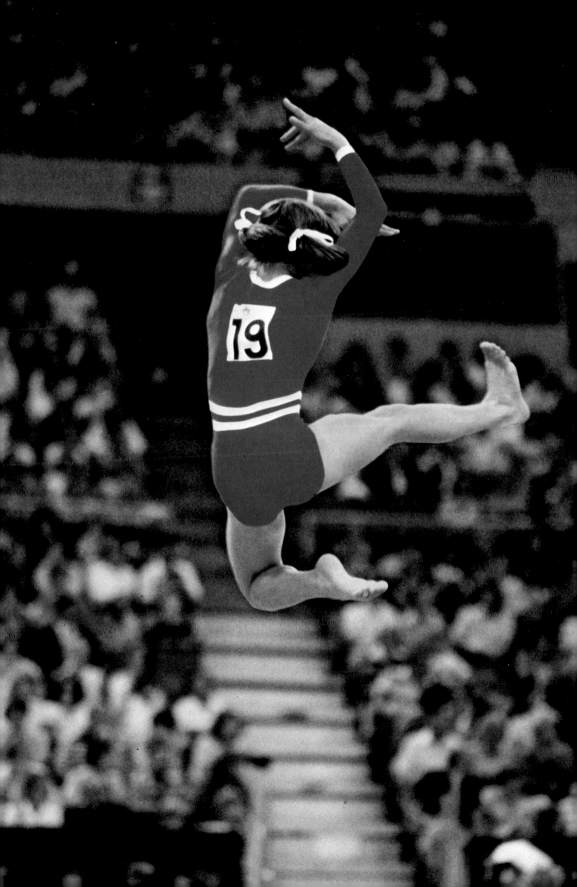

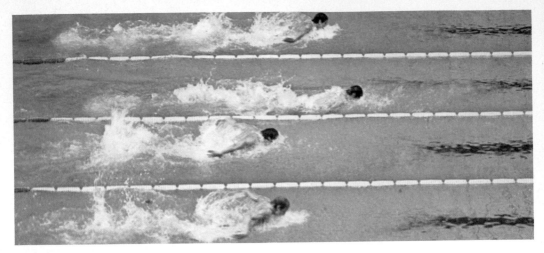

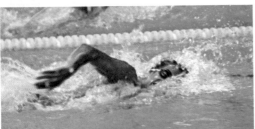

The search for good close-ups

The best lenses to use when photographing swimming events are 200mm and upward, as they can isolate in close-up the most expressive details. The shot should be synchronized with the movement of the arms, and it is not advisable to use speeds below 1/250 second.

Above: This purely journalistic shot was taken with a 105mm from a raised position. Left: A 300mm was used to isolate the vigorous arm movement of the freestyle. Below: An even more powerful lens brings out at close range the irresistible power of Mark Spitz on his way to his seventh Olympic Gold Medal in Munich in 1972. Lateral shots are the best for freestyle and frontal shots for butterfly, breast stroke, and backstroke.

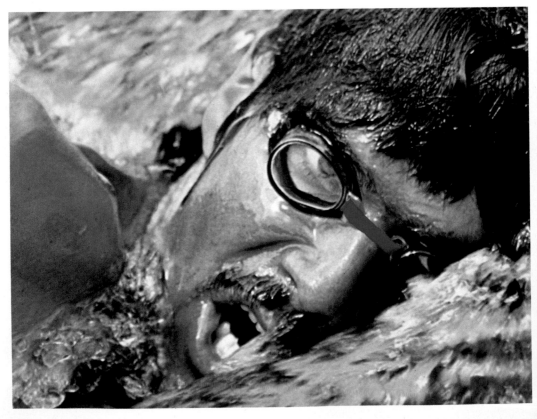

At the pool

A swimming photograph "works" only if you manage to center the attention on the foreground. This often involves using powerful telephoto lenses such as the 300mm or 500mm, so the most satisfactory shots come from open air events, as they allow you to use super-telephoto lenses under the best conditions. Indoor events need high sensitivity film. The more movement there is in a water polo match, the more exciting the photograph, and you can position yourself at the edge of the pool where you are in a good position to see the action in the net, which is certainly the most dynamic. Distances are not great, so even a medium range telephoto lens of 100mm can be used.

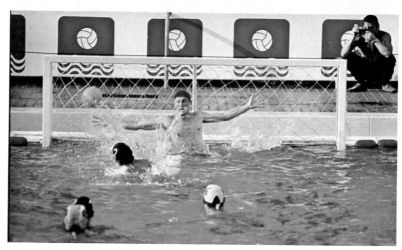

Above: A goal shot in a water polo match. The photographer had chosen the best position and used a 200mm lens, but even from behind, good results can be obtained with a 50mm. The drawing shows the area in play with the positions of the two photographers. Below: Indoor pools pose the same lighting problems as all other covered areas.

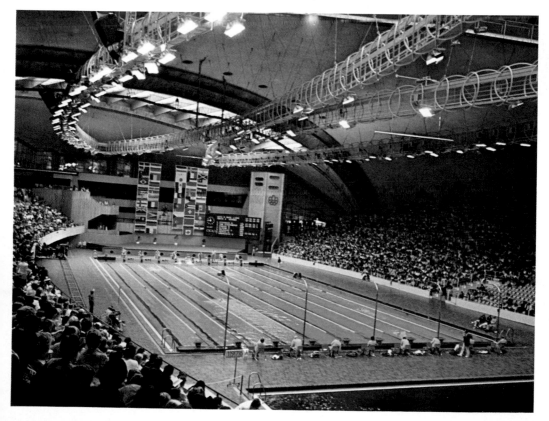

Klaus Di Biasi in flight

The use of a motor set to a frequency of three frames per second made possible this interesting sequence of Klaus Di Biasi diving from a 10 meter (33 foot) board at the Munich Olympics. The photographer used a 200mm lens to get close to the athlete. The bottom photograph had to be taken by following the diver as he came down, for he had already reached quite a considerable speed. It is difficult to say which is the most significant picture, but possibly it is the one at the top on the right showing his concentration after leaving the board. The photos should always include the space below the diver so as to give the viewer a constant reference point.

Splashdown

Diving is one of the specialties in sport that is as fascinating and spectacular for the public as it is difficult and frustrating for the photographer, who is restricted to positions below the action with only the bad lighting of indoor swimming pools available. Compounding the problem is the fact that it is so difficult to capture all the successive phases of a dive in one single photograph. The photograph on the right is a good example of a creative description of this event. The perfect entry made by the young American Kathy Flicker (14 years old) was taken with a camera encased in a glass box, which enabled the photographer to frame the areas above and below the water surface. The shutter was operated by remote control and the different levels of brightness on the two halves were reduced by using two powerful electronic flash guns.

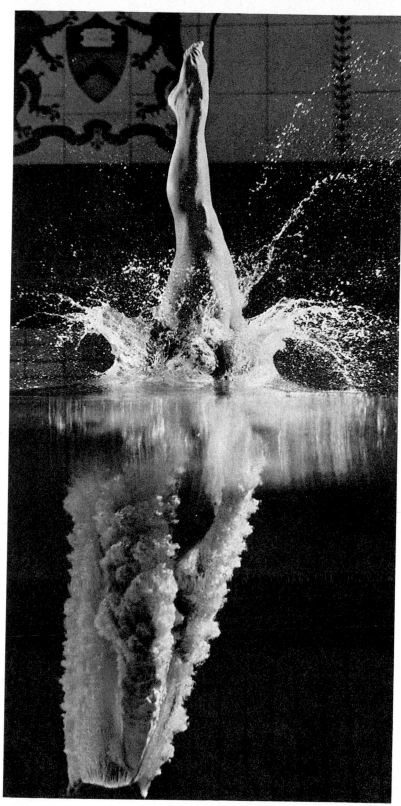

Tennis

The sport of tennis offers a photographer a series of excellent shots, whether played on well-trodden red clay, on perfectly mown English grass, or on an artificial turf, for dynamic pictures can be composed within the classic linear frame of the court. All the basic moves in a tennis match culminate in certain characteristic figures: the serve, forehand, backhand, volley, or smash, and it is always best to capture these moves at their peak so as not to show the players in meaningless poses. It is also very important for the success of the photo to catch the ball at just the right moment, though it travels at very high speeds; blurring of the racket often emphasizes the dynamism of the actions in play. The three elements that need to be composed correctly are the player, the racket, and the ball. You can use a 200mm or 300mm lens from the sides of the court or from the front rows of the spectators to fill the frame with the player. One part of the game that photographs well is the serve. The picture can be taken just before the ball is tossed, when the server's concentration is at its most intense; or when the ball is at its maximum height, with the player arched backwards; or, alternatively, the second after he or she has hit the ball, as the concentration required lends itself to excellent close-ups. A shot of a player poised to return the service, at the peak of concentration, is equally effective. Close-ups can be used to good effect during the changeovers.

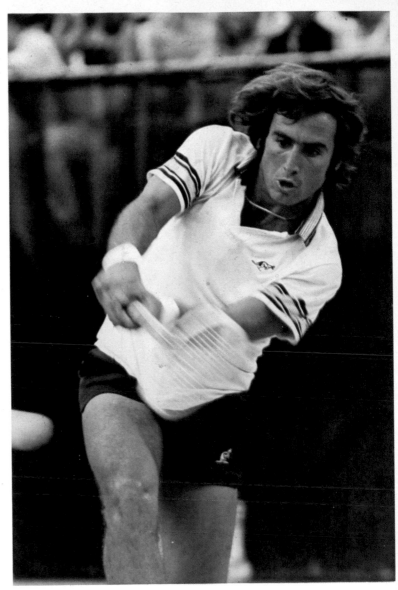

Up in the stands
Above: Eddie Dibbs making a powerful return. Left: A drawing of the court. The best positions to photograph the forehand and backhand are at the height of the net along the base lines, if you can get that close. A powerful telephoto lens (200mm and upward) can produce effective shots even from the other side of the court, particularly when the players are close to the net. A good position in noncompetitive events is from the referee's seat at the height of the net. From that point, an 80–200mm zoom lens or even a medium range telephoto is enough to obtain good pictures of the players standing out in relief against the uniform background of the court surface. The same effect can be obtained with a more powerful telephoto lens if you are shooting from the stands. The speed of the game makes it necessary that you use shutter speeds of no less than 1/500 second.

A challenge for the photographer

Right: The impulsive play of Jimmy Connors. Below: A view of the gallery from the stands during a match in the Foro Italico in Rome. Bottom: John Newcombe, taken with perfect timing during a volley at the net. The speed of the returns makes it impossible to center the ball at times in the shot, so you have to familiarize yourself with the style of the player to such an extent that you can anticipate the shots and release the shutter very slightly ahead of time. For effective pictures of Borg's two-handed backhand and Panatta's burning stroke, your speed has almost to compete with theirs. However, as tennis is such a popular amateur sport, excellent photographs can be taken on almost any club court where you can take advantage of the freedom of movement to find the best position.

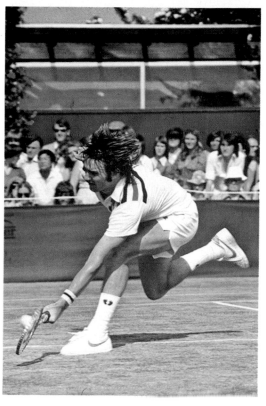

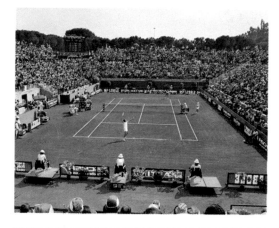

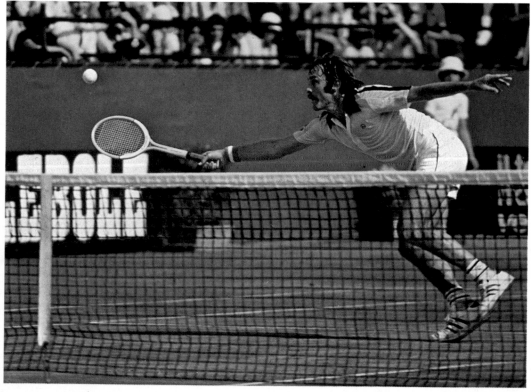

Team sports

Football, soccer, baseball, basketball, volleyball, and hockey all offer the photographer an endless series of themes and situations, both with shots of individual athletes and of groups, from midfield battles for possession of the ball to close-ups of a player hurt on the ground after a tackle, but you should always remember the frame of the match when taking photographs of team games. The photograph on the right was taken during the 1970 World Cup in Mexico City immediately after the 4–3 goal against Germany that secured Italy a place in the final against Brazil. The photograph has captured all the atmosphere and emotion of that unforgettable afternoon: it shows Rivera's incredulous delight after having scored the goal in overtime and Domenghini's triumph as he rushes to embrace his colleagues, looking as though he could have hugged all the fans, contrasted with the impotent rage of the German goalkeeper Mayer and the disappointment on the face of Beckenbauer as he realizes that all is lost.

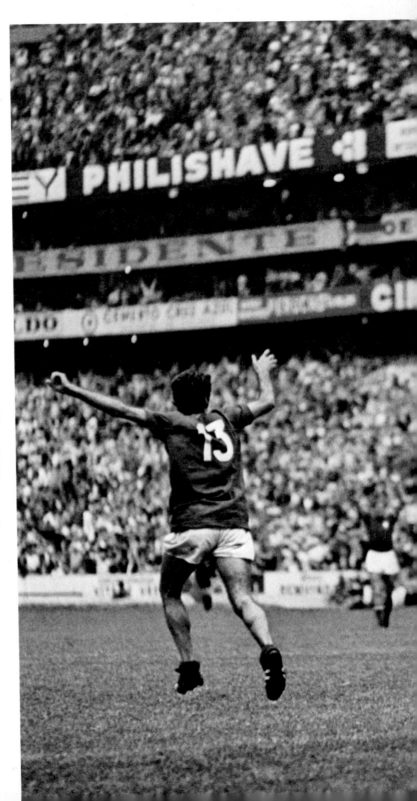

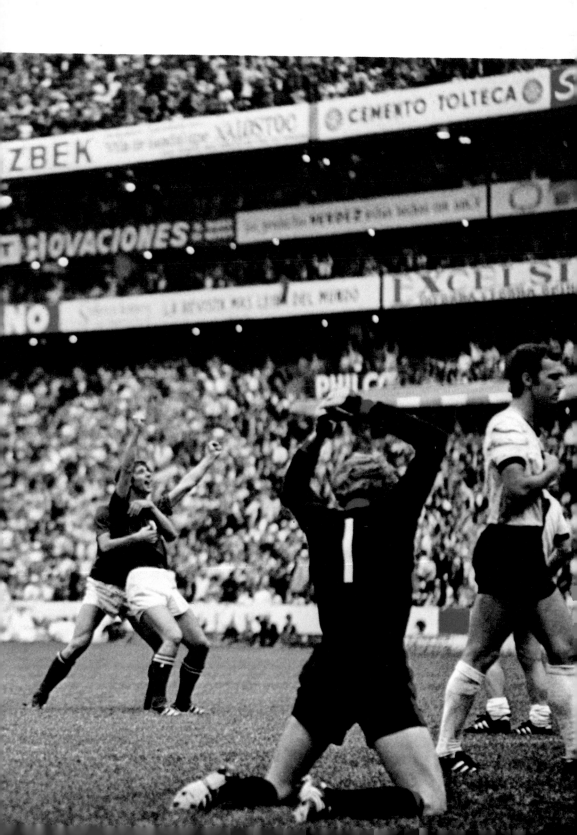

Soccer: 90 minutes of passion

One of the most popular and widespread sports in Europe is soccer, followed by millions of fans every season during September through May. Throughout the 90 minutes of each match, the minds and muscles of the 22 players, as well as the eyes and hearts of the supporters, follow every move of the ball on the field, where the action builds up and vanishes in intricate patterns as the players try to get the ball into the back of the opposing team's net. The game moves very quickly and follows no set pattern, testing the photographer's reflexes and ability to anticipate what is going to happen. The best position for photographing the peak moment of a match, the goal, is from the sides of the goalmouth, where professional photographers vie elbow to elbow for room. The speed of the action requires maximum possible depth of field, with a minimum speed of 1/500 second and short focal lengths. If you have a good position, the 50mm or 80mm lens gives the best guarantee of a clear shot, with no need to lose precious time by

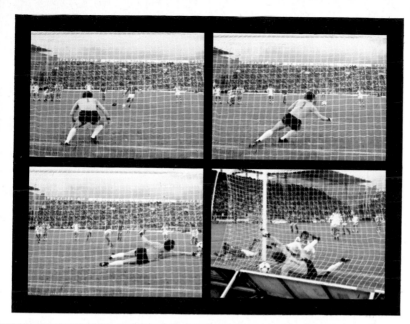

The thrill of a goal

Left: The full sequence of a penalty goal kicked by Paolo Rossi. The goalkeeper cleared the ball the first time, but Rossi kicked it back into the net. A motor is useful for this kind of account. Bottom: A powerful goal kick during the Holland-Argentina World Cup Final in 1978, taken from an original angle midfield with a powerful telephoto lens Opposite, top: Two close battles for possession of the ball. A 300mm telephoto lens or an 80–200mm zoom are ideal for this kind of shot. Opposite, bottom: The crowd of photographers at the beginning of a championship game when the players come onto the field. Games with less important teams on suburban fields give amateur photographers their greatest opportunities.

checking the frame and focus while the player is shooting at goal. The strain on the players is greatest at this stage of the game, and a long field will enable you to capture the interesting relationships between the players, their meaningful expressions, and contrasting emotions. It can also be interesting to get behind the goalkeeper during goal kicks and penalties so as to be able to photograph the defensive dive. The position of the ball is very important when you take the picture, but it takes experience to be able to time the shot perfectly. Releasing the shutter as soon as the player has kicked the ball usually arrests it in the right position, in the air a few feet away from the player. Using a motor or a winder can also be useful to create interesting sequences. With a longer focal length, preferably a 200mm or 300mm, since they are more manageable and can be used freehand, you can capture fascinating midfield battles, fouls, falls, and other details, which

are often very expressive. For quick changeover of the focal length, it is better to have two camera bodies. Powerful telephoto lenses used from ground level enable you to isolate certain players from the rest of the group and give the photo a more individual and human interpretation, as the attention then centers on a different plane, such as the disappointment or enthusiasm of a player who has followed a move through from the other side of the field to the goalmouth; or the grimace of an attacker brought down by the other side's defense; or even the imperious gesture of the referee reprimanding a player for fouling. Other shots useful in making up the full story of a match are of the supporters, with their excited, uncontrollable, and often violent fervor in the stands.

Seeing in a new light
Photographs of any popular sport like soccer can be stereotypical and run-of-the-mill, largely because there is a flood of pictures on the subject published every day in the press. On close examination, these routine shots are all the same apart from the colors of the uniforms and the importance of the match. The reason for this is that the agency photographers who follow the important games are obliged to work to strict deadlines to satisfy the requirements of the sporting press, which is not very tolerant of personal interpretations. Every now and again, though, a photographer manages to come up with something original.

Right: A classic and well-structured photograph of a goal. The goalkeeper is beaten and there seems to be nothing left to stop the opposing player from getting to the goal. Below: The use of a fisheye lens and the perfect choice of shutter speed have produced a very original shot of the same action, showing the ball thudding into the foreground, taken with a remote-controlled camera at the back of the net.

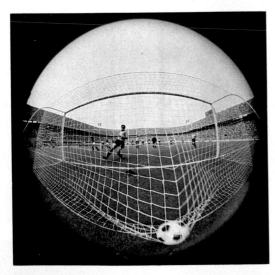

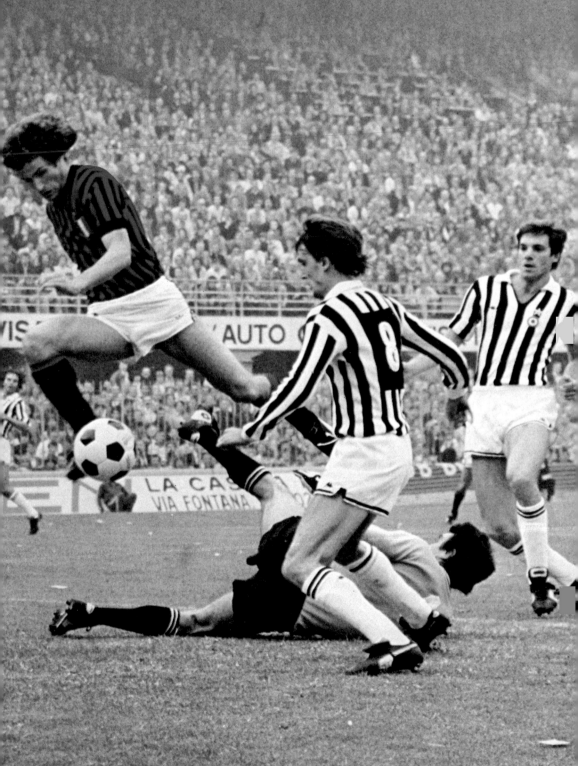

ts in frame

its players padded and
ng like giants or medi-
eval knights, football is one
of the most photogenic
sports today. Two camera
bodies are essential for a
well-equipped kit, one with
an 80–200mm zoom lens to
follow all the stages of the
game quickly, and the other
with a 300mm telephoto lens
to take close-up shots of the
players. Shots taken from a
low angle enable you to
capture the players against
a background of the sky,
thus creating an effective
monumental effect. On a
good sunny day, you can
work at 1/500 f/16 with a
400 ASA film.

Above: The two opponents
face each other while the
ball is brought into play. The
drawing shows the field with
certain recommended posi-
tions for the photographer
near the goal line and the
line of scrimmage. Opposite:
A halfback is tackled near
the goal line.

Football

Football is one of the
most popular team
sports in the United
States and has a wide
following in Canada as
well. Compared to soc-
cer, the game proceeds
in a rigidly patterned way
and action is not continu-
ous. This allows the pho
tographer to know when
the action will be taking
place; but the game is
such that he can never
be certain what the out-
come of a particular play
will be. Photographically,
some of the most inter-
esting moments come at
the line of scrimmage as
the opposing front lines
come into contact, and
when the ball carrier is
tackled. The end zone
area can be fruitful for
the photographer when a
team is threatening to
score, both for intensity
of action and for the
reaction of the players
after a touchdown. Pass-
ing plays are often dra-
matic, but the
photographer must be
something of a prophet
to have the receiver in
his viewfinder at the
proper moment. The
players' bench offers
good views of the color-
ful, massive uniforms
and of the players and
their moods. General ac-
tion shots are improved
by varying the details,
and a zoom is particular-
ly handy from the
sidelines.

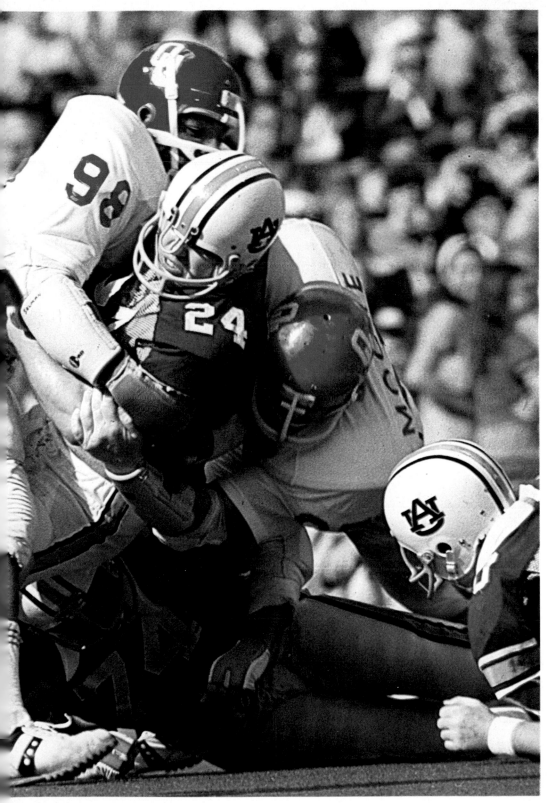

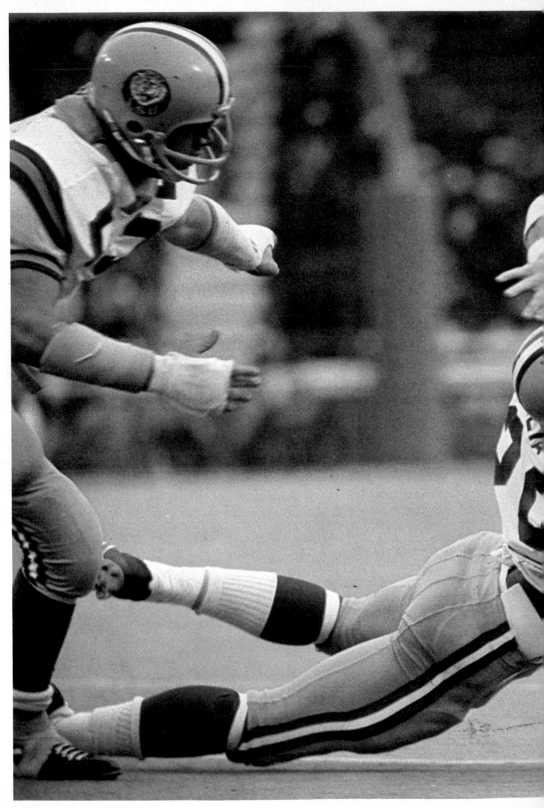

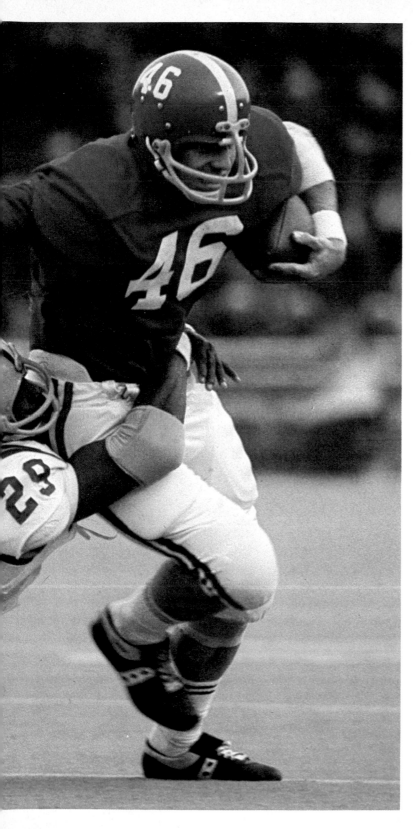

A relentless tackle

A perfect choice of shutter speed and an equally inspired frame are the features of this well-structured photograph, which successfully involves the spectator emotionally and catapults him into the heart of the action. The 400mm lens has brought out the players against a clean, uniform background, and the shutter speed of 1/500 second has frozen the tackle at its most significant point, with the players in a position that effectively conveys continuity of action and all the violence and competitiveness of the game. The best professional photographers committed to football experiment with a variety of interpretations. For two equally effective but completely different ways of seeing the action through the lens, compare the photograph on the right with the one on pages 48 and 49 taken by Ernest Haas.

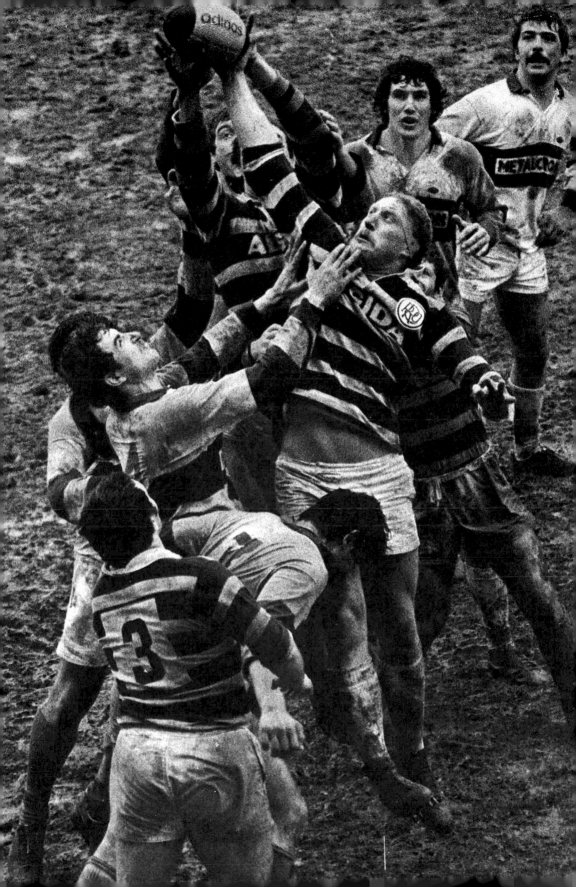

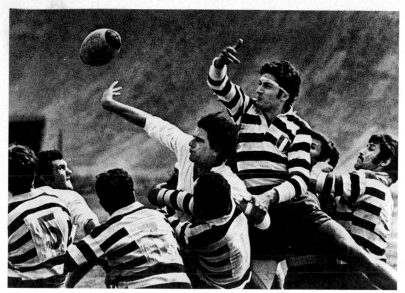

Useful advice
Left and below: Action-packed scenes of a rugby match, a sport that can be photographed equally successfully in color or in black and white. Recommended equipment includes two camera bodies with lenses from 80mm to 300mm to cover the widest range of situations possible. An 80–200mm or a 75–150mm zoom lens gives the greatest flexibility. The best photographs of the most spectacular moments, such as a scrum down or line out (opposite), are taken from a slightly raised position with a good telephoto lens. The drawing below shows the field with the opposing goal lines.

Rugby

Rugby is an older game similar to American football, but it offers certain features that make it just as interesting for the photographer. The most frequent mistake found in photographs of rugby is a lack of sufficient characterization, so that some photographs are difficult to distinguish from the more common photographs of soccer. In rugby, two teams of 15 players attempt to score by grounding the ball over the opponent's goal line or by kicking it through an H-shaped goal on which the crossbar is 10 feet high. The players can kick, carry, or pass the ball to advance it, but they cannot throw it forward. The team gets four points for a "try" (similar to a touchdown in football) and the right to a conversion place kick which, if successful, adds another two points to the score. Rugby is a fascinating sport and also a very demanding one, requiring great physical effort on the part of the competitors. This is to the

photographer's advantage, for it offers numerous opportunities to depict the intensity of the game. As with football, rugby matches take place even under adverse weather conditions, and this makes possible good photographs of the players all covered in mud and tensed with effort on a field that is a sea of mud. Under these conditions, details such as the shoes, leg muscles, shorts, and shirts spattered with mud, as well as facial expressions and action shots, make excellent photographs. A zoom lens is useful to enable you to alternate quickly between group shots and detail shots, which bring the spectator right into the world of the player. By situating yourself in a position above the field of play with a good telephoto lens, you can get geometric compositions of the scrum (the head-to-head scrimmage between the forwards of the two teams to put the ball in play) against the green background of the field.

127

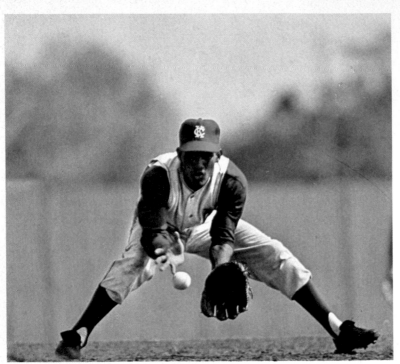

The photographer and the field

Baseball has one great advantage for the sports photographer: The most exciting and dynamic moments all take place at certain fixed points on the field, which facilitates the use of long focus lenses.

Left: A photo taken at just the right moment before the infielder scoops up the ball. Right: All-Star pitcher Denny McLain in action for the Detroit Tigers. A 600mm telephoto lens has "squashed" the distance between the pitcher and the batter (who are in fact 60 feet 6 inches apart), projecting the onlooker into the heart of the action. The foreground's being out of focus is not at all distracting and actually helps to frame the picture, and the ball in midair brings out the depth. Below: The drawing shows the field with certain recommended positions for the photographer.

Baseball

The national pastime of the United States, baseball is a major spectator sport in Japan and enjoys wide popularity in Central and South America. Softball, which was derived from baseball, is also widely played and presents many of the same features to the photographer. Because of the large field of play and the fact that the players are spread out over much of the field, the photographer is well advised to direct most of his effort toward capturing the details of play. Most of the action will take place in the infield, with the classic duel between pitcher and batter holding center stage. Interesting photographs can be taken of the pitcher during the various phases of his motion—from capturing his concentration as he looks for the signal from the catcher, to the moment of follow-through as he watches his pitch in flight with intense anticipation. The batter uncoiling in a powerful swing is also a good subject for the baseball photographer. Action on the basepaths can yield exciting pictures, especially when a runner sliding into base makes the dust fly. Compared with fast games such as soccer or football, in which the direction of play changes quickly, you can concentrate in baseball on certain areas of the field (the batter's box or pitcher's mound or the three bases) so you can pre-focus—even with critical telephoto lenses such as the long focus— and you can also mount the lens on a tripod. But the speed of the action at these points requires fast exposure speeds to arrest the ball in flight.

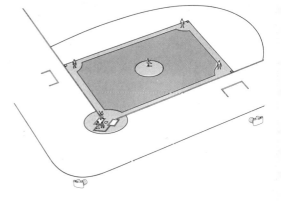

The geometry of the pitch enables good shots to be taken from the stands behind the batter; there are good opportunities for sequences of certain moves such as a pitcher's delivery or a runner trying to break up a double play. From a position behind the batter, using a good telephoto lens, you can frame both subjects: with

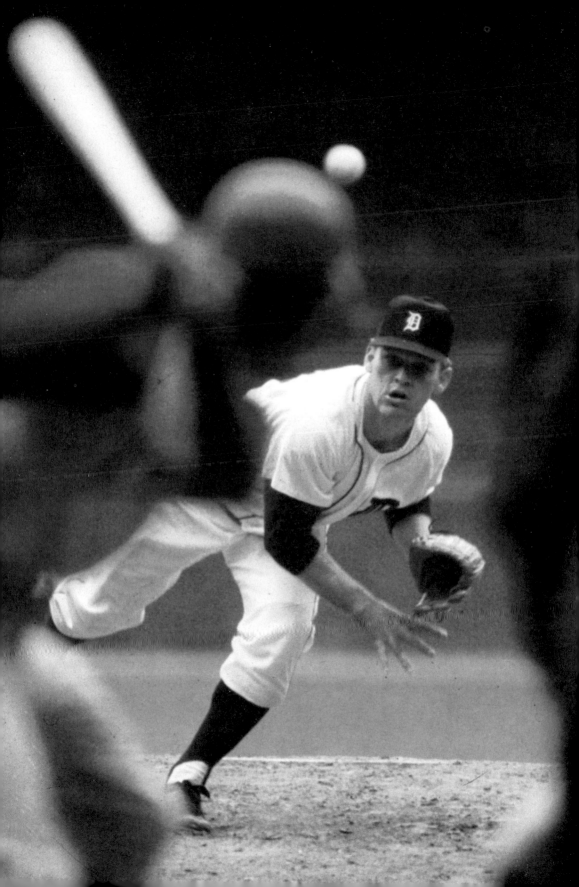

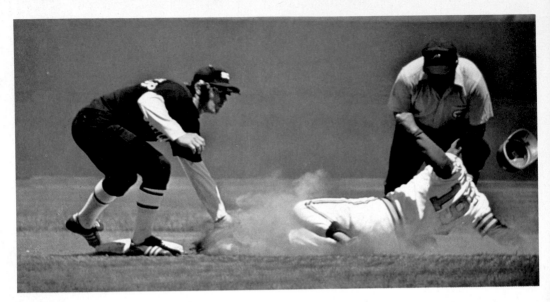

Setting up a telephoto lens

An attempted steal, where the runner slides successfully under the throw, is one of the most spectacular plays in baseball. Once you have chosen the base where your intuition tells you the action will take place, all you have to do is to set the focus carefully and wait. It is not even necessary to have a motor to take very dynamic shots.

Above and below: Two slides, one unsuccessful and the other successful. With a solid tripod and lenses ranging from 300mm to 1000mm, results like these can be obtained even from the box seats in the stands. Opposite, top: A shot of the batter taken from above. Opposite, bottom: Pitcher Vida Blue about to hurl a fastball, in a very three-dimensional image. The photo successfully conveys both energy and tension by capturing the dead point of the action. The ringing effect in the background shows that the photographer used a mirror lens.

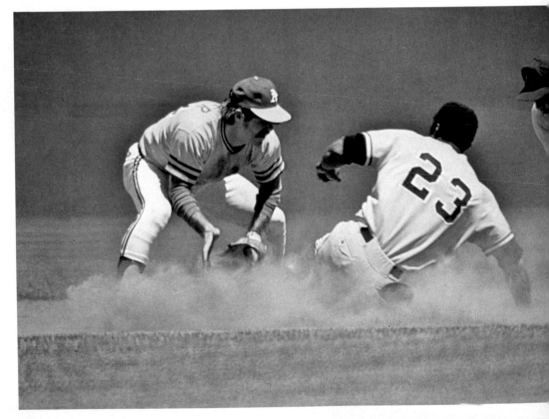

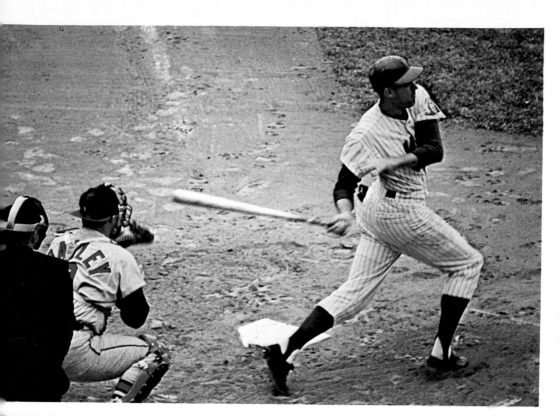

the pitcher perfectly in focus, the batter will become a confused, colored shape, enabling you to capture the most important, characteristic moment of this sport. Good, unusual shots can also be taken of the individual athletes, particularly the catcher, in face mask and chest protector, crouched behind the batter. Long, running catches in the outfield provide some of the most thrilling action of the game, but their unpredictability makes them very difficult for the photographer to capture effectively on film. The dugout is a potential source of good mood shots, as the players and coaches react to events on the field. The spectators, too, can be the subject of effective photographs, and can form a multicolored background to the action.

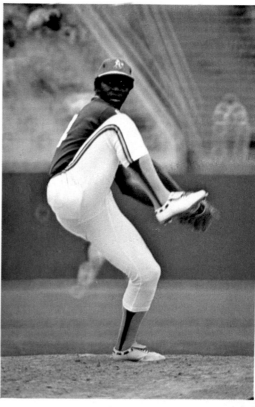

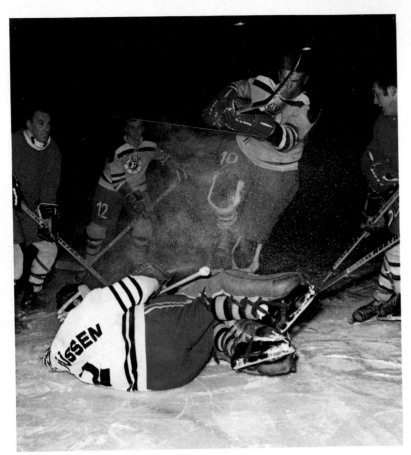

The use of flash

It is always better to avoid direct flash lighting, even in bad light conditions, as it usually produces a picture that is artificial and flat, making the whole atmosphere of the game unreal as the subjects in the foreground seem to move in total darkness. In these cases, it is better to use powerful flash lamps in strategic positions to back up the natural light sources. Flashes can now work in thousandths of a second and freeze even the fastest action; but the normal blind-type reflex camera cannot exceed speeds of 1/125 second, so this often causes double images on the negative. Faster speeds can be obtained with a central-shutter-type camera. Left: A photo taken with the flash positioned at very close range to the action. Opposite: A fast action shot of the goalmouth taken in ambient light.

Field hockey

Field hockey is very similar to soccer as regards the speed of the action and is played on a field 91 meters (100 yards) long between two teams of 11 players each in a match that lasts 60 minutes. The rules are also similar, so the photographer's best position is at the sides of the goal or near the corner on the sidelines. The size of the field makes it essential to use lenses of 135mm upwards, and good sensitivity film enables fast shutter speeds (1/500 second) to be used even on a cloudy day. The most interesting moments of the game generally occur around the goal area, which is a half-circle of 15 meters (16 yards) radius from the goalmouth. A characteristic and interesting moment of the game is the "bully" between two opposing players, who use their sticks to try to gain possession of the ball thrown between them by the referee after some infringement of the rules. Camera shooting techniques are very similar to those of soccer.

Ice hockey

The very uniform worn by the players, who are armored like ancient Samurai, suggests the violence and determination with which the two teams of six players each face each other, using their sticks to send the little hard-rubber puck hurtling towards the opposing net at speeds approaching that of a racing car: 180kph (112 mph). The players move quickly and nimbly on their skates and can suddenly stop, jump, and change direction, so hockey presents the photographer with all the problems of fast action. These problems are aggravated by the artificial lighting on the rink, which is normally adequate for speeds up to 1/125 second with 400 ASA film, because of the mirror effect of the ice. The best position is behind the goal, slightly off-center toward the corner, so that you can photograph the players as they approach. Bright lenses of medium or normal focal length are indispensable. The colorful garb of the players also adds to the photographs.

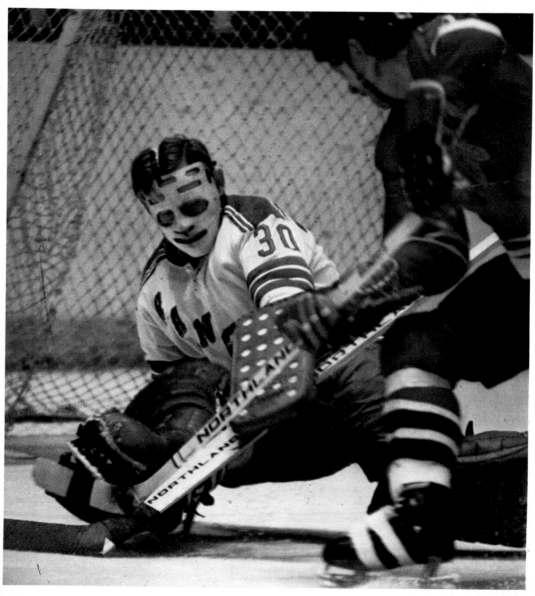

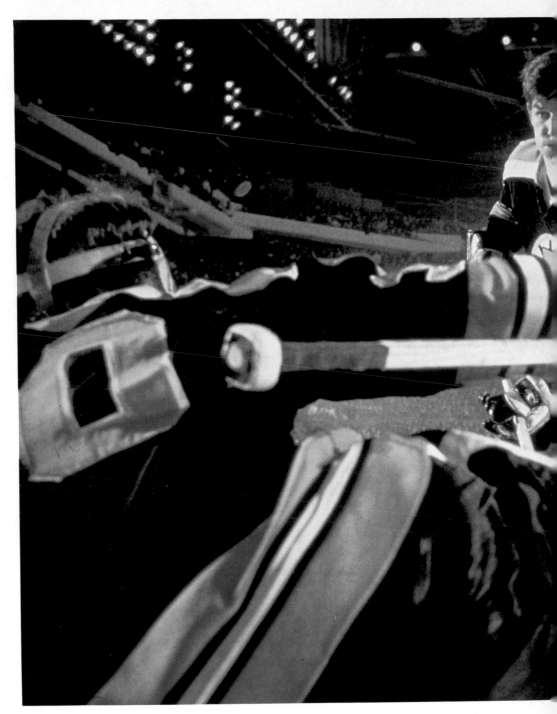

Attention to detail

Very often, problems arise which can only be solved with intelligence, inspiration, and imagination. To get this extraordinary shot, John Zimmerman had to make detailed preparations and get permission to place a motorized Nikon F with a 20mm lens inside the goalmouth. The remote control cable had to be dug into a channel in the ice so that the players could skate over it, and four large electronic flash lamps were synchronized at the four corners of the rink. The grimace on the face of All-Star defenseman Bobby Orr adds immeasurably to the picture, which required a great deal of patience to obtain. The most detailed preparation always pays off when dealing with the unexpected: A few minutes after the start of the game the lens was hit by the puck and had to be changed (Kodachrome 25 at 1/60 second f/8).

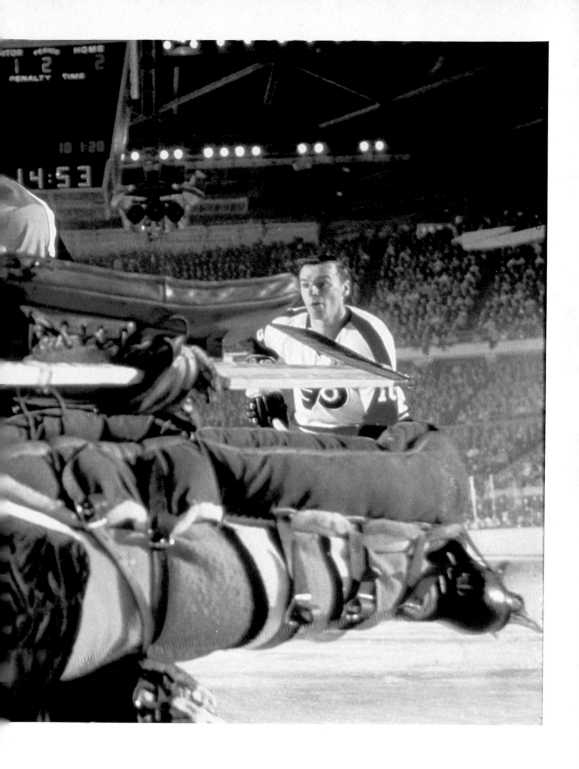

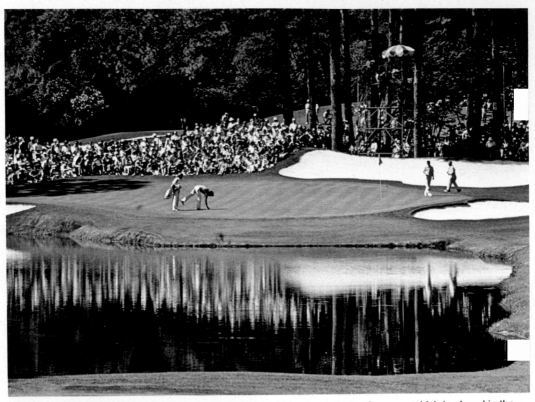

The green fields of cricket

This typically English game can be played on almost any large area of grass. Preparation of the field is simple: all you need is two wickets made of three stumps 4 inches (10cm) apart, with two bales on top. The wickets are 20 meters (22 yards) apart and are defended by the batsman. The sport is interesting from the photographer's point of view because of the excellent natural background frame, even though the game itself presents no particular emotions or dynamic situations: a game can last for an afternoon, a whole day, or even more. The best positions for the photographer are slightly at an angle behind or facing the batter. Similar problems as those found in cricket are also found in the game of fiollet, which is played in the Val D'Aosta in Italy, or in curling, a winter mountain sport played on ice with large granite stones that can weigh as much as 44 pounds.

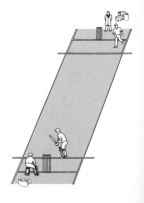

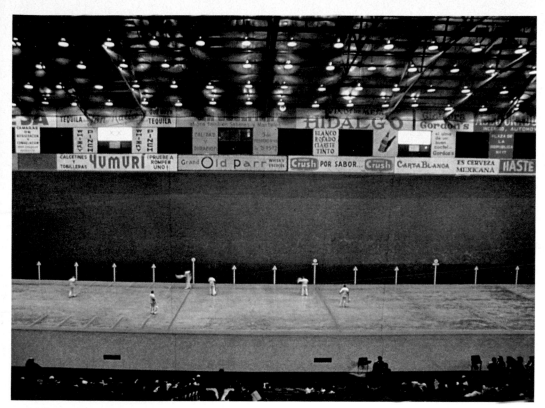

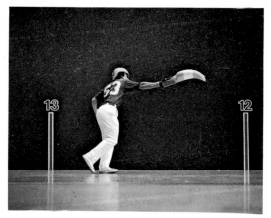

The elegance of cricket

Opposite, top: The well-kept green of a golf course furnishes the same elegant frame found in cricket, the sport of the English upper class. Opposite, bottom: A frontal shot taken with a 500mm mirror lens. The drawing shows the best positions on the field for the photographer, facing the bowler or batsman or at an angle behind them.
Top: The special indoor court used for pelota, taken with a 50mm lens from the spectator stands. Above: Close-up of a player. The most dynamic and original shots have to be taken from the court itself, and the artificial lighting, combined with the speed of action, can be used to obtain suggestive blurred effects with shutter speeds under 1/60 second. Right: A section drawing of the court, which is delimited on three walls only.

The lightning speed of pelota

Jai alai, which originated in the Basque regions of Northern Spain, is commonly known as pelota and is rapidly spreading through Europe and the United States, where many bets are placed on the results. The game is played on a special three-walled court, with the fourth wall made of glass, behind which the public sits. It is a stimulating sport for the photographer, but very difficult to photograph effectively, as you can only get good panoramic shots from the spectators' viewpoint and the light makes it difficult to use telephoto lenses. Ideally, you should get onto the sides of the court (during a training session perhaps) and try to take pictures of a player at maximum elevation. High sensitivity film and fast speeds are essential, as wicker baskets are used to launch the ball at tremendous speeds. Similar problems are presented to the photographer by other fast-moving sports such as squash, handball, and paddleball.

137

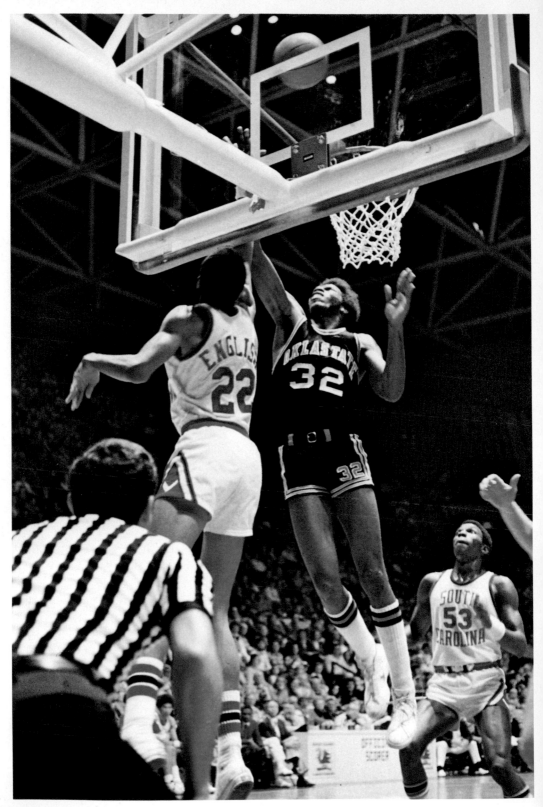

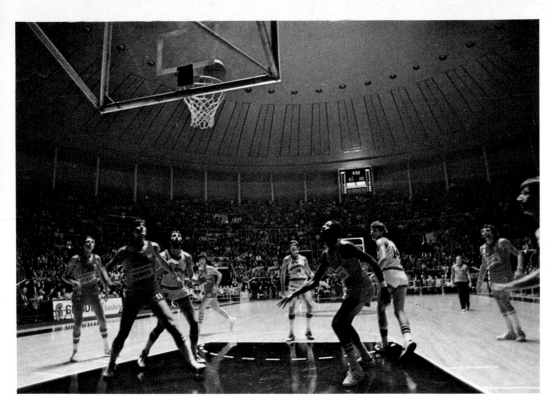

On the basketball court

One of today's most popular team games is basketball, which is mainly played on indoor courts, so the photographer's biggest problems are those of working in badly lit surroundings. The very nature of the sport, being a quick game with fast breaks, leaps, and passes, poses its particular problems. Because of the limited distance within which the action takes place and the closeness of the stands, you can use sufficiently bright medium range telephoto lenses such as the 80mm or 105mm to get excellent results. The most spectacular moments of the game are the attempts to score when the players crowd beneath the basket in almost a pyramid formation; the photographer can take excellent shots of this from below, using preferably a wide-angle lens such as the 35mm, 28mm, or 24mm to emphasize the formation and the height of elevation. A powerful wide-angle lens also reduces the problems of focusing. In these classic shots from beneath the backboard, with the players outlined against the natural background of the ceiling, it is better to catch the players at their moment of maximum elevation (the dead point of the action). This enables you to emphasize the spectacular effects achieved with the wide-angle lens and also to arrest the movement without having to resort to very fast shutter speeds, which would give you unsatisfactory results because of the limited amount of ambient light.

Lighting problems

For good results in photographs of basketball or volleyball matches, you must choose high sensitivity film and, if necessary, push the nominal sensitivity to its maximum, as this is the only way to be able to use shutter speeds fast enough to stop the unpredictable action. Artificial lighting creates great problems, as it often comes from different sources. To avoid unwanted dominant shades on color photos, it is better to do a few test shots and examine the possible use of correction filters. The type of lighting can vary greatly from the simple diffused-type of floodlights (which can give out almost white light) that are used for televised programs. Getting to know the court in advance is always a help in finding the best positions.

The human and the machine

On burning asphalt tracks, where vehicles shoot like meteors at 300kph (186mph), on land, water or in the sky, humans compete against nature, striving to increase their ability to move rapidly through space at almost impossible speeds. Both the human and the machine become one single unit, designed for a competition that began many years ago, when humans first discovered that a wheel can move faster than they can. The challenge of speed has dogged the sports photographer since photography was invented, but only recently has photographic technology given us the arms necessary to succeed. The headiness and fascination of speed are well-represented in this eloquent picture at right: using a wide-angle lens from just over a yard away, the photographer followed the racing car as it passed at an incredible speed, using a shutter speed that made the photo explode while retaining the sharpness of the driver's helmet.

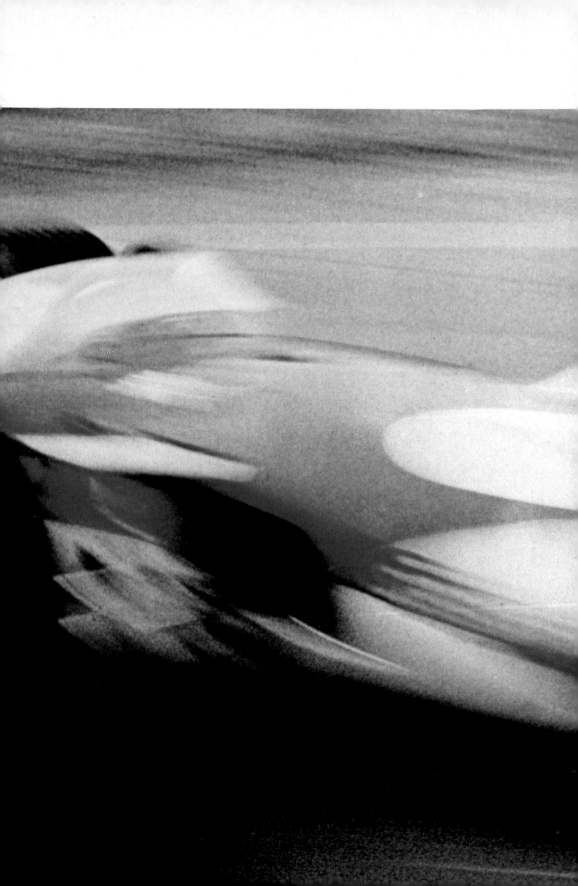

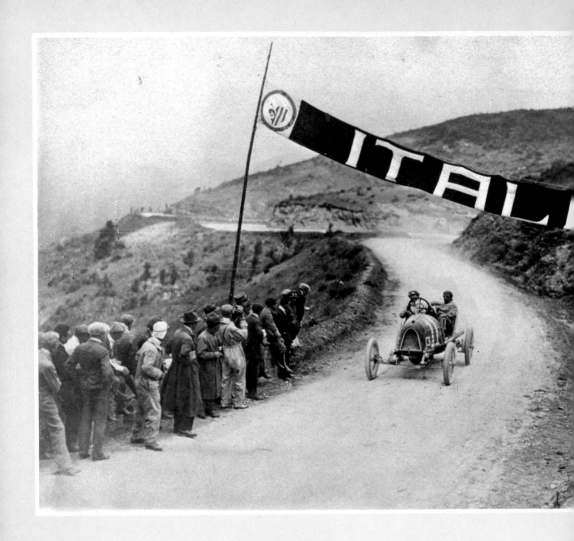

The record mile
The first motorcycle in history was a single-cylinder tricycle built in 1885 by the Germans Benz and Daimler; this machine was indeed a long way from the aggressive, aerodynamic racing machines of today. The photo shows the English rider Harry Martin breaking the speed record for a standing start mile in 1903. He broke the record on the Canning Town circuit with a time of 1:24.

Road races

Left: A photograph taken in 1920 which recalls the pioneering days of road racing: the Italian Consuma Cup, which preceded the famous Mille Miglia. Below: A photo taken by Lartigue in 1912 at the Parish Grand Prix. The curious oval effect on the wheels was caused by the type of shutter fitted on the camera (which had 9 × 12 glass plates) used by the genial French amateur photographer. The same phenomenon still occurs when photographing moving subjects with modern blind-type reflex cameras, although to an almost imperceptible degree. The deformation varies according to the direction of movement of the blind with relation to the movement of the subject.

The early reporters

This photograph is something of a symbol of the two great professions that grew in Europe at the beginning of the century: speed and photography. The caption that went with the photo (taken in 1906) read "photographer on the hood of a racing car." It appeared in a contemporary French newspaper to show the occupational hazards of the early sports photographers.

The challenge of speed

It is very difficult to represent in a photograph the force of a group of race cars speeding down a track. The machines register no emotion and do not change expression, so the only difference is one of engine revolutions, but the photograph remains the same: a splendid, aggressive but impassive machine that glides at 300kph (186mph) along the track. Even the driver is hidden, enveloped by the car and masked by a crash helmet, with no name, only a number, a symbol, or a sponsor. There are only two possible ways of effectively getting across the dynamism of a race: one is through use of the effect

of blurring and the other is by photographing a countersteering car on a bend or in a skid to convey the sense of movement. Good results can be obtained by panning, following the car in the viewfinder as it passes by, preferably with a medium range telephoto lens such as the 100mm or 200mm, which will clearly pick out the shape of the car on the track. Keeping the camera still (with speeds no more than 1/250 second) produces interesting colored streaks conveying the speed with which these meteors pass by the spectator stands. A frontal shot, however, with a very powerful telephoto lens of at least 500mm, is the most successful method of con-

The Monza circuit

veying the feeling of motor racing as the modern equivalent of medieval tournaments.

The drivers are enclosed in a rocket-shaped armor built with a science-fiction technology, and they are propelled at

incredible speeds by the thrust of monstrous engines of over 500hp, trusting to just the tenuous grip of the enormous tires on the track. The "squashed" perspective of a telephoto lens creates an almost two-di-

The 200 mph circuits
Frontal shots taken with very powerful telephoto lenses are undoubtedly the most exciting, particularly when the cars are braking or accelerating into and out of a bend. Left: Villeneuve and Scheckter's Ferraris going into the chicane at Monza in 1979, framed from some distance away with a 1000mm telephoto lens. Shots of this type are more successful when the focus is preset. Below: A competitor having to withdraw from the race because of a break-down. Bottom: Another effective frontal shot at the Nurburgring "jump." A series of photos all taken at one significant spot gives an interesting analysis of the handling of the cars and the style of the drivers; often, when it is impossible for you to change position, it can also make up an excellent photographic theme in itself.

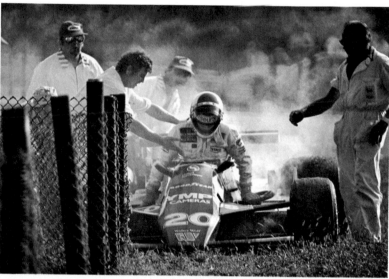

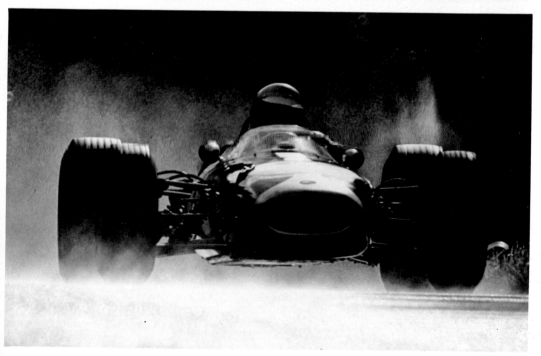

mensional pattern of the formation of cars screaming towards the onlookers, and the best position for this kind of shot, which also captures the delicate phases of braking and accelerating, is from a bend, where the technical interest is the greatest. All kinds of unexpected things happen: cars overturn, pass each other, or crash, and on each circuit from Monza to Monte Carlo there are particularly insidious stretches where the photographer might be positioned to catch something out of the ordinary.

It is a good idea to go down to the track during trials when you will be less restricted in taking the photographs, checking passes, and framing. Amateurs and professionals alike can have the same opportunities at rallies, drag races, dunebuggy-meetings,

speed trials on normal roads or off the road. Equipment is no problem if you find the most favorable positions, having studied the route in advance. At rally speed trials, the most spectacular position (and also the most dangerous) is where the cars come out of a bend, skidding in countersteer and throwing up gravel, earth, or snow. Excellent results can be obtained with a 100mm telephoto lens, and some very good shots can be taken of the cars in the air. The ever-changing countryside framing the rally is an important element to be remembered by the photographer, for it adds meaning to the competition. Since the roads are obviously closed to traffic during the trials, you have to familiarize yourself with the competition route in advance in order to get the best positions.

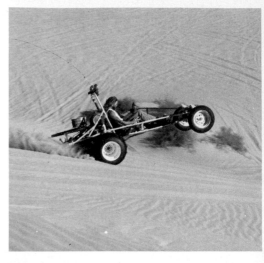

Rallies and off-the-road races

Amateur and professional photographers alike have equal opportunities in competing for the best picture at road races, off-the-road events, autocross, and dragster exhibitions. The choice of position counts for a lot more than technical equipment, and there are no special restrictions on the movements of nonprofessional photographers at these events.

Above: Spectacular dunebuggy races are organized on the sand dunes of the Atlantic and Pacific coasts. Below: Speed trials at the Monte Carlo rally, which takes place every year on the icy roads of the Maritime Alps. Opposite, top: An original "interpretation" of the famous East African Safari. Opposite, bottom: Two Citroen Dyanes taking part in an exciting autocross meeting on an unknown track.

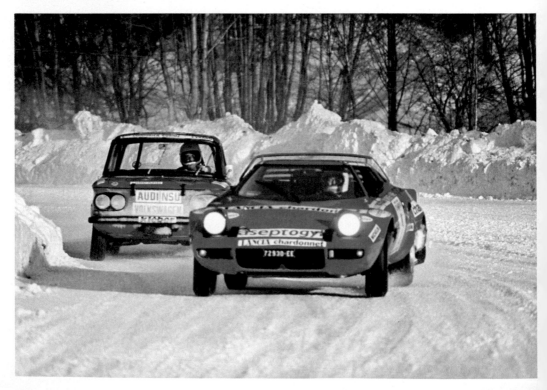

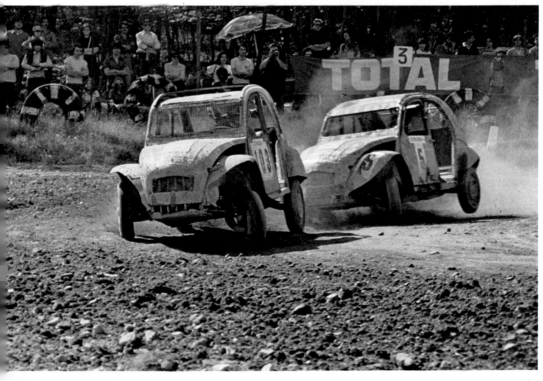

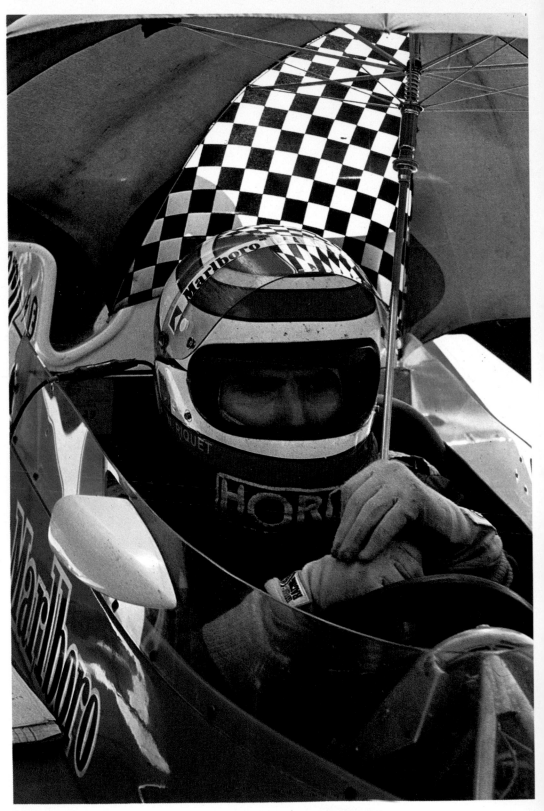

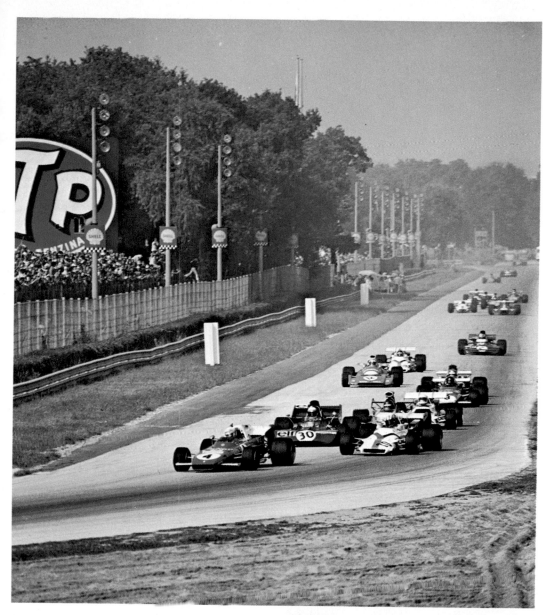

In the pits

All the big races, particularly Formula 1 races, have their picturesque entourages of mechanics, drivers, spectators, reporters, and publicity people. This colorful assortment of people animates the pits, where the roaring cars are attended to before the start or during the race. There, the mechanics work miracles, changing tires or replacing parts in record time. In the pits, the photographer can capture the hectic activity that takes place behind the scenes as the cars flash by, and so can take thousands of unusual or original shots.

Opposite: The Brazilian driver Piquet waiting in the pits at Monza. Right: Mario Andretti's Lotus. Above: A classic shot taken from above a tightly packed group on a bend during the first few laps. The compressed effect created by the telephoto lens increases the drama of the pictures and directly involves the onlooker.

On two wheels

The team of athlete and machine is particularly expressive in motorcycling, where the driver seems to control the roaring, two-wheeled rocket as a jockey does a nervous yet responsive horse, ready to obey the slightest command. Aerodynamic design has fused the driver and the machine into a single protected, polished, and aggressive unit like something out of science fiction. Only accredited professionals can get inside the network at the tracks and circuits and can sometimes set up powerful telephotos on tripods on special platforms; but nonprofessionals have to settle for the normal position on a bend, so it is better to have a good view of as much of the track as possible, including, for example, the point where the bikes round a bend or where they accelerate away. Since a motorbike is smaller than a car, a telephoto lens with a longer focal length (or a doubler) is useful to pick out individual competitors as they try to overtake or lean at a dangerous angle. The presence of the rider is much more vivid at these times, for it is real and active, an element that is sometimes missing in motor racing, where the gliding stability of the

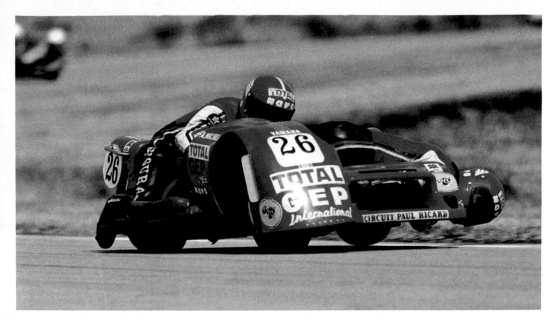

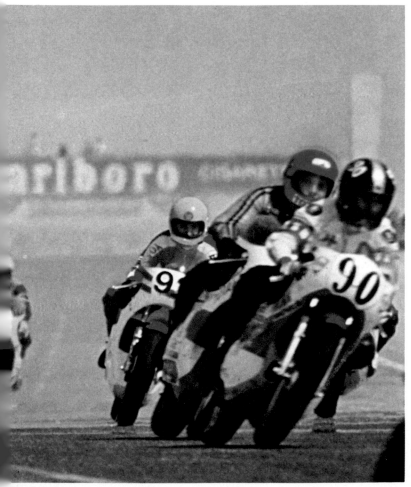

The skill of the cyclists
Opposite, top: A daring rider skillfully accelerating out of a bend. Left: The tightly packed group in the first laps comes into a bend after the straight past the stands. A frontal shot with a powerful telephoto lens shows the angle of the bikes on the bend most clearly. Above: A sidecar combination with the second hanging over the side to compensate for the roll of the bike; this is a perfect example of complete mutual understanding and trust. The speed at which the bikes pass by makes it necessary to set the focus in advance. The angle of the bikes is greatest when they follow an ideal arc along the inner edge of the track.

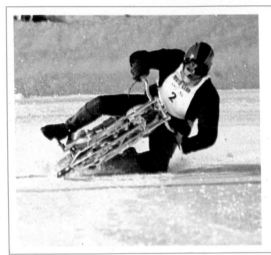

Speedway
This sport originated in America and is a spectacular exhibition of courage. The machines are very powerful, with no gears or brakes, and are raced over ice or ash oval tracks by the riders, who skid round bends using their metal reinforced boots as brakes. The public can watch from the sides at close range, so a normal lens and a medium range 100mm telephoto lens are all you need. Some problems may be found with indoor or night competitions because of the usual difficulties of bad lighting.

cars often gives the sensation that everything is remote-controlled, as on a model track. Panning is a very effective technique for conveying the sensation of speed in motorcycling. The shutter speed should be chosen in accordance with the results you want to achieve, the speed of the bike, and the angle of movement relative to the film surface. With long focal lengths and subjects moving at full speed, 1/250 second gives good results. Motocross and speedway are even more

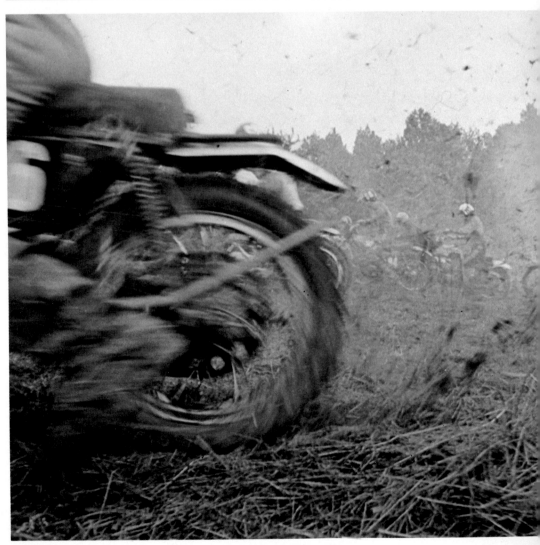

spectacular than track racing, as the drivers fly through the air and skid around bends skillfully or recklessly, using their heels and accelerators to maneuver over the rough open ground, testing both the mechanism of the machine and the driver's strength and reflexes. Within certain limits, the photographer is not restricted in his movements along the track at motocross meetings and can get close to the most interesting points. Those sections of the course that may cause difficulty can be anticipated to a large extent, as can the reactions of the machines and the drivers, so the photographer's task becomes much easier as he or she can focus on certain key points of the course in advance. But you must pay constant attention to what is going on so as not to miss the numerous unexpected events that take place regularly throughout the race, for the slightest hesitation on the part of a driver at the most exciting moment can often result in spectacular but costly pile-ups.

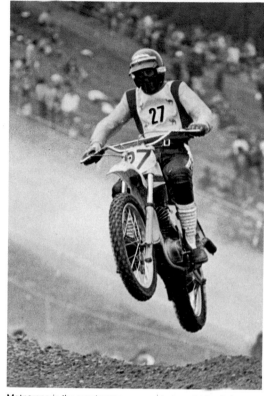

Motocross is the most popular and spectacular of the motorcycle sports and is a favorite with sports photographers for, among other things, the freedom of movement along the track. Above and below: A bike flying through the air and another plowing through mud, both taken from close range with a 135mm. Try to position yourself where problems are likely to arise.

Waterskiing

Many years ago, it may have seemed impossible that a person would be able to skim swiftly over water, only lightly brushing the surface; but now, with the aid of a powerful motor boat, a tow rope, and a pair of skis, anyone with an aptitude can do it. Waterskiing has very rapidly become a competitive sport with its own rules, champions to imitate, and records to break. Photography can capture the most spectacular moments of this thrilling sport executed on the smooth surface of a lake or in the rougher waters of the sea: the sureness of an athlete in making a turn in the slalom, taking off for a jump, or caught in a fall. The best pictures are taken with a medium range telephoto lens from the stern of the boat towing the skier, but obviously this is possible only in noncompetitive events. Very fast shutter speeds of no less than 1/250 second are needed to avoid blurring the image with the speed of takeoff, and you must also avoid leaning on any part of the boat, as it can transmit the engine vibrations. If you are photographing an exhibition as an outsider, the best thing to do is to position yourself with the judges or get aboard a support craft, particularly if it is moored by a buoy that the competitors must pass around regularly. A clear yellow filter can be useful with black and white film to bring out the contrasts, or a skylight filter with color film. If you are unable to position yourself close to the buoys or the takeoff board for the jumps, you will need to use a super-telephoto lens.

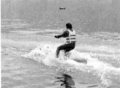

Flying on water
Waterskiing offers the photographer a variety of subjects, particularly when the athletes perform perfect geometric turns around slalom posts or balletic figures in freestyle. The biggest problem is that you normally have to follow the action from a great distance away.

Top: All the energy of this picture lies in the incredible position of the skier, who seems to be suspended horizontally above the water. The sequence above, showing the takeoff, was taken with a motorized camera. The drawing below shows the tortuous track of a water slalom event.

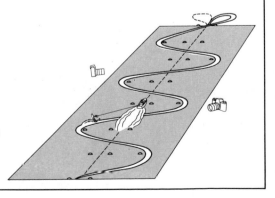

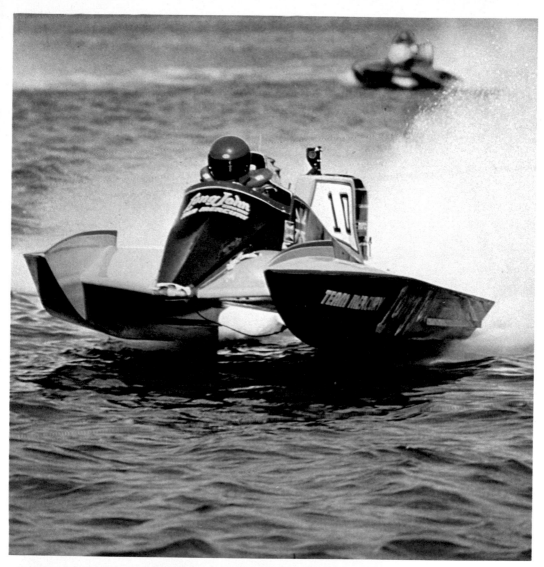

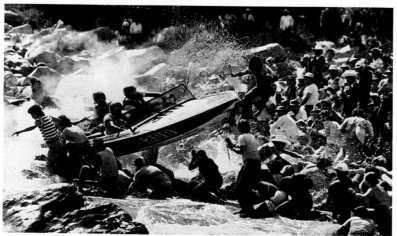

Speedboat racing

Speedboat races take place on the calm waters of a lake or a river basin. The best and most significant pictures show the boats half covered with spray, going around the buoys that delimit the course. Very powerful telephoto lenses are necessary to bring the subject into close range if you work from the shore.

Above: A very fast speedboat taken with an almost frontal shot. Left: This dramatic photograph arrests the startling instant when a speeding boat went out of control during a race in Mexico in 1979. The accident resulted in death for a photographer and a spectator who were hit by the boat when it struck shore.

155

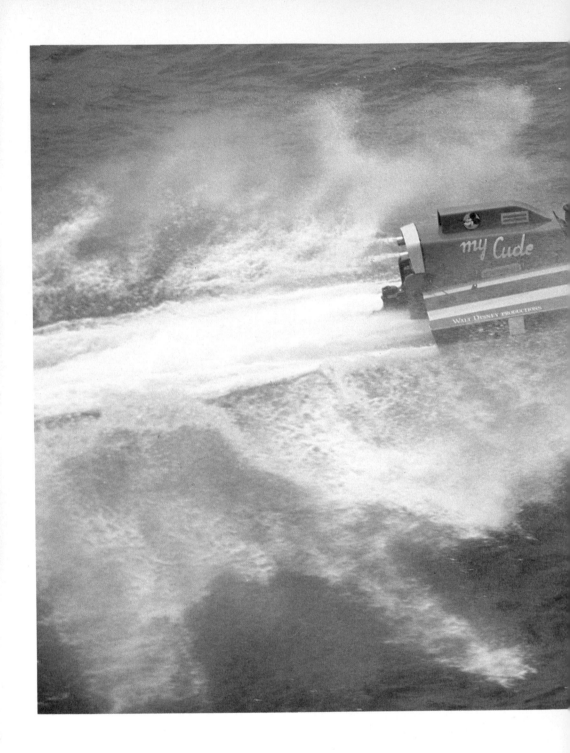

The offshore monsters

The monstrous offshore motor boats that carry over 1200 hp—the Formula 1s of the sea—can comfortably cover long distances on open water. It is a difficult sport to photograph and follow because of the speed of the boats and the nature of the course. Nearly all the best shots are taken from a helicopter (as above and in the drawing), but this angle does tend to squash the boats onto the blue surface of the water, with the result that any sense of movement comes only from the turbulence of the wake. A shot taken from a low side angle, however, enables you to show the boats at their most spectacular, leaping off the waves and flying through the air. Although a rough sea makes the pictures even more thrilling and dramatic, it will complicate the shot a lot, whether you are shooting from a plane or from another boat.

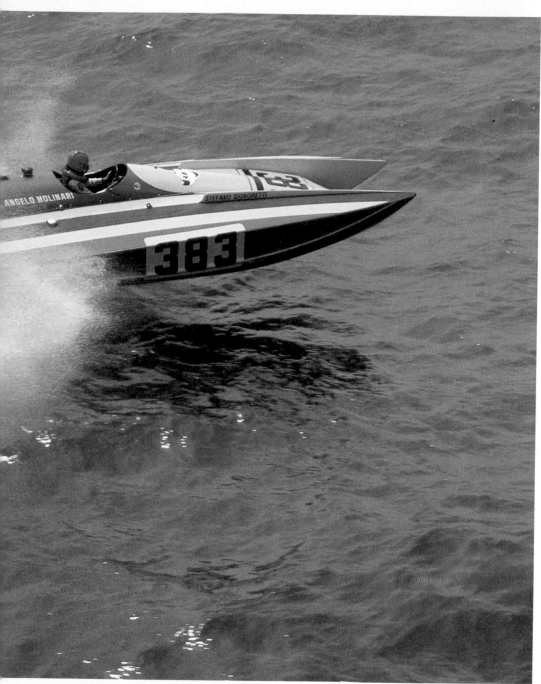

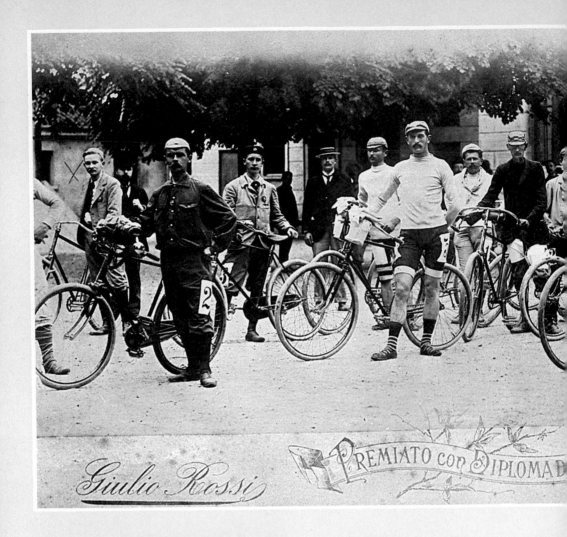

Giulio Rossi Premiato con Diploma d...

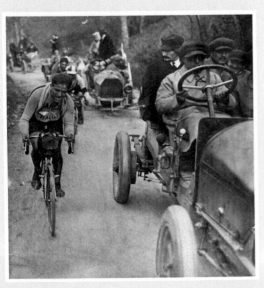

Pioneers on two wheels

Cycling boasts a long competitive tradition in Italy, which explains its popularity there with the public, particularly in the north.

Above: A number of riders in Milan in 1900, waiting for the start of a race. Left: A picture taken from a 1905 sports album showing the cyclist Giovanni Gerbi in the foreground with his spare inner tube around his neck during a stage of the first Tour of Lombardy. He won with a record average speed of 24.970kph (15.5mph), leaving the rest of the competition well behind.

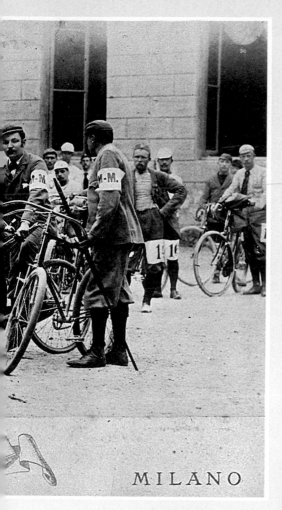

MILANO

Above: The Milanese rider
Gilberto Marey who was the
bicycle speed champion of
Italy over tracks in 1887 and
on the road over a distance
of 100km (62 miles) in 1887,
1888, and 1889.

A controversial photograph

The rivalry between the
Italians Bartali and Coppi
was strongly reflected in the
loyalties of the Italian fans
just after the war. Right: A
famous and much discussed
photograph taken by Valfrido
Chiarini from the Olympia
agency during a stage of the
Tour de France in 1952. Is
Coppi passing his drinking
bottle to his eternal rival or
vice versa? Interpretation of
the picture divided the fans
into two groups, each want-
ing to claim the generous
gesture for their own hero.
In fact, the bottle in question
was a bottle of mineral water
handed to Fausto Coppi by
the photographer just before
he took the shot.

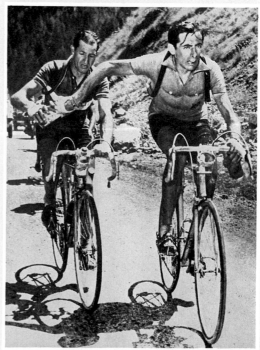

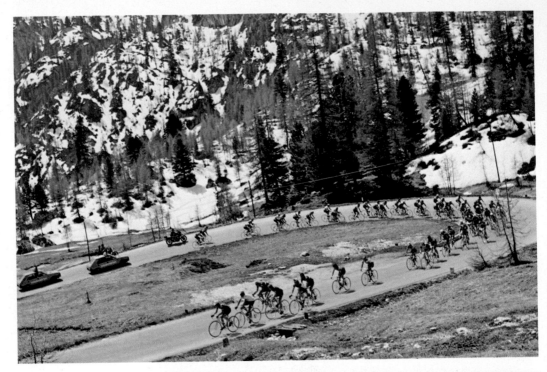

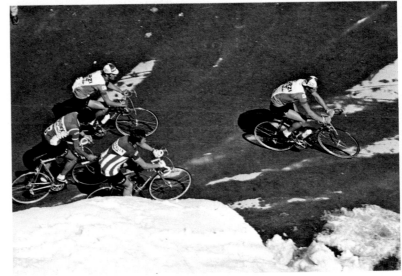

Above: A group of riders breaking up on one of the early hairpin bends of the Stelvio in a stage of the Giro d'Italia. Right: A good detail shot that effectively completes the panoramic one above.
 Opposite: A mechanical check during the race. The traditional entourage that follows the cycling world offers the creative photographer a variety of good subjects away from the action.

Champions on the bicycle

Road cycle races have in Europe traditionally attracted thousands of spectators along the routes, which are normally divided into stages, putting the athletes who attempt the various skills of this popular sport severely to the test, whether in timed speed trials, or endurance tests over flat tracks, or exhausting mountain roads. Cycle races are held both in towns and in the countryside, so there are no limits to the public viewpoints—with the obvious exception that the road itself is kept clear of traffic. As a result, the cyclists pass very close by the fans and photographers, so you can take good pictures even with modest equipment and with no need for special lenses; but you should choose your viewpoint with particular care and anticipate all the problems that may arise when you take the picture as the leader or a tightly packed group of riders passes by. The riders pass only once, so

your chosen position must enable you to capture all the feelings of the stage or speed trial. The best position is near a bend, on a hill, or at the finishing line, where the effort made by the athlete is greatest, for cycling can be rather monotonous at other times, with nothing unexpected or out of the ordinary happening worth photographing. Technical problems, such as photographing against the light (though this is not impossible), or the presence of fans along the roadside, can also affect your choice of viewpoint. If you have the opportunity to follow

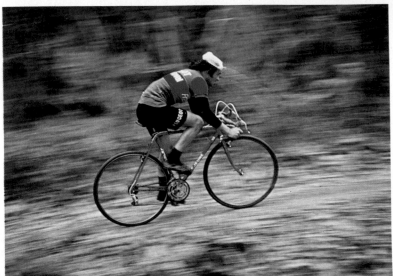

the race, you can concentrate on one particular rider instead of wasting time on general shots and photograph that rider's expressions and positions, alternating from close-ups to longer shots, to build up an original photographic report, which is probably more interesting than the common shot of the finish. The environment of the race is another feature that should never be ignored: any complete report of a race must include a panoramic view of the conditions in which the athletes must work. It is just as important to get the reactions of the spectators and photograph the organization, the support teams, the followers, and all the traditional publicity circus that goes with these road races, to capture every aspect of the sport. At track races, panning can transfer the sensation of speed onto the photograph, as you will inevitably be photographing from the side, with maximum angular speed. Shooting at night or indoors requires relatively slow speeds, but these are normally

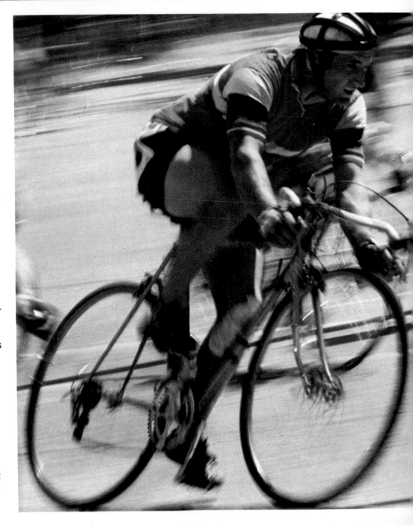

Left and below: Two intense moments of a cyclocross race, where the racers have to follow a rough and exhausting course. This kind of event can very successfully be built up into an account through a sequence of photographs that summarizes the story of the competition. A very effective way of getting across the feel of this kind of meet is in close-ups of the riders' faces covered with mud and clearly showing their exhaustion.

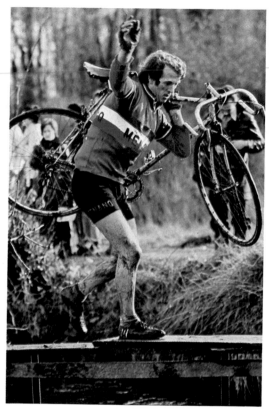

too slow to arrest the action clearly; following the subject is a possible solution, although it does create streaking of the background. Cyclocross, on the other hand, is easier for the sports photographer, as you can follow the athletes from a close range over short stretches that the riders repeat many times. The speed is never too great because of the rough ground of water, mud, rocks, and scrub that the cyclists have to cross, giving rise to amusing incidents. The photographer can perch in a tree, or wait for the cyclists near some obstacle or at the top of a hill, or even go in front of them along a path or a short cut if you know the course well enough to have picked out the best spots. In this way, you can compose photographic reports that include detailed shots and general views of these energetic sporting events. When the ground is soft with rain, cyclocross is a murderous event for the racers, but it gives the intelligent photographer an ideal subject.

163

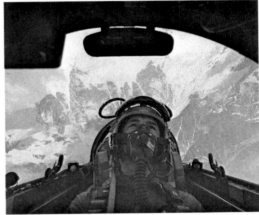

Aerial acrobats

The spectacular figures of aerial acrobatics like looping the loop, rolling, stalling, and spinning draw thousands of fans to air shows to follow the daring feats with their eyes glued to the sky. Many demonstrations are organized each year, which use all kinds of aircraft from high speed Air Force jets to fragile propeller biplanes from the heroic early days of aviation. Many countries such as France, England, and the United States have private flying clubs whose members spend their time maintaining the most incredible and colorful pre-war flying machines in perfect working order. For the photographer, these acrobatic demonstrations are both exciting and difficult: from the ground, the aircraft are little more than dots in the sky, but good results can be obtained if the aircraft leave smoke trails, so you can capture the sensation of movement on the photograph. Some reference point is needed on the picture such as the outline of the mountains, or another aircraft in the vicinity, to give full value to the sensations created by the daredevil aerobatics of the aircraft.

A thrilling sequence

The photographer who took the sequence above can boast of a unique experience: He lived for a few days on the Rivolto air base in 1977 to do a report on the pilots of the Italian air display team, the "Tricolour Arrows," with whom he went up in a Fiat G.91 while they performed daring acrobatic feats. The photos show the commander of the group performing a vertical roll over the peaks of Lavaredo. To get these exceptional pictures, the photographer had a motorized camera fixed at the front of the cockpit (see drawing) and operated it by cable from the seat behind the pilot. Because of the limited space he chose a 20mm lens. Opposite: A dizzy dive taken from the side with a 105mm telephoto lens against a background of the Dolomites covered with snow.

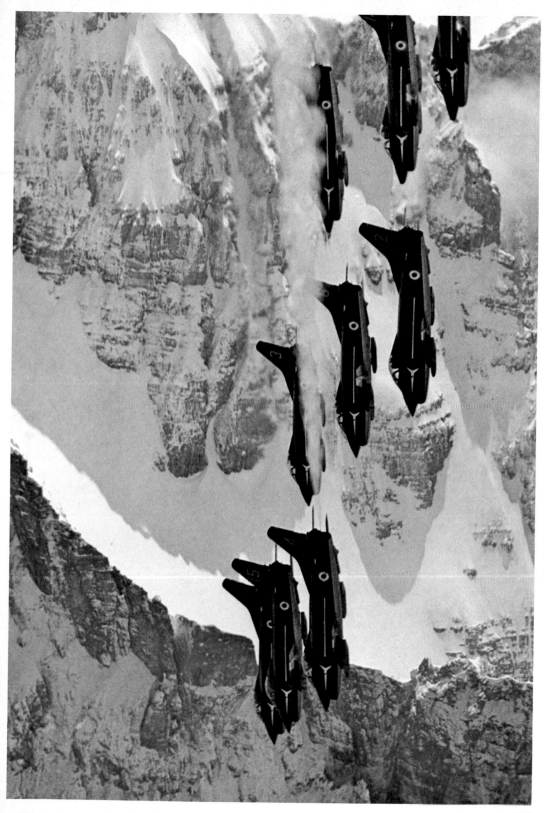

Sports in nature

An expert surfer darting beneath the crest of an enormous ocean wave challenges the strength of the sea: this picture symbolizes all sports that take place in the changeable, fascinating, and diverse reality of nature. The justification for climbing, skiing, canoeing, and sailing lies in their surroundings, far from the smoothly geometric tracks and stadiums. Nature sports provide the photographer with an infinite variety of stimuli to his creativity, but he must always be careful to emphasize the relationship between the athlete and the natural surroundings, as this is fundamental to both the technical aspects of the sport and its visual nature. Very often, the photographer has to take part in the action so as to reach the ideal observation point that only direct involvement can provide. Within the suggestive framework of nature, the competitive spirit found in sports often becomes a search for technical perfection, the challenge of the impossible, or simply aesthetic fulfillment, and the photographer must be able to capture and interpret this.

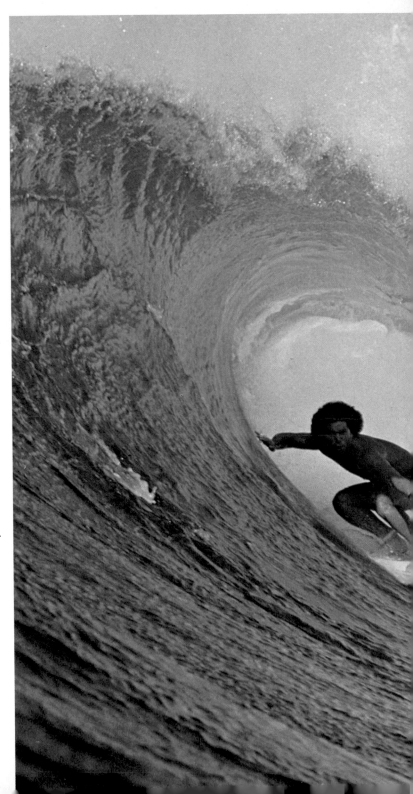

The birth of aerial photography

The conquest of the skies opened exciting new horizons to photography. The first experiments in aerial photography were made in 1858 on collodion plates by the French photographer Nadar ("the Titian of photography"), who worked from a balloon in the skies over Paris. Left: A witty lithograph dedicated to the event by Honoré Daumier. Above: A photograph that now has its place in the history of aeronautic adventure shows the German engineer Otto Lilienthal, the inventor and pioneer of winged flight just before a new and courageous attempt. Lilienthal's last attempt, which took place in 1896, resulted in his death.

In search of new horizons

The birth of photography almost coincided with that of modern climbing, so it was natural to use the new method to document a climber's first steps in a dangerous and hostile but also fascinating and breathtaking atmosphere. The Bisson brothers in France were among the first to carry the heavy equipment of the time onto the glaciers of Mont Blanc. In 1860, Napoleon III commissioned them to document his expedition with his wife Eugenie onto the slopes of the mountain, led by a veritable army of guides and porters, and they successfully managed to overcome the great technical difficulties of the task. The Italian Vittorio Sella, who compiled an invaluable archive of photographs taken on the highest mountains of the world during thirty years of dedicated work, was also both an expert climber and an excellent photographer.

Right: An interesting photographic record of the early days of climbing, showing a woman crossing a chasm of the Junction on the French side of Mont Blanc.

Hanging over the abyss

Travelling the world to take photographs or simply working in the country far from populated areas during the latter 1800s meant carrying at least 100kg (220 pounds) of equipment, including the camera, fragile glass plates, a small laboratory of chemicals for the reagents, a heavy tripod, and various other accessories. But despite all this, an army of travellers, explorers, climbers, ethnologists, and scientists compiled a systematic record of the world about us in just over a century. The mule became the travelling photographer's most faithful companion during this period.

Left: William Henry Jackson hanging over an abyss in a large valley in the Yosemites. As a peerless reporter of the real American West, Jackson used enormous 50 × 60 plates which, he said, were the only ones that could convey the majesty and greatness of this new territory.

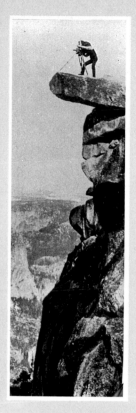

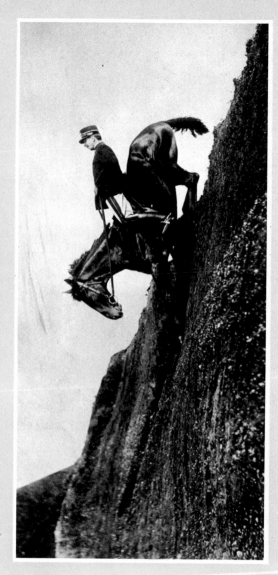

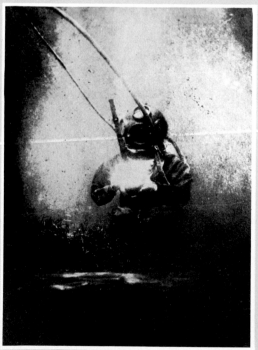

The photographic record

Above: A photo taken in 1898 documenting the style of Federico Caprilli, the cavalry officer from Livorno in Italy who "invented" the modern school of riding, completely revolutionizing former techniques.

Left: One of the earliest underwater photographs, taken by the French photographer Louis Boutan around 1893. The pioneer of this technique was William Thompson, a Briton, who lowered a camera in a waterproof housing into the Bay of Weymouth in 1856. He exposed the plate for 10 minutes at a depth of 6 meters (20 feet). To overcome the problems created by the natural filter of the water, which absorbs seven-eighths of the surface sunlight at a depth of 10 meters (33 feet), Boutan devised the earliest original underwater artificial lighting systems, using an electric contact to ignite magnesium powder contained in a spiral within a glass balloon full of oxygen. In 1899, he obtained good clear pictures with an electrically controlled camera and flash light at the record depth for that time of 50 meters (165 feet).

The photographer and the sailing boat

Sea sports are among the most popular for photographers because they take place mainly in the summer when the holidays demand the ritual taking of photos. Sailing, in particular, offers the photographer a vast range of opportunities in the ever-changing face of the sea, which can be calm one minute and threatening the next, as well as in the vivid colors of the sails and the elegance of the ship driven along only by the power of the wind. Yet the most popular viewpoint is often the worst: you can only get run-of-the-mill pictures from the shore in most cases, and even a good telephoto lens has problems in capturing any emotion. The horizon or opposite shore of a lake divides the picture into two unnatural levels on top of each other, unless you can fill the vacuum of the postcard-blue sky by taking advantage of the colors of a storm, or bring out the shape of the clouds through slight underexposure. The right position for the horizon line is the first problem to face when photographing from the water surface. It is useless to try to lay down a set of rules, but you should remember that the middle is hardly ever the best position. On the one hand, a predominance of sea can emphasize its vastness and, on the other, a predominance of sky can bring out the tones and thousands of variations of a stormy background. The classic composition manuals recommend a ratio of 2 to 1. A raised vantage point on land gives the photograph a more unusual and suggestive angle in which the ship

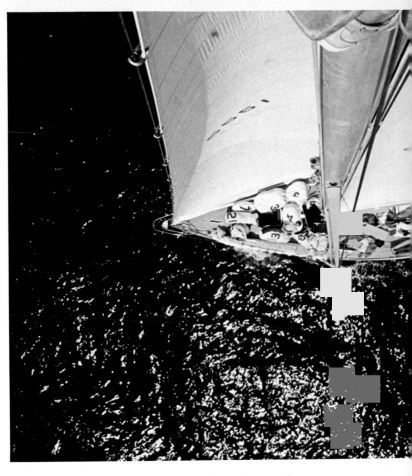

Choice of viewpoint
Even in the limited space offered by a sailboat, it is possible to pick out a few key points that give a photograph its own particular characteristics. Above: An aerial view taken by the photographer from the top of the mast demands a good deal of composure. Below: The wettest and least effective angle is from the stern. Opposite: The most effective frame is from the bow. In all three instances, a wide-angle lens is recommended.

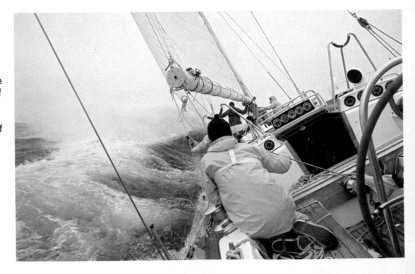

can appear lost (though clearly distinguishable) in the vast blue sea. A 135mm or 200mm lens is all you need to contain the framing, and reflections against the light emphasize the wake and make the photo more vivid. But the most spectacular photos are those taken from on board, as they immediately involve the spectator. The bridge of a cruiser is the best possible point from which to view the tight engagements that take place between groups of ships, and the closer range enables you to get excellent results, even with a 50mm lens, though fuller frames need an 80mm or 105mm lens. More powerful lenses are rarely useful, as they are difficult to handle with the pitching of the boat. When you get used to the rhythmic movement of the boat, you can stand on the forward platform and straddle the stay to use a powerful wide-angle lens of 24mm or 20mm to convey the power and speed of motion by including the sails, swollen with the wind, and the waves, which appear enormous from the well. If you want

to capture the listing effectively and avoid the basic mistake that has ruined many a photograph, pay great attention to the line of the horizon: a composition with the bridge and mast of the boat on the diagonal emphasizes the movement. A wide-angle lens is also ideal below decks to photograph the varied aspects of life on board, as it magically enlarges the limited space available. The great light reflection, especially when the sun is at its highest, makes a polarizer or a UV filter very helpful (it is indispensable with color film). Yellow or red filters with black and white are useful for emphasizing the contrast of the sky, and the filters also protect the lens from spray and salt. The light reflecting off the water can affect the exposure meter readings, showing 1/2 or 1 stop too many, but correction becomes instinctive after a while. Photographing against the light with the boat in silhouette is a popular theme that is often abused. Nonetheless, it can still be effective, particularly with more powerful lenses.

Three points of view
The drawing shows the three different points from which the photographs on these two pages were taken, each offering stimulating possibilities. In this kind of picture, the most common mistake on the part of the photographer is to lose the line of the horizon when the boat is listing.

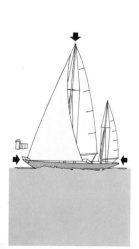

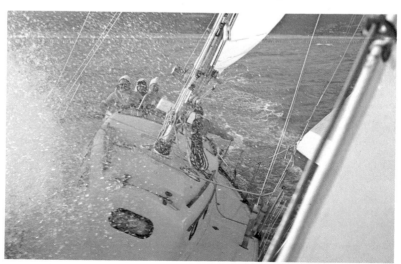

In rough seas

Summer days basking in the sun, when the sea is a sheet of blue and the light is dazzling, are the worst for both the sailor and the photographer. The best conditions occur when the sea is difficult, the water is rough, and the wind high, as these elements bring out the adventurous and sporting nature of sailing and its ancient romantic fascination. They are also the most critical conditions to photograph, and many a magnificent opportunity has been lost because the photographer has left the camera on shore or in some room where it is not easy to get. Days with a clear, sharp sunset, or cold winter light, when the water is the color of steel and the sky is painted with clouds, give the photographer the right atmosphere and temperature and everything is much more interesting—the detail of a sail under tension, the oilskins of the crew, or the bridge and waterway drenched by breaking waves. There are basically two "musts" for the photographer on board: fight seasickness and protect your camera, particularly the lenses, from seawater. It is easiest to protect the equipment with your body, keeping out of the wind and holding the lenses downwards after you take the shot. A lens hood and an improvised screen made from a plastic sheet are very handy, but ideally you should have a waterproof camera such as the Nikonos Calypso. But whatever your camera, you still need to be careful to wipe down the lens cover and try to protect the camera body from knocks. A rather safe position can usually be found in the hatchway, and standing on the steps of the inner staircase you can easily photograph your colleagues to stern. Very good dramatic pictures can also be taken from land or from above, as the perspective underlines the threat of the white crests of the waves chasing the boat as it battles its way forward. Using a telephoto lens, you can project the spectator onto the fragile nutshell. Shots from land can be effectively alternated with those taken on board the same ship.

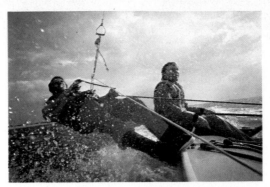

Small boat acrobatics
It is practically impossible to take a good photograph from on board a small boat without having to resort to special devices. It is better to follow them from shore with a powerful telephoto lens or with a medium range telephoto lens from on board another craft. The most spectacular moments are of the yachtsman trapezing. Left: A dynamic picture taken with a 20mm lens and a remote-controlled camera that was fixed to the bow of the boat.

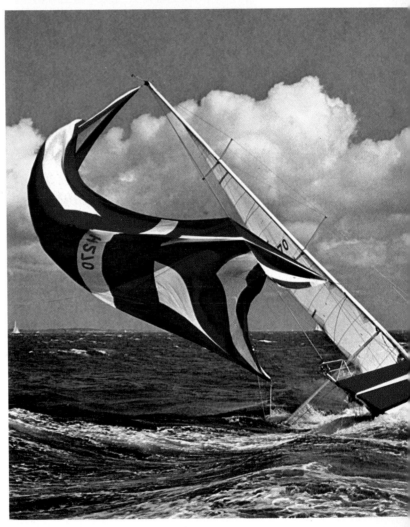

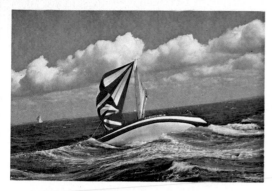

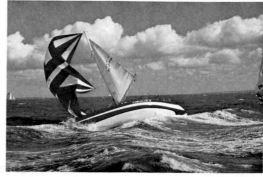

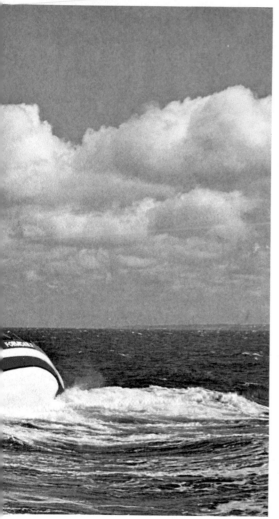

An unforgettable adventure

The sequence above was taken during the 1979 Fastnet race, which was one of the most tragic in the history of sailing: 19 people were killed and 23 boats sunk after a cyclone hit the competitors in shallow Irish waters, causing exceptionally destructive breakers. The conditions were not quite prohibitive when these photos were taken, but the wind was already strong enough for the boat to yaw under the spinnaker. The photographs were taken from the judges' boat follow-ing the race in its early stages. A powerful motor-boat is the best way of quickly getting close to a sailing boat and of varying the distance and angle. Inevitable movement of the boat makes it necessary to use a shutter speed of no less than 1/250 second, and even more with a telephoto lens. For successful pictures of a sailing boat maneuvering, you have to understand the technicalities of the action. An expert photographer can even anticipate a small boat's suddenly capsizing by knowing how skilled the crew are.

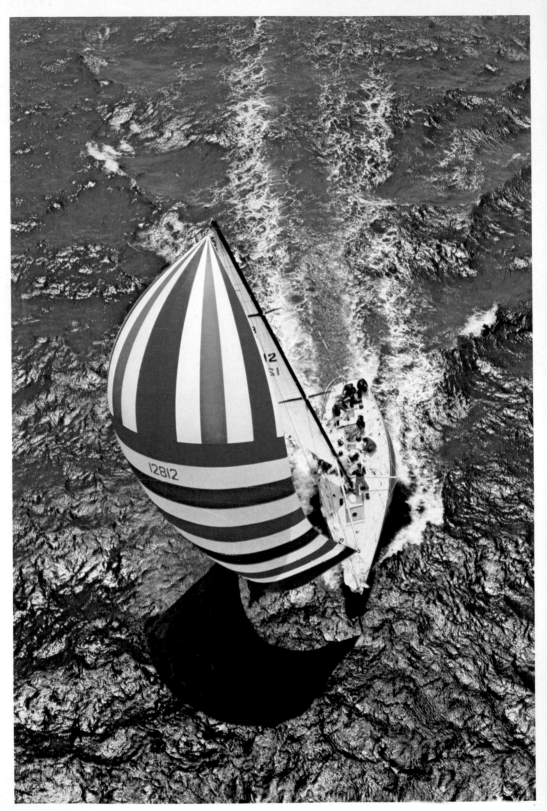

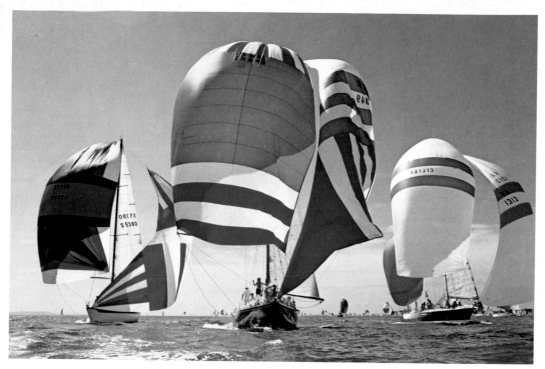

Opposite: A racing cruiser photographed from a helicopter, with the wake of the boat indicating its speed. Below: A graphic composition of boats sailing wind ward in a race. Above: The same, but running before the wind with spinnakers. The drawing shows the classic race triangle marked off by three buoys.

Wind direction

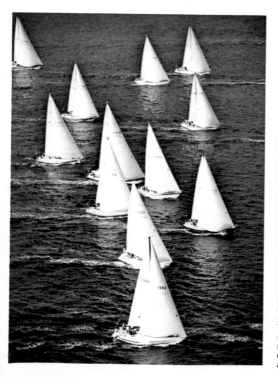

Photographing a race

There are two ways of looking at sailing, either as a way of going to sea in a boat, or as a way of racing. The distinction is equally important for the photographer, who can find the competitive spirit in the boat race with its specific course and can photograph the sails disappearing into the horizon, compressed by the telephoto lens. Races on the open sea are strictly for the large ships, but the photographer can use the start of the race for shots of tens or hundreds of boats all gathered together in one spot. The battle for first position on the starting line often results in exciting duels and complicated maneuvers to avoid being rammed. Trian-gular races, however, are open to smaller boats too and take place over a course that puts the boats through all their paces from tacking to running before the wind with their colorful spinnakers hoisted. The best position for the photographer is alongside the judges' boat when the competitors turn around the buoy. You have to understand sailing to know what you are photographing and not miss the most interesting moments both visually and technically.

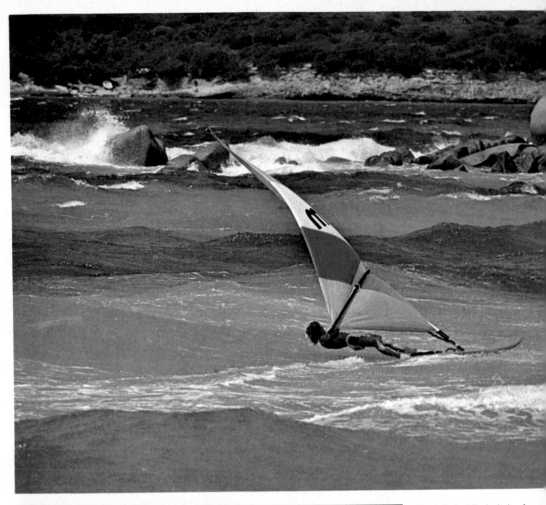

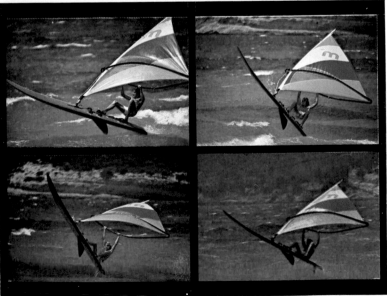

Top left: A skilled windsurfer demonstrates his art in a 30 knot wind on the waves of the sea off Sardinia. At this speed, he can use the waves as a take-off ramp and fly off the surface, as in the incredible leap shown in the sequence below, which was taken on Ektachrome 200 film with a motorized Nikon fitted with a 500mm lens. Top right: A frontal shot requiring great skill in focusing. Right: Even the best make mistakes.

Water acrobatics

Invented as recently as 1968 by two electronics engineers with the aid of a computer, windsurfing has caught on very quickly across the globe. It is an amusing sport

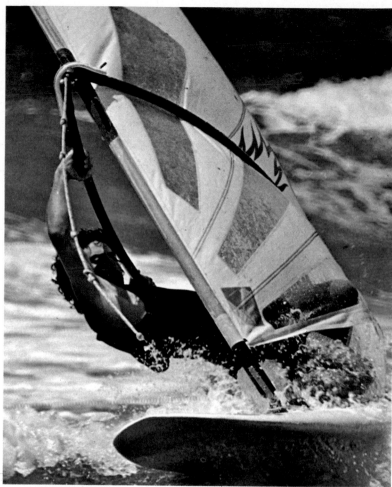

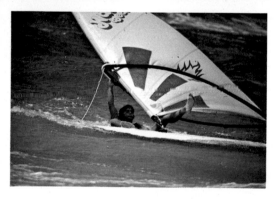

jump, which only the champions manage to do well. The best photographs of windsurfing are those taken from the shore with a very powerful telephoto lens such as the 300mm or 500mm, as this brings out all the hidden facets of the sport. A shot facing the athlete underlines his tension with the effort of trying to balance the sail and shows the angle of the mast with respect to the board. Long-focus lenses (mounted on a support but not clamped, so that you can move the camera and keep the subject in the frame) are a lot easier to use if you can get the athlete to agree to keep at more or less the same distance away and perform in just one area. The speed at which the events take place, as in high speed jumps, requires shutter speeds of no less than 1/250; and a motor, used either for sequence shots or rapid reloading, helps to keep the framing under control. Good suggestive results can also be obtained with wide-angle lenses if you come into the water at a reasonable distance from the shore and photograph the board from the water surface, but the subject has to be as close as possible for the pictures to be successful.

that has now become fashionable on beaches everywhere, and its spectacular nature can be effectively brought out in a photograph such as the ones on these pages, with the champi- on battling a strong wind. Regular windsurfing competitions are now organized as with surfing, but the most emotive opportunities for the photographer are found in the free style and the

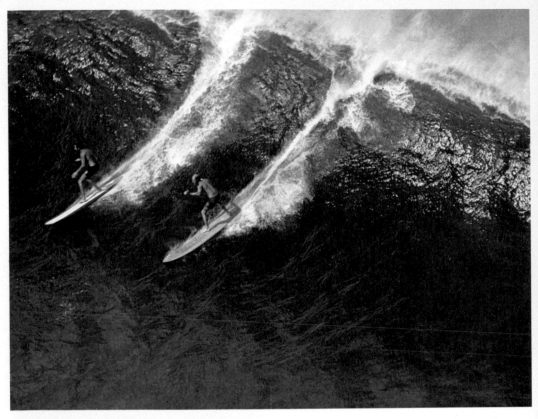

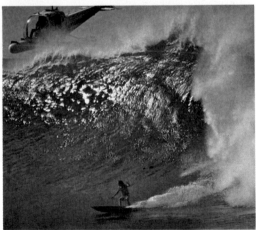

Close-up on surfing
Riding the great ocean waves on a fragile board seems to have been the main pastime of the Hawaiians even before the arrival of the first Europeans. The natives' test of courage has now become one of the most

popular American sports along the Pacific Coast. The movement of the ocean regularly drives great long waves, often hundreds of yards apart, toward the shore, where they rise like great walls of water several yards high and there begin to

Top: The wake of spray, the breaking wave, the azure sea, and the tension of the two surfers cutting across the wave in parallel conspire to make this picture taken from a helicopter in the bay of Waimea, Hawaii. In all photographs of sports that take place in nature, some element of

the surroundings must be included. Left: The position of the photographer can be seen from a second helicopter. The drawing above shows two possible angles: one from the shore using a powerful 600mm lens and the other from overhead with a simple 80mm.

break thunderously along their whole length. The greatest achievement for a surfing expert is to ride his board in the heart of the wave beneath the crest, escaping the oncoming breaker on the diagonal. The photographer's biggest problem is his distance from these acrobatics, as it is impossible to get close to the mountains of water that come crashing down on the shore. As a result, all you can do is resort to powerful telephoto lenses (500mm or 1000mm) preferably from an elevated vantage point, to enable you to include the vastness of the sea or the approach of other breakers. Only sophisticated, original equipment will enable you to produce out-of-the-ordinary photographs when dealing with surfing, and those taken from a helicopter or with a water-

proof camera really capture the sensations of the sport, though you have to take the risk of losing your equipment in an approaching wave. A camera enclosed in a watertight casing fastened to the front of the surfboard can give excellent results when operated by remote control. Another good vantage point is often on the point of the headland that marks off the bay where the events take place; in this case, even a 300mm can be used. But the most exciting photographs are those taken from a helicopter flying low over the waves, and fortunately, this is one of the many facilities offered by some tourist spots. Even a medium telephoto lens can bring the surfers into close range from this point. Panoramic shots taken from the air can also be interesting.

The photographer's secret
Even the most commonly photographed sport can take on a new and original look if the photographer can find the right position or at least use a suitably placed remote-controlled camera. Below: An exciting picture taken in 1963 by the photographer George Silk. As he could not get close to the surfer, he positioned a mo-

torized Nikon in a waterproof casing at the end of the board (see drawing), so that the surfer could release the shutter himself by remote control. Using a 20mm lens, Silk was able to include all the interesting elements of the scene and ensure the widest possible depth of field. In addition, the shutter speed and aperture were set in advance.

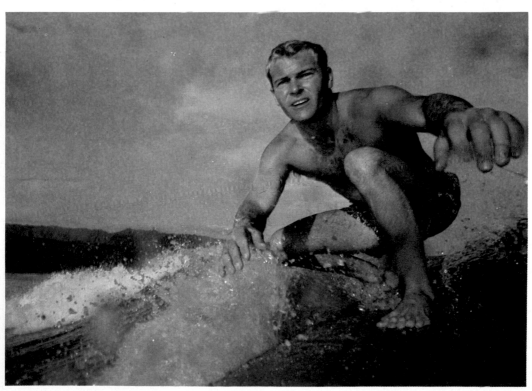

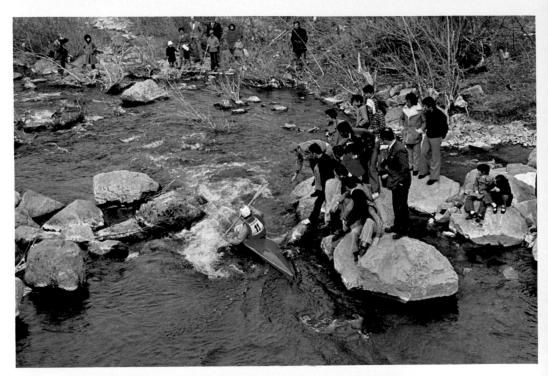

Knowing the course

Above: A competitor passes a point where the spectators can come really close to the kayaker. For good results, you must know the course and the only way to do this is to check it out before the event. Left: A canoeist going round a slalom post. This view from the front is more effective than that from the opposite bank. Below: A very close range shot taken with a wide-angle lens operated by remote control in a manner similar to that used to take the photograph of the surfer on the previous page.

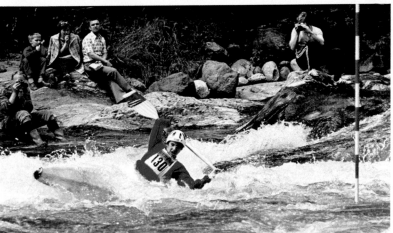

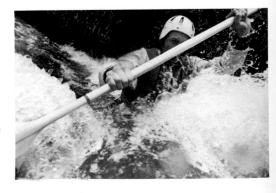

Shooting the rapids

To take effective photographs of a canoe going downriver you should know the route and all its possible difficulties. The most exciting moments occur in shooting the rapids, when the boat flies through the air, so you should find these points in advance to be able to get the best position on shore. The riverbank is usually a good observation point, but the best perspectives are taken from a height of about six feet. Choice of focal lengths depends on the width of the river, but a 105mm is usually adequate to isolate the action yet still include the most important features of the scene (rapids, groups of rocks) within the frame. A classic 80–

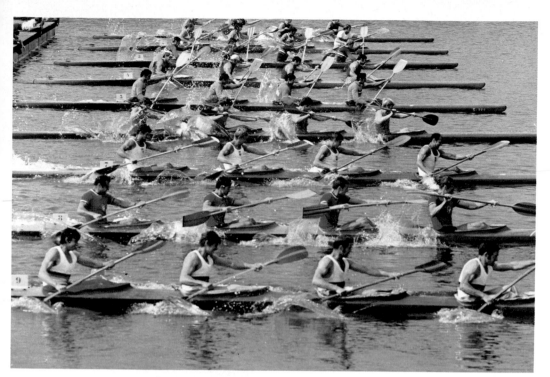

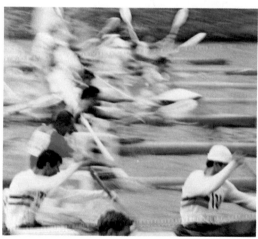

200mm zoom lens is useful for following a passing canoe from further away, and a motor can be useful for breaking the sequence of actions in shooting the rapids. To avoid any unwanted blurring, do not use speeds below 1/250 second, and take care that the canoeist's face is not obscured by the paddle (as you can usu-ally catch meaningful expressions showing the great deal of concentration required). A particularly intense moment to photograph is when the canoe is covered with water. Any of the numerous spring events will provide the photographer with the opportunities to vary the viewpoint and follow the passing competitors.

Canoeing

Speed races in the responsive one-, two-, or four-man kayaks take place over courses of 500 to 1000 meters measured on wide, calm river basins.

Top: The lineup at the start, photographed with a medium range telephoto lens, which accentuates the close distance between the boats. Above: The same scene taken with a shutter speed of 1/30 second to show the movement of the paddles. The lateral shot is the most common, but an overhead shot is often equally effective, particularly in river races when the many-oared boats pass below a bridge. The elegance of the boats and the synchronized stroke lend themselves well to graphic compositions. The drawing shows a slalom course on a river with good shooting positions indicated.

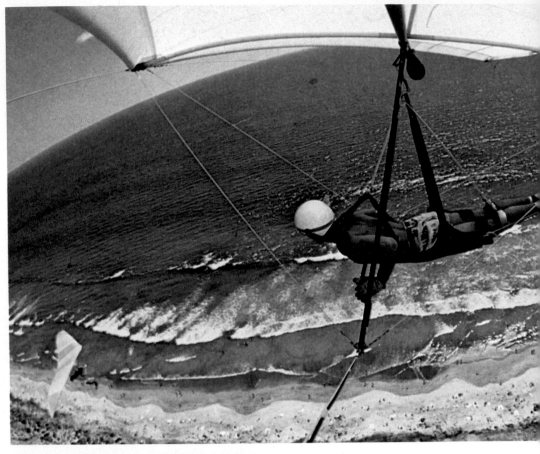

Leonardo's dream

The NASA engineer Francis Rogallo is the one to give the credit to for having made Leonardo da Vinci's old dream a reality. The Rogallo wing is the result of a prototype designed for the reentry of Apollo

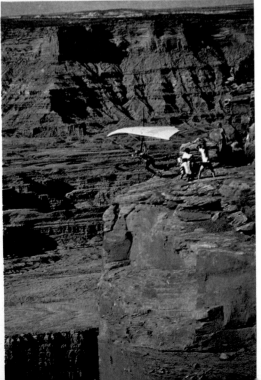

Top: A picture that says everything about the exhilarating sport of hang gliding. The drawing shows how the photo was taken, with a motorized camera with a 15mm lens fixed onto the rib of a wing and operated by the pilot using a cable. An automatic exposure camera is preferable because it can cope with any variations in light. Left: An exciting takeoff from the edge of a deep canyon.

Below: Takeoff of a hang glider. The low speed makes it possible to take photographs in succession without the use of a motor. The pilot hangs on a sling at the center of gravity and controls the direction of flight by moving with respect to a control bar.

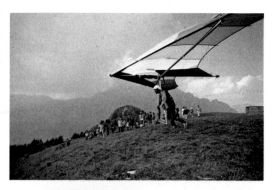

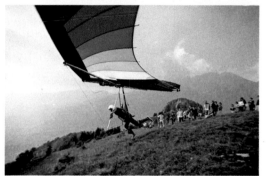

capsules into the earth's atmosphere, and now over 60,000 people in the United States take part in this dangerous but fascinating sport of free flight. The most common form of hang glider is made of a simple tubular aluminum framework covered with fabric and has a gliding coefficient of 1 in 4 that allows 400 meters (450 yards) travel at a height of 100 meters (110 yards) or upwind along the ribs of a mountain or in strong rising thermal currents. Photographs taken against the sky are the least interesting, so it is better to follow the delicate maneuvers of takeoff or landing from close range. This allows the land to act as a reference point and conveys a sense of the height involved.

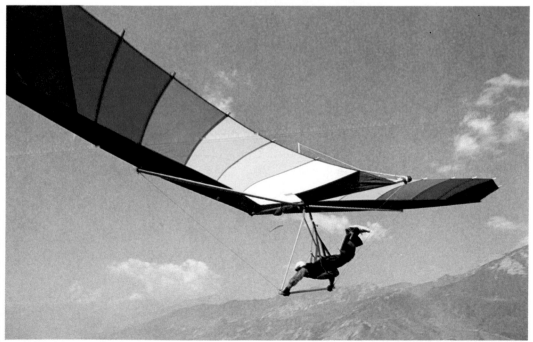

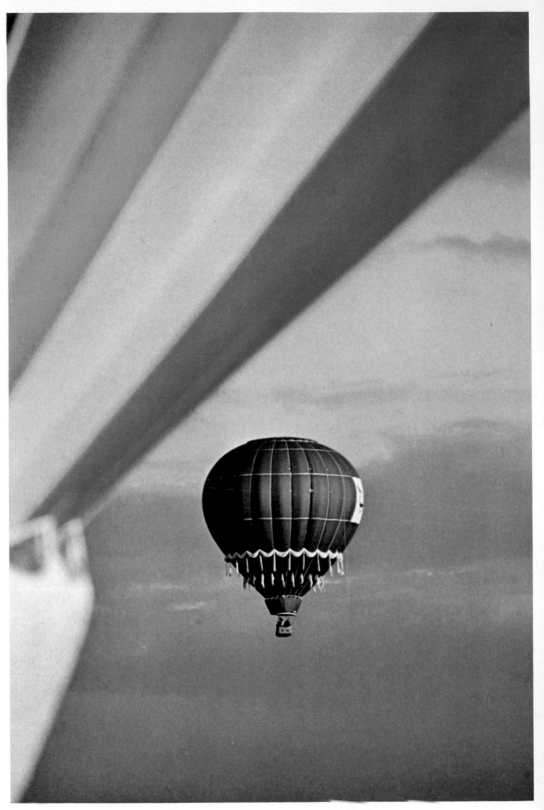

Silent flight

The sensation of boundless freedom and playing with the wind, air currents, and clouds while the earth below becomes a geometric mosaic of lines and colors is what you feel when you put your trust in a light structure of fabric or aluminum ready to respond to the slightest command. The only sound to accompany the glider pilot in the air is the slight rustling of wind. As soon as the glider is released (at a height of about 600–1000 meters/2000–3300 feet) the tow rope is jettisoned and the pilot flies the glider by spiralling in hot rising air currents or in a series of figure eights along a mountain ridge bluffed by the wind. An expert pilot with a good meteorological knowledge of the area can stay up for many hours. Interesting photos can be taken from inside the glider during the initial stages of flight and on landing, but more effective photographs are taken from outside with a UV an timist filter (making sure you always include the horizon or the ground as a reference point). The ideal observation point is from a light aircraft flying slightly above the glider's path, or from a mountain ridge where gliders from a nearby airport regularly fly along the slopes. From a good position, a medium range or 200mm telephoto lens should be adequate to capture the beauty and serenity of the glider pilot's world.

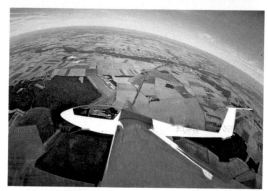

The problem of clearance
In many countries, aerial photography is subject to various restrictions and complicated bureaucratic procedures often get in the way of anyone who just wants to document some sporting event.

Top: A glider, taken from a powered aircraft with a 35mm, stands out against the misty background along a crest in the Grigna. Above: Remote control has once again made it possible to get a suggestive photograph, taken this time from the wingtip. Opposite: A hot air balloon flying freely and unweighted between earth and sky.

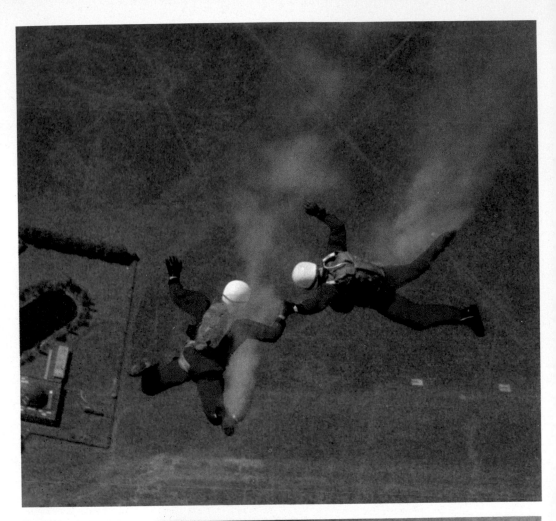

The romance of ballooning
Travelling slowly through the sky in a balloon is not just an eccentricity or a nostalgic return to the roots of aeronautic adventure; it is a true sport, which requires a license and for which annual meetings are held. The most spectacular event is the crossing of the Alps at the beginning of June; the setting off is from Mürren in Switzerland, where a photographer with a 28mm or 35mm lens can get a good view of dozens of balloons. The best angle is from the air if you are lucky enough to get on board, as you can photograph the other balloons taking off. The photo at right shows a balloon meet in the United States.

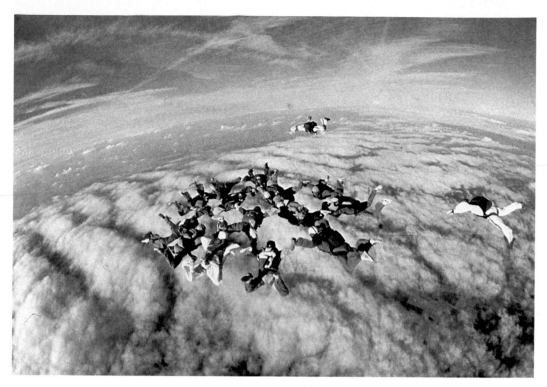

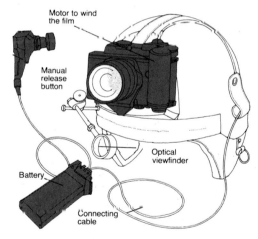

Motor to wind the film

Manual release button

Optical viewfinder

Battery

Connecting cable

Dropping out of the sky

It is very difficult to express the thrill of skydiving from the ground, so if you want to avoid uninteresting photographs, you have to be daring enough to join the skydivers in the sky with your camera fastened to your crash helmet and operated by cable. In this case, a wide-angle lens with the aperture set at f/11 will enable you to have both the foreground and the background of the earth in focus. If you do photograph from the ground, you can use a telephoto lens of at least 300mm to follow the exciting stages of the parachute's opening, when the speed of the fall is cut down drastically to 15kph (10 mph); landing presents no problems, especially when it is done to a target. It is useful to have a motor driven camera to cover the different stages of the fall and to get an effective sequence of shots in a free fall.

Photographing a free-fall
Taking a photograph while plummeting down to earth at 190kph (118 mph) demands experience with both camera and parachute above all else. For the greatest freedom of movement, a motorized camera should be fitted to the crash helmet with a reference viewfinder for checking the frame. The drawing above shows the ideal system for taking photographs during a free-fall. A 35mm lens set for 7 meters (25 feet) gives the best depth of field. Top and opposite: The other skydivers were taken at 1/500 f/16 with a super wide-angle lens. Right: An exciting close-up taken during an aerial rendezvous.

The most difficult test for the photographer

Mountain climbing is struggle, adventure, romance, escape, and sport, as well as being a character-forming school of life. It is the sport of individualists par excellence, but with the ideal link of human solidarity in the rope that ties two or more climbers together. The climber-photographer is a common figure essential to document a difficult climb and convey the unforgettable sensations experienced at great altitudes. The

choice of equipment is often determined by its weight, so much so that many prefer pocket cameras such as the tried and tested Rollei 35. But modern reflex cameras of limited weight and size such as the Olympus have eased the problem somewhat. A medium range telephoto lens such as the 100mm or 135mm is often useful in addition to the universal 35mm for photographing other lines of climbers en route. It is often difficult to use automatic cam-

eras because of the temperatures. The world of the mountaintop can present the photographer with various ideas and themes, such as the wind blowing up the snow along a crest against the sunlight or a dark rock scene, made more meaningful by the presence of climbers. The climber-photographer normally photographs just the other climbers during the climb, but a more complete report is obtained by alternating rockface pictures with more general shots taken in sequence with a powerful telephoto lens from below other lines of climbers, as this describes the climber's life more effectively. The best picture possibilities often occur in the worst conditions, frequently when the camera is lying useless in a rucksack.

Recommended equipment

The climber-photographer's equipment has to be simple, practical, sturdy, and always at hand, even in the most precarious and difficult situations. The 35mm and 100mm are the best lenses to use.

Above: An acrobatic leap from one ice peak to another, taken from below (Nikkormat 135mm, 1/250, f/8). On snow and at high altitudes, the reflection affects the exposure meter readings, which should be corrected by one or two stops.

Opposite, bottom: A line of climbers on a difficult artificial section and another on the latticed Rochefort peak of Mont Blanc. In the near photo, the use of a wide-angle lens has thrown the action into relief: in the far photo, the majesty of the surroundings in which the climbers are moving establishes a real equilibrium and gives a greater sense of proportion.

The UV filter

An ultraviolet filter or a skylight should be used to compensate for a slight dominance of blue, particularly in snow and above 3000 meters (2 miles). Low sensitivity film gives the best results in color saturation and detail

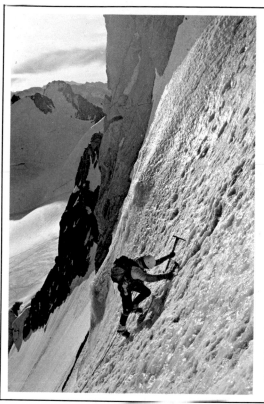

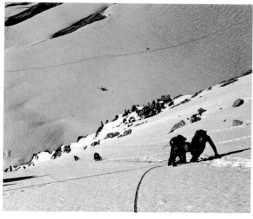

The effect of the angle on the shot

It is almost impossible to reconvey the sense of the vertical in a climb, for photographs taken from below looking up or vice versa are often flat and meaningless. The most realistic angle (even if it can be exaggerated by holding the camera at an angle) is from the side, but you can only use this on a traverse.

Above and left: These two photos taken at the same spot on the north face of the Tour Ronde clearly show how much effect the angle has on the shot. Photographs that are taken from above or below the climbers can convey an impression of depth only by including the rope in the foreground. Pictures of climbing have to be as involving, documentary, direct, and free of affectation, conventionality, or artificial devices as possible

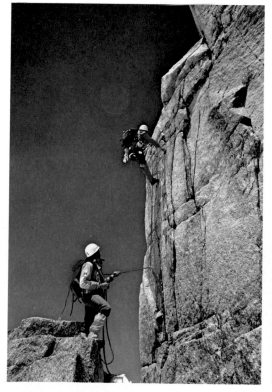

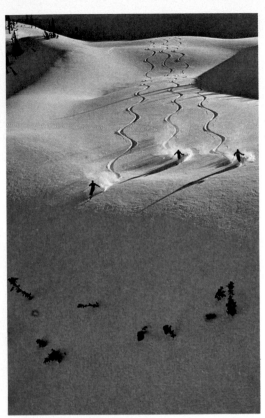

Snow sports

The biggest enemy of all those who attempt to photograph white ski slopes is the cold: the low temperatures make battery operated exposure meters unreliable or even useless, jam the camera mechanisms and the motor drive, and steam up the lenses. The basic equipment for a good kit is a reliable reflex camera, preferably nonautomatic, a range of lenses from 105mm to the most exciting of the specialties, where the skiers reach speeds up to 130kph (80mph). UV or skylight filters are essential with color film, particularly in shaded areas, to cut down the strong predominance of blue. The flurries of snow thrown up by the skis on the turns are more effectively caught when photographed from below against the light and with a neutral background, and these are

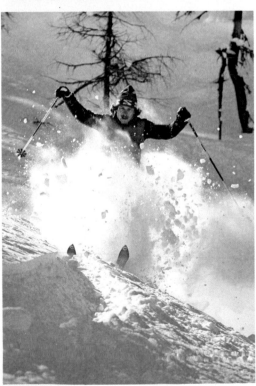

the compact, light 500mm mirror lens, a tripod for powerful telephoto lenses, and possibly a motor to enable you to take sequence shots of the various characteristic and technical moves in negotiating a fast series of turns, or following a slalom course, or even the tumbles of a fall. A zoom can be the right choice for following the descent of a skier without having to alter the frame, despite the fact that its luminosity is lower than other lenses with the same focal range, for this is no problem because of the brightness of the surroundings. You can use shutter speeds of 1/500 second or 1/100 second (with the aid of panning when shooting from the side) to photograph the competitors even in downhill racing, also the ideal conditions for photographing runs around the slalom posts, where you have the advantage of knowing what to expect: with a 200mm lens from about 15 yards away, you can cut down the frame to center interest on the skier. Free runs are more complicated, as you can often work only from the side, for which reason you should choose the dizziest slopes to convey the angle of the run. A 50mm lens is adequate for this. Knowing the course is always essential, as it enables you to wait for the competitors on icy moguls, the worst turns, or where they will have to make a jump. The most photogenic falls happen even at slow speeds in the special slalom. In noncompetitive events, the most suggestive photographs

In step with the experts
The experts of the slopes challenge each other every year from December to March, in a busy calendar of events in the three classic specialties of alpine skiing: the slalom, the giant slalom, and the downhill.

Right: Hinterseer's expression as he negotiates the slalom poles. It is easy to set the focus in advance in the slalom and then wait for the most intense moment of the action. Downhill racing is more difficult to follow because of the record speeds reached by the skiers. Below: The Norwegian Haker at Wengen.

Opposite: Two pictures of noncompetitive skiing off the track in fresh snow. The drawing shows the track of a slalom event.

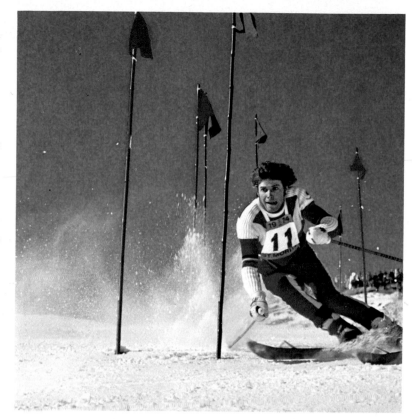

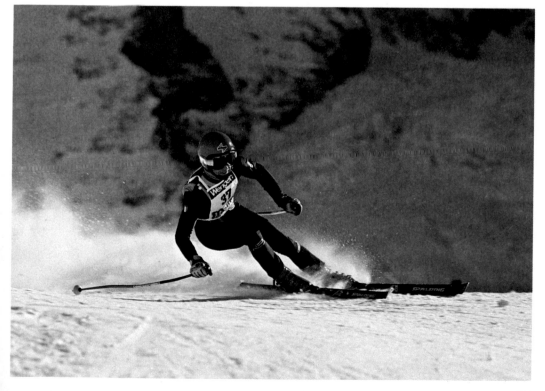

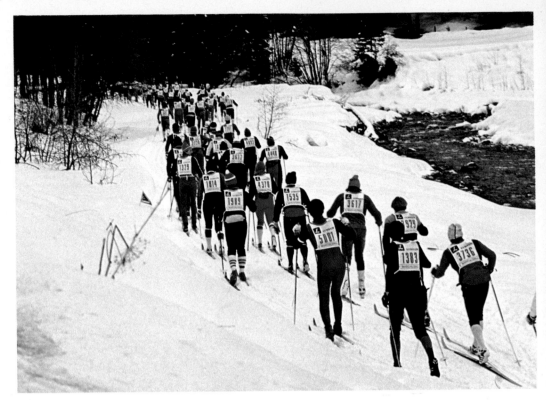

are those in fresh snow where the skill of the skier is easy to see. The photographer can draw new and original stimulus for his creativity from the regular patterns of tracks snaking over the immaculate surface of the snow on the slopes. The best pictures are those taken in low light from a position that is high enough to include all the beautiful designs that are traced on the snow and the imposing frame of the mountains in their winter clothing. Equally spectacular is a shot of a parallel descent of a group of skiers whom the photographer can freeze at the right moment by making prior arrangements with them to photograph them from the right angle.

On the route of the Marcialonga

The long cross-country races organized each year in the wake of the legendary Swedish Vasaloppet are the photographer's opportunity to follow events that are sport, spectacle, and costume all at the same time.

Top: The long column of the 5000 competitors in the Marcialonga in Italy snakes off into the woods of the Fiemme and Fassa valleys. Left: A photographer at work. Above: The route of the race—70 km (43½ miles) from Moenza to Canazei then Cavalese. The greatest problem for a non-professional is to follow the race and overcome the inevitable restrictions on spectator movement. Having a look at the route in advance makes it possible to decide on a few key points: the start, points along the route, and the refreshment stops.

Cross-country skiing

Cross-country skiing is synonymous with skiing in all the Scandinavian countries and has recently enjoyed a popularity boom in other parts of the world. A photographer can find the best opportunities out of the many snow marathons at the legendary Vasaloppet, which is run in Norway every year on the first Sunday in March and attracts over 10,000 competitors from all over the world. Other similar events are organized in the Alps, such as the classic Marcialonga, which also attracts great crowds. From a raised vantage point (you can always ask someone if you can use their roof or window) and with a panoramic focal length, the start offers exciting shots of the thousands of competitors launched in triangular formation towards the funnel of the track. A medium range telephoto lens is enough to follow the competitors as they pass along the route, for you can pick them out against the background from a close range and bring out all the effort and dedication needed for this gruelling sport. The competitors do not move at high speeds, so you have plenty of time to follow them and check your focus. The best frame is usually a head-on shot with a 300mm or more telephoto lens. Getting to know the route in advance enables you to pick the most interesting spots and find your way through the crowded streets on the day of the competition, and you can take close-ups at the refreshment points and capture the festive atmosphere of these events as tea, sugar, lemons, and sandwiches are doled out.

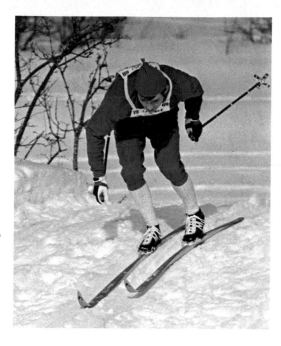

Above: The last few yards of effort for Italian cross-country skier Franco Nones, who won the gold medal in the 30 kilometers (18½ miles) in the 1968 Winter Olympics in Grenoble. Below: This striking photograph was taken with a 135mm telephoto lens frames the athletes in full stride against the background of the snow.

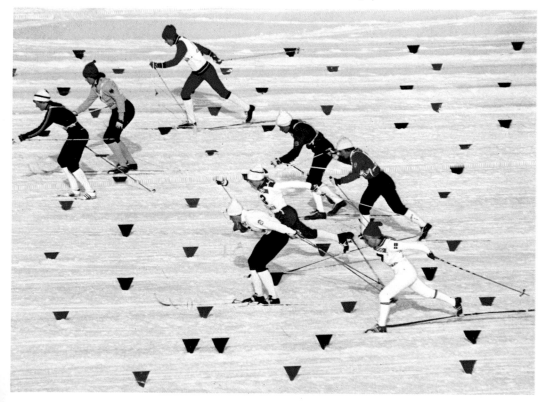

Right: By following the jumper in flight, the photographer was able to pick him out against a background of trees and increase the dynamism of the picture (Nikkor 200mm at 1/125, f/8). Below: The overhead angle gives a different dimension; the use of a 35mm makes it possible to keep both subject and background in focus, extending the dizzy heights of the jump.

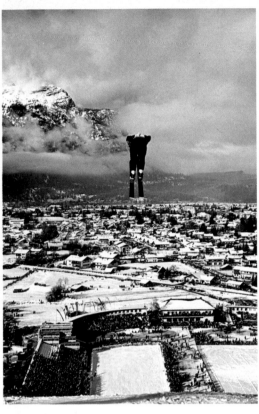

In flight on skis

Technical perfection, self-control, and courage are the essential qualities needed to throw yourself off a ramp 60 meters (200 feet) high and trace an endless curve through the sky. The most significant moment occurs when the athlete takes off into the air after the run and is in the position of maximum aerodynamic penetration. The biggest problem for the photographer is getting close enough to the subject: a normal lens used from below creates pictures in which you can hardly tell whether the black spot you can see is really a skier; but a 50mm lens is the most you would want to use from halfway down the track if you want to include the interesting structure of the takeoff ramp and the competition area. However, the best shot from this position is of the ski jumper in flight. Panning with a 200mm gets the best results, as it makes the background uniform and emphasizes the speed. 1/125 second is the best shutter speed to arrest the figure perfectly in close-up, but a background of sky with no other reference points can destroy all the dynamism of the action. Positioning yourself lower down the slope is useful for documenting the deli-

194

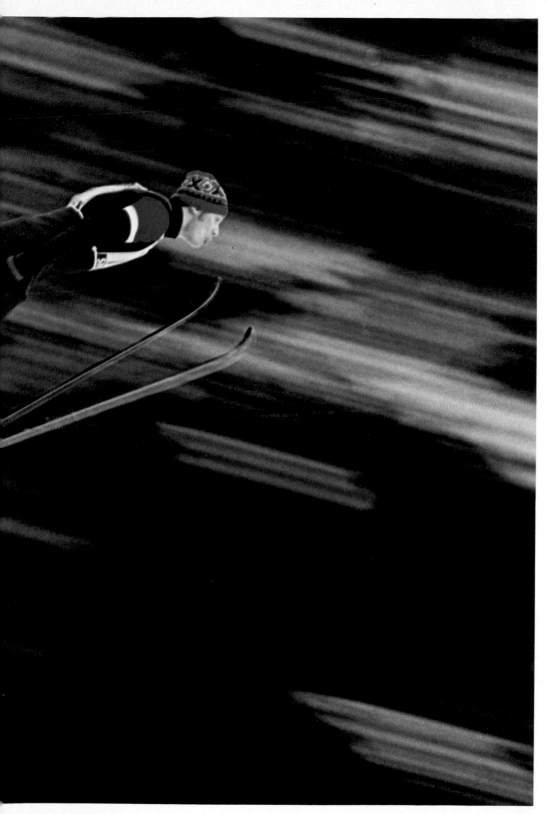

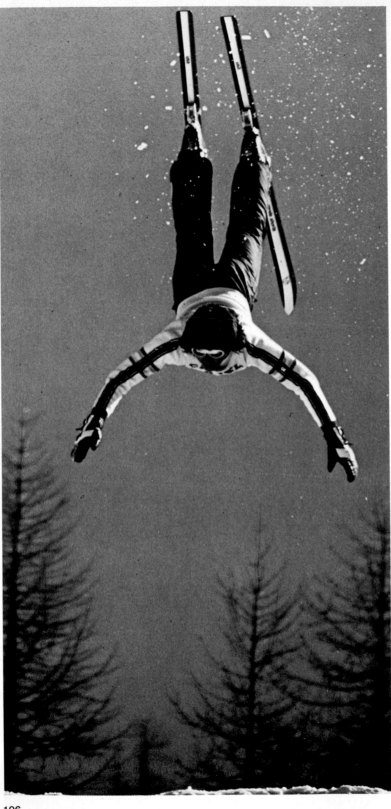

cate landing stage; it is less meaningful but can be full of surprises. The edge of the takeoff platform is an ideal position for picking out the athlete against the distant valley bottom with a normal or wide-angle lens to emphasize the aerial dimension of the sport. Most photographs of this difficult Nordic specialty are quite repetitive if you look at them closely, as there are normally only about three or four conventional frames. Ski jumping is one of those sports where an original viewpoint and the photographer's initiative in overcoming the inevitable limitations can bring out a whole new dimension. The photographer has much more freedom at "hot dog," or ski acrobatics, exhibitions, where the public is only a few yards away from the athletes (the short distances present no particular problems with lenses). It is interesting to take rapid motorized sequences underlining the skill of the figures performed through the air in fractions of a second. It is important to remember to include a reference point in the frame in order to be able to interpret the pictures fully and to be able to answer the instinctive curiosity of those who want to know the position of the athlete relative to the ground. Pointing the lens at the sky can give deceptive readings on the exposure meter and lead to underexposed photographs.

Left: A hotdog acrobat photographed with an 80mm lens from close range (1/500, f/8). The spectacular nature of the somersault is emphasized by the reference of the trees and the ground.

The kamikaze bobsled teams

The crews of the two- and four-man bobsled teams go down iced tubes of track at speeds of about 130kph (80 mph), challenging the hands of the stopwatch. The classic competition route is over 1500 meters down a fifteen percent slope, which also goes around at least fifteen banked curves. A perfectly frontal shot or one taken as the bobsled comes out of a bend, hanging perilously on the side wall of the run, is the best. More panoramic shots are also interesting, for they put across the diffi-culties of the run.

Left: A night shot taken with a very bright 50mm lens and 400 ASA film. The frontal angle solves the problems created by the speed of the bobsled and makes it possible to use even the relatively low speed of 1/60 second. Below: A fast-moving team frozen at 1/1000 second. The same angled position indicates the speed. Bottom: The push start, which is often crucial to the result. Unusual photographs can also be taken from behind the athletes with a powerful telephoto lens.

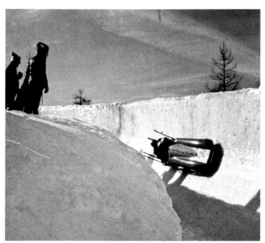

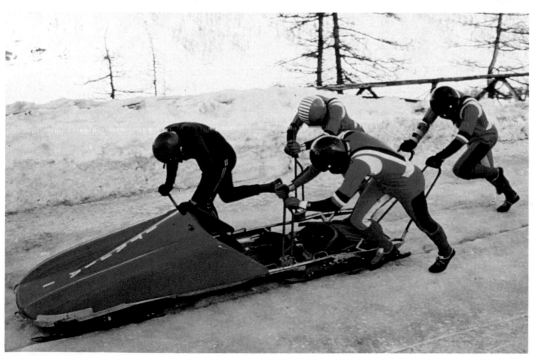

On ice

In speed skating, there are time trials, team relay races, and chases that all take place on an iced track. The sport is not particularly inspiring from the photographer's point of view, but one can get good shots of the skaters' aerodynamic positions, particularly as they come out of the turns and try to gain maximum thrust. The speed of the skater lends itself well to panned lateral shots, but not against the uniform background of the ice, as this removes all the dynamism of the action. A frontal shot with a good telephoto lens (300mm or more) is the best, as it shows the athlete hurtling towards the spectator, but this means lining the camera up on a support and focusing on a reference point; you must have quick reflexes in taking the shot (slightly before time to compensate for the inertia delay) when the skater reaches the set point. It is better to use speeds of no less than 1/250 second. Figure skating poses different problems—you will find the same difficulties as in any other kind of indoor photography, but knowing the figures and rhythms of the moves can be a great help.

Below: The use of a 300mm has isolated the athlete from the background, which is distinguishable but not obtrusive and thus projects the action toward the onlooker.

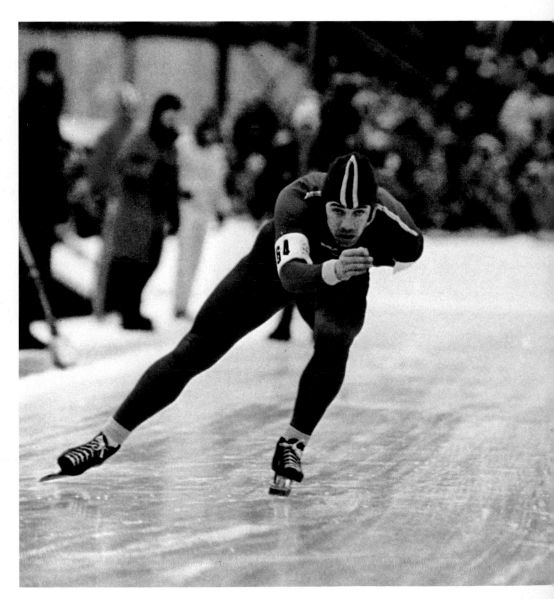

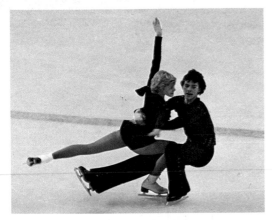

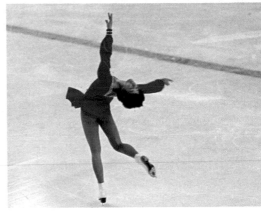

Balletic figures

Figure skating competitions generally take place indoors under artificial lighting, which requires the use of high sensitivity film. The most interesting of the different types of events is pair skating. Because of lighting problems, which generally prohibit the use of very fast shutter speeds, particularly with medium range and long-focus lenses, it is very useful to know the balletic figures used in well-con-structed routines. In this way, it is possible to pick out the brief moments of rest that can be found even in the whirling spins performed by the skaters, which coincide with certain peak positions at the climax of a dance figure. Pair skating offers a photographic subject that is constantly new in its acrobatic evolutions. Some of the figures are also good for effective interpretation using deliberate blurring.

Skateboarding

Originating as a summer fad some years ago, skateboarding can now be considered a true sport. There are cement tracks in the United States where skilled exponents of the sport carry out authentic acrobatic feats. The photo above was taken on one of these during a dead point at the top of a banked curve. Slight flash lighting has toned down the effect of backlight and illuminated the subject in the foreground.

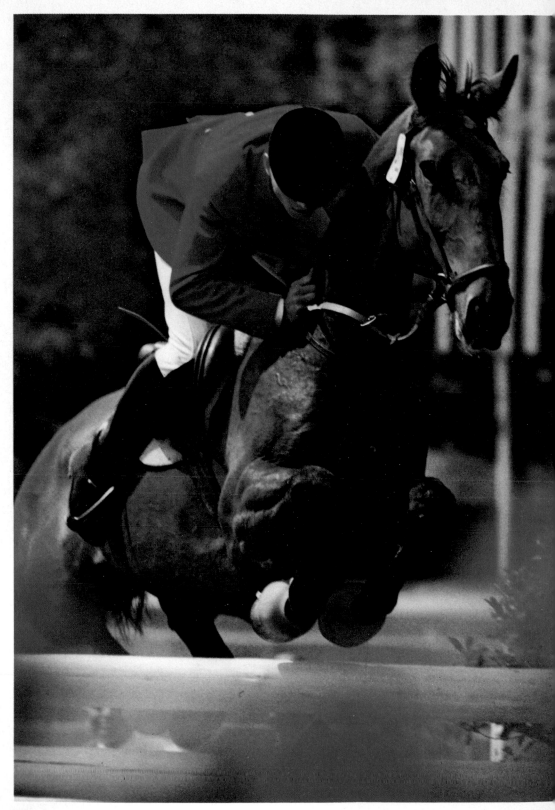

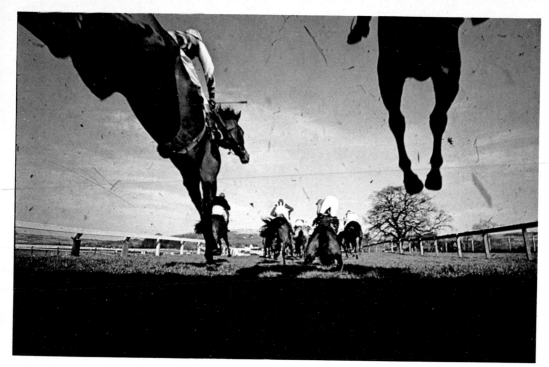

Equestrian sports

The eloquent, powerful movement of the horse and its rider's ability to make it gallop or jump without falling off present some of the sport photographer's most inspiring subjects, and also recall the early days of photography when a sequence of the various movements of the horse celebrated the conquering of the instant. Races or trials of riding skill fall into basically three categories: horse racing, trotting, and show jumping. Each of these specialties presents the photographer with slightly different problems, although the main problem for the amateur is getting close enough to the subject and finding more original viewpoints than the TV angles you get from the stands. Long-focus lenses are almost essential unless you can get to certain key positions. Horse racing is a challenging sport that takes place on oval courses up to 3km (2 miles) long. The horses leaving the paddock, coming to the starting line, and setting

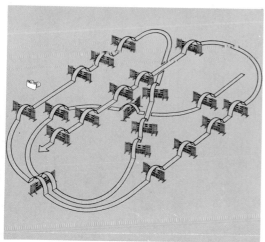

Show jumping

Show jumping events are tests of skill in which the rider has to face a series of characteristic fences. The peak moment for the photographer is when the horse is completely off the ground, clearing the fence with its front hooves over the bar. The ideal position is in front and slightly at an angle, looking up to emphasize the sense of elevation. A medium range telephoto lens is most commonly used, but a wide-angle lens can also

result in interesting photographs when used from a viewpoint immediately behind a fence.

Opposite: A perfect composition rich in technical information, which brings out the interdependence of rider and horse. Right: A fall, which is not uncommon in show jumping. The drawing gives the layout of the course. Top: A remote-controlled camera with a 20mm lens made this suggestive "live" shot of a steeplechase possible.

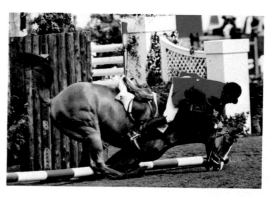

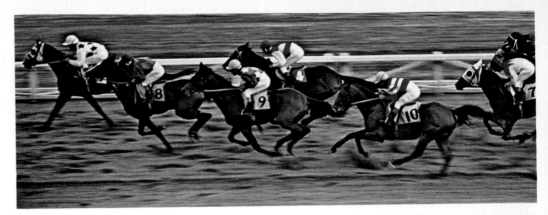

off are the key points of the action, which fans often have to follow with binoculars. The opening of the starting boxes, when the horses surge forward, is lost to the public in the stands; but the photographer can create an original report of the events if in a suitable position. Sequence shots can also break the action down into significant moments. You get only a fleeting glimpse of the group of horses and the jockeys in their bright colors from the sides of the track, so you should photograph the group before it comes even with your position. You might try to catch the horses as they come out of a bend into the last stretch, framing from a distance away with a 300mm or more telephoto lens to isolate the horses and compress them into an effectively tumultuous composition.

Photographing from below increases the spectacular effect of the horses under gallop, and focusing on a reference point on the track allows you to devote all your attention to the photograph when you have carefully chosen your frame. The very limited depth of field on powerful telephoto lenses makes it difficult to keep all the horses in focus

Three ways of looking at a race
Above: A lateral shot using the technique of panning gives the classic photofinish effect of the winning line. Right: A moment often ignored because it is out of range of the public—the horses coming out of the starting boxes. Below: A frontal shot with a 400mm telephoto lens has compressed the group and makes you feel almost as though you are in the middle of the track with the horses bearing down on you under gallop.

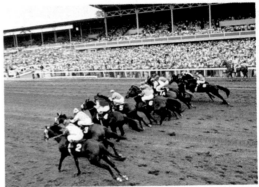

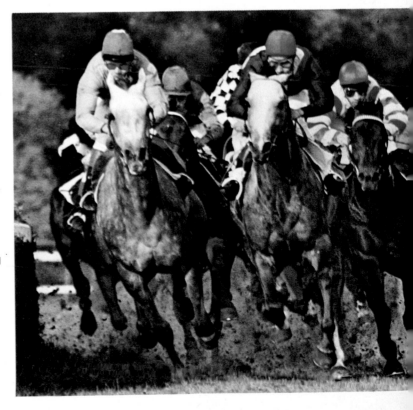

when they are staggered, so it is wiser to focus sharply on the leaders and hope that they are all in line. Selective use of depth of field (which can always be modified by altering the diaphragm) can be useful in emphasizing the distance between the leaders, but when a group passes in front of you, the classic method is to pan, which is much more effective if done from a certain distance away with a 100mm or 135mm lens and a shutter speed of 1/125 sec. The hooves also blur, as well as the normal blurring of the background, because of their different relative speed to the main group itself. The photographer may prefer the more technical specialties of steeplechasing or the more aristocratic show jumping with its usual frame of fashionable society to the pure speed of horse racing or trotting. Steeplechases and the even more gruelling cross-country races are much more difficult competitions, with mass falls occurring frequently at the hurdles. The most difficult and spectacular jumps are the water jump and the ditch, for the fences make no allowances for horses that do not jump high enough. An elevated viewpoint can effectively convey the sensations of this particular type of race and also brings out the difficulties of the track. Three-day events are also particularly interesting, as they demand everything of both the horse and its rider in the dressage, long distance, and jumping, and challenge the photographer with many situations.

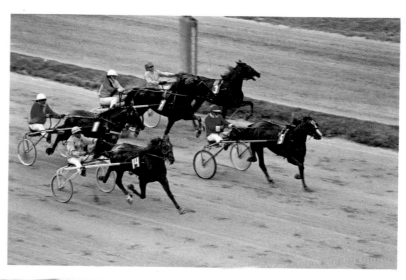

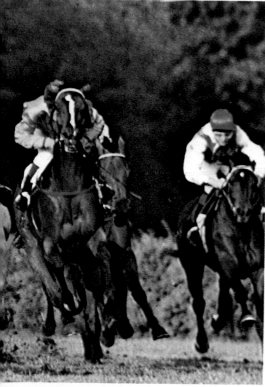

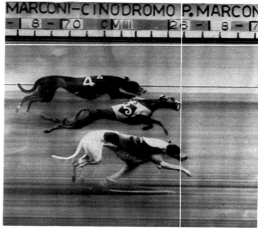

Top: It is possible to photograph some of the exciting stages of a trotting race from the stands if you have a good, manageable telephoto lens such as the 200mm. Above: Only a photograph of the finish can often decide the exact order of arrival when dealing with the great speeds of dog racing. The dogs chase a mechanical hare, which runs on rails around the circuit. The betting that accompanies this kind of competition (as in horse racing) can provide an interesting and original subject for indirect photographic reportage.

Freezing the race

The picture above was achieved with technical skill inspired by the special demands of sports photography. The great pace of the greyhounds was photographed from below, so the effect of the dirt flying is the more spectacular. The speed of the action and the poor ambient light required a double battery of electronic flashes, which are shown in the drawing, with the direction of the flash angled at forty-five degrees. The position chosen at the first bend was proved by experience to be the most interesting, because the dogs are still in a tight pack. The direction of the flash lamps directs the viewer's attention into the middle of the pack; this is further achieved by the effect of the dirt being tossed up by the strides of the leading hound, who appears as a dark shape. The use of a flash gives maximum depth of field with a 85mm lens. Three days of hard work were required to prepare for this extraordinary photo.

Right: The horse and its following of beagles specially trained for the foxhunt make an excellent subject for this elegant composition, which depicts well the character of the sport.

Opposite, center: Returning from a winter's outing. Opposite, bottom: Part of a polo match, which is played on a field measuring 150×300 meters (500 × 1000 feet), between two teams of four riders each. An 80–200mm zoom lens can be very useful and you can wait near the goal line at the end of the field for the action. The game is most commonly found in England and associated countries.

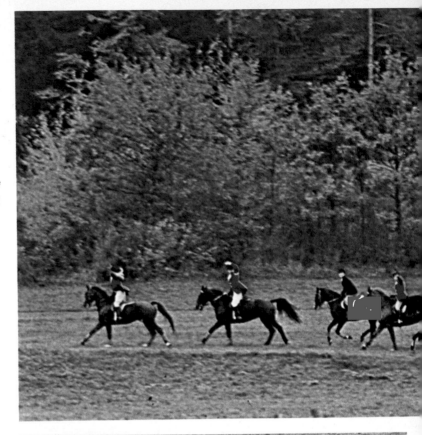

The colorful foxhunt
Right: Steeped in the frame of the English countryside in its autumn colors, the hunters follow close behind the pack. The hunt is, in fact, an excuse for spending a few hours riding in the country and often ends without having shed any blood. The photographer can draw a great deal of inspiration from the colorful dress of the riders and the baying packs of hounds.

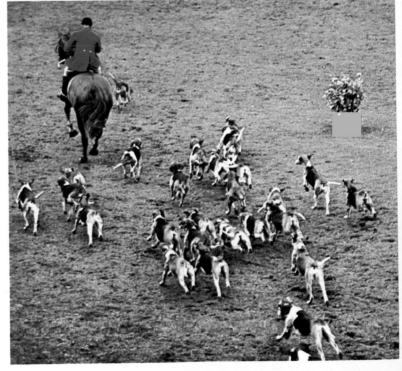

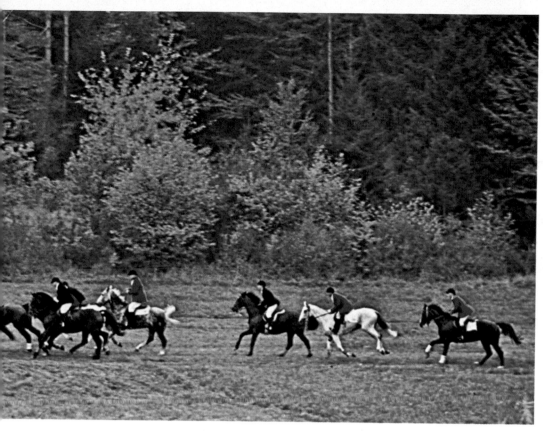

On horseback in the country

Far from the urgency of desperate competition, which is a significant part of many other sporting activities, horseback riding in the country provides the opportunity for leisurely, peaceful communing with nature. The photographer must put the key to the right interpretation within the frame of the action, for any observer with sensitivity can draw stimulation from the countryside, given the relationship and proportions of the subjects in frame. If anything, the technical problems of a photographer with cumbersome equipment lie in being accepted by the group of riders, so try to limit yourself to items that are absolutely necessary. Carry your equipment in a bag or pack with a sweater or towel in it to keep the various pieces from being jostled about by the rhythmic movement of the horse. Fasten the bag securely to your body, and try to have enough presence of mind to protect it if you should happen to fall. Country riding lends itself well to good effects such as lying down behind a fence with a 200mm lens and taking the shot as the horses jump, or using a 135mm to photograph a group of riders crossing a ford, slightly against the light. The unrestricted field of movement allows all kinds of experimentation, and the experience gained with a group of riders in the countryside will prove to be invaluable training for taking pictures at serious competitions.

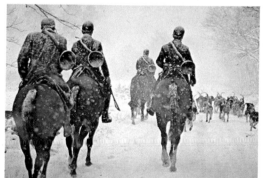

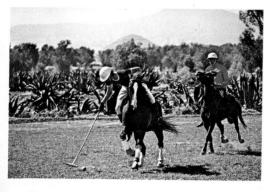

The photographer as hunter

The concentration, dedication, and at times physical effort required to control heavy equipment and change position quickly make the sports photographer comparable in a way with what he frames in his viewfinder. In fact, many noncompetitive sports such as climbing or sailing on the high seas demand the photographer's participation, but sports and photography are actually one and the same thing on a photographic hunt. The fascination of this activity is found after long hours of waiting and the tiring efforts to get close to the animals, with the rewards of capturing the elegant dance of a heron, the noisy takeoff of a duck from the waters of a marsh, a chamois bounding among the rocks, or the majestic flight of an eagle. The prey of the photo-hunter is an image of life captured on film forever. In areas like oases, or in national parks, you can actually get close to the animals and take splendid pictures with a medium range telephoto lens; but the essential "weapon" is a long-focus telephoto lens or a light 500mm or 1000mm mirror lens. High sensitivity film allows you to work with the fast shutter speeds necessary. Photographic hunting is an avocation that demands of its devotees a good knowledge of nature and a deep interest and great respect for the natural environment.

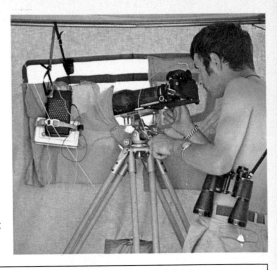

The photographic hunter's equipment

The photographic rifle consists of a special support, which is very handy for using lenses up to 500mm freehand. Shutter release is operated by cable from the grip. At right, the ideal equipment for the travelling photographic hunter, although if you want to work from ambush, you will need a solid tripod, powerful telephoto lenses, a blind, and a great deal of patience.

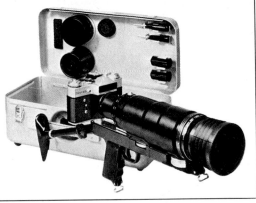

Roadwork

Photographs of footracing, and of cross-country running in particular, should always include elements of the natural surroundings, such as wet ground, trees, and the green of the grass. A medium range telephoto lens used from a lower position gives the best results when the frame is chosen in advance. The moment in which the stride is at its maximum extension conveys the speed of the athlete most effectively. Panning also gives excellent results. Left: The marathon runner Franco Fava during a training session in Trentino, Italy. A 200mm telephoto lens has framed his movement in the splendid green surroundings of the wood.

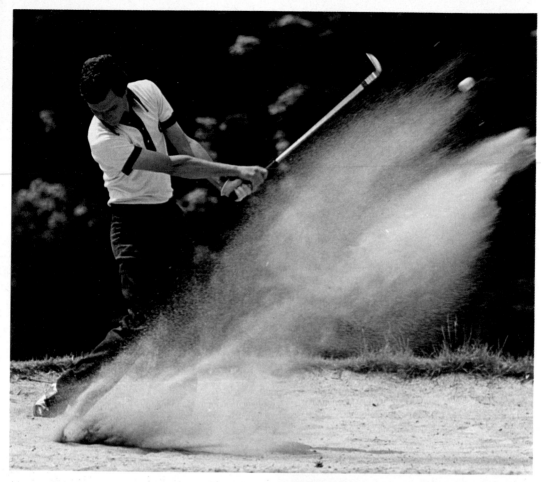

Golf and archery

Not even a motor can ensure good shots of a golfer's swing, as the speed of the action is such that you have to release the shutter early to include the ball in the frame, which requires almost as much concentration as the player needs to make the shot. Above: A golfer in action. The shutter speed of 1/1000 second has frozen his movement at the most vivid moment. During competitions, a telephoto lens of at least 200mm allows you to stay far enough away from the players and not disturb their concentration. With very powerful wide-angle lenses, using their very great depth of field to the full, you can obtain interesting frames from a position on the ground with either the ball or the hole in sharp foreground.

Archery also offers a whole range of good subjects, of which the details can make up a very interesting story in pictures. Left: A group of archers taken in a lineup with a 300mm. Above: An interesting detail picked out by the photographer.

In the arena at five in the evening

Hemingway once wrote that the bullfight is the soul of Spain, and bullfighting is in fact full of ritual, sport, and tradition. The most frustrating position for the photographer is in the stands, as it is almost impossible to use a good telephoto lens because of the exuberance of the fans. The best rows to work from are the first few beyond the barrier. From this position, good shots can be taken with a 135mm or 200mm, keeping the public in the frame to give greater meaning to the skill of the matador. Knowing the figures performed with the cape and the muleta (the bullfighter's red flag) is essential if you are to know when to shoot. It is also important to be constantly ready to shoot the many and frequently dramatic moments when the bull gains

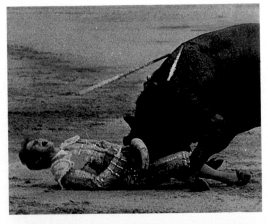

the upper hand.

Above: The corrida as seen from the normal position in the stands. Below: A different position, the right lens, and good timing are behind this picture, which sums up the eternal themes of the bullfight—elegance and courage against the brute strength of the bull. Left: The roles are reversed here. El Cordobes is lying on the ground, his face contorted with pain (Madrid, 1964). The elegance of the turns in front of the bull and the perfection of the figures make a motorized camera an asset.

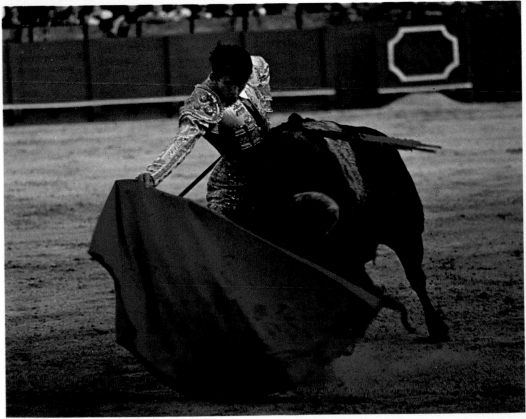

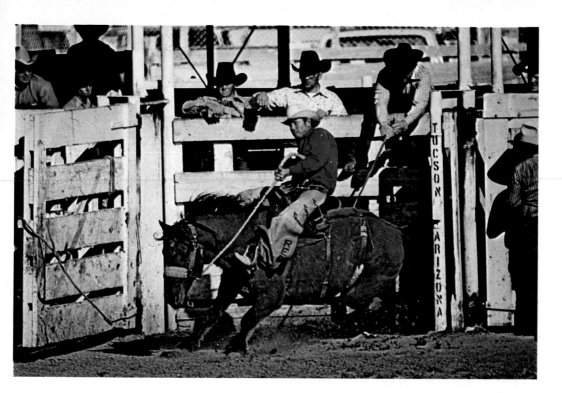

The sporting spectacle

In the arena, competitors challenge each other or defy the laws of gravity and balance, and an audience cheers them on, whistling and applauding, yet mainly wanting to enjoy themselves. Sports spectacles include Spanish bullfighting, American rodeos, the medieval horse races celebrated in various regions of Italy, the tug-of-war of country festivals, and circuses the world over. They are also the occasions on which perhaps most tourist amateur photographers get the opportunity to photograph live sporting events, although, unfortunately, the right lens for the job is hardly ever the normal 50mm lens fitted on the camera. Even when travelling, the light, universal kit of a 24/28mm, 35/50mm and a 105/135mm lens is ideal for all possible situations. A doubler is also useful for converting the 50mm lens into an acceptable medium range telephoto lens in order to overcome the problems of a bad position. The audience itself can be a good subject for the photographs. A bright medium range telephoto lens and 400 ASA film are advisable in circus tents. A good blurred effect can be obtained by photographing the somersaults performed by trapeze artists at 1/15 or 1/8 second, making sure that the background is steady.

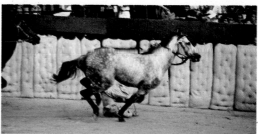

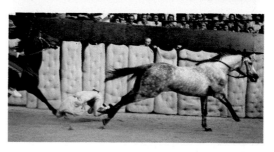

Top: Coming out of the chute at a rodeo. The bucking of the horse makes it necessary to use shutter speeds of no less than 1/500 second. Right: A motorized sequence taken during the Palio horse race in Siena, Italy, at the difficult San Martino bend.

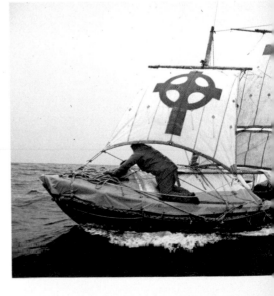

Brendan's odyssey

There is still room in the world for adventure, so after the *Kon-Tiki* and the *Ra* expeditions, another boat took to the sea in the wake of the ancient legends. Five Englishmen took thirteen months to cross the 4,500 miles between Ireland and the American coast in an eleven meter (36 foot) boat built on the lines of the medieval curragh. They followed the same route as the one taken in 580 A.D. by Saint Brendan and other Irish monks. The photos show the expedition under sail in the *Brendan*.

The photograph as document

All photographs are by their very nature a record: they arrest a moment in time, a fragment of reality that is frozen as if by magic within the frame of a photograph, creating an illusion of life. In some "fringe" sports, photographs provide an objective record, giving information and passing on experiences. In 1967, news came through of the progress of Francis Chichester on his single-handed voyage around the world in his boat, *Gypsy Moth.* In fact, it was a photograph taken from an airplane of the ship rounding the legendary Cape Horn in a force seven wind that captured the world's imagination. The camera has recorded all the last great adventures of modern exploration, from the conquest of Mount Everest to the ocean crossings of *Kon-Tiki* and *Ra* to the astronauts' first steps on the moon. The extremely severe environmental conditions and the difficulty of using a camera at the most intense moments of a major undertaking push technical and aesthetic problems into the background. The photographs taken draw their meaning and value from the unique nature of the experiences undergone, and very often they fit more into the category of history rather than sport.

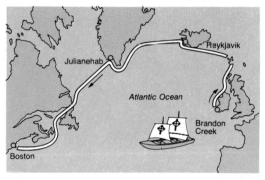

Left: The route taken by the *Brendan* (see photos opposite) to make its adventurous crossing from Ireland to the New World.

Photography in grottoes

The dark and mysterious world of the grotto presents the photographer with the same problems as climbing, but in reverse. But that's not all: There is also the darkness and the consequent need for artificial lighting as well as the knocks, mud, and damp that the camera is exposed to. High sensitivity film and long exposure times must be used in the ambient light produced by torches or the weak light that filters through from the surface, but if clear flash lighting is used (as it is brighter than blue flash lighting) a medium type B film is preferable. Flashbulbs are generally brighter than electronic flashes, although the latter are more convenient and easier to use. Avoid direct light, even to the extent of setting up a dark foreground in an illuminated background if necessary. In vast expanses, it is better to increase the diaphragm by one or two stops more than the guide number. You might use open flash (which allows repeated use of one or more flashes) to illuminate large areas of complete darkness; the shutter should be set to the T exposure with the camera resting on a support as the flash is set off in various directions. A waterproof housing is useful, even if it is only homemade, to protect the camera and films. A wide-angle lens is always useful on these underground expeditions.

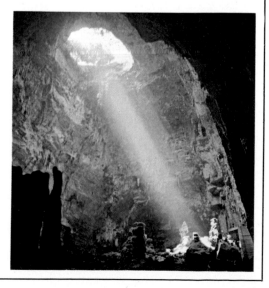

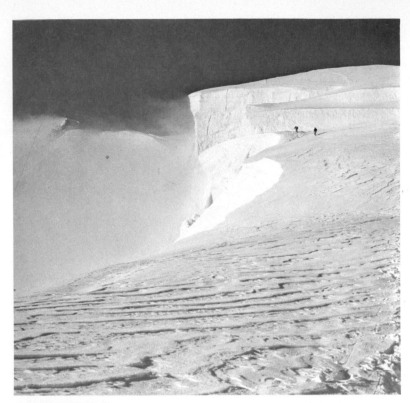

Problems caused by temperature

Cold and heat are two formidable enemies of both the camera and the film. At temperatures below zero, the cold can affect certain important mechanical functions of the camera, but the danger is even greater in damp conditions, since the humidity can freeze inside the camera and jam the shutter, the focus, and the mirror. Silicone lubricants have solved some of the problems, but in extreme conditions it may be necessary to remove all lubricants completely. Cold cuts down the efficiency of the batteries and makes the film very fragile, and, at very low temperatures reduces the sensitivity of the film. The humid heat of tropical climates, on the other hand, can cause the formation of mold, alter the film emulsions, and unstick the lenses.

Top: A line of climbers heading for the peak of the Ortles, buffeted by the wind. The height of the mountain often creates difficult conditions (Yaschica Mat 124G, 1/250, f/8). Right: The monochromatic black and white colors convey the threatening atmosphere of a descent made in bad weather in the Dolomites. Above: This historical photograph shows Sherpa guide Tensing Norkay on the peak of Mount Everest (8848 meters / 29,000 feet). The photograph was taken by his colleague Sir Edmund Hillary on May 29, 1953.

Impossible conditions

The expiration date and sensitivity values of film and the conditions of use of the equipment are given with reference to the optimum photographic conditions, with temperatures of 20°C (68°F) and a relative humidity of 50–60%. When the conditions of use are far outside these values, you have to take certain precautions to ensure successful results. At polar temperatures, shutter operation is anyone's guess: the completely lubricant-free cameras used by Bonatti and De Biasi in their report on the "cold pole" in Siberia (–65°C) jammed after three or four shots. In these conditions, the simplest cameras are the least vulnerable, as is black and white film, which is much more resistant and less critical than color film. Handling the camera in the cold is

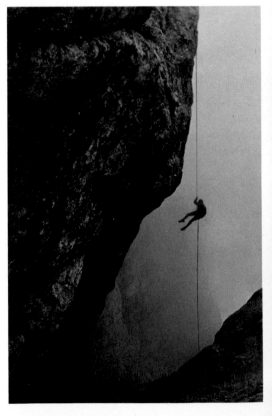

The dry climate of the desert also poses certain problems for the photographer. Above: A sand dune in the Erg d'Admer in Algeria (Nikkormat FTN, 35mm lens).

The primary enemy in the desert is sand (rather than heat), as it gets in everywhere, grinding the lenses and jamming internal mechanisms.

easier if you use the climber–photographer's system of very light silk gloves worn beneath heavy outer ones. You should take care when changing the film in the open air (remembering not to breathe on the shutter) and try to avoid condensation effects in rapid changes of temperature. Some companies make motors with an independent battery case you can keep in your pocket for special use in the cold. It is better to keep the exposure meter batteries in your pocket as well until they are needed. In tropical climates, the film should always be kept in its original sealed container or, better still,

in a box hermetically sealed with silica gel, or in a heat resistant bag, and it should be developed immediately after use. Static can build up in dry climates (whether hot or cold) when you wind on or rewind the film, so this should be done with great care. In the desert sand is a formidable enemy, so a filter should be fitted over the lens to stop it from being scratched, and the camera should be protected particularly against the wind. Well-known for sturdiness and exceptional water-resistant qualities is the Nikkor Calypso, which deserves its reputation as an authentic "off-the-road" camera.

The camera on the moon
More than 33,000 pictures contained in 266 magazines, representing 9000 hours of shooting time in all, gave a direct view of the space ventures that culminated with the moon landing on July 20, 1969. Fifty-two special Hasselblad cameras were used, based on the 500EL/M. They were motorized, had no mirror, and were treated against UV and radiation.

Underwater photography

Experience, constant self-control, and good resistance under water are the basic requirements needed to attempt underwater photography. There is a silent, unreal world just below the water surface where the diver moves with a constant sensation of discovery. Seawater acts like a filter that progressively absorbs all light radiation: in optimum conditions of visibility and clarity the first 3 meters (10 feet) are reasonably balanced, but beyond this limit, blue becomes progressively dominant. Below 15 meters (50 feet) all the colors disappear and the photographs become monochromatic in tone; and only a flash can restore the brilliant natural colors to the flora and fauna of the deep. Below 100 meters (300 feet), the darkness becomes total. The water also acts as a lens that brings everything closer by about a quarter, but this phenomenon is automatically removed when you focus in accordance with what you see. There are a few simple rules to remember for photographing in ambient light: increase your aperture one or two stops once below water level and another stop for every five meters (16½ feet) of depth and distances over 2 meters (6½ feet), although the clarity of the water will obviously vary this rough guide. It is also advisable not to get more than 2 or 3 meters (6½ to 10 feet) away from the main subject. Grottoes and reef outcrops give the best natural frame for underwater photographs. The lens effect of the

Universal housings

Any normal camera can be encased in a waterproof housing for use under water. In fact there are special-purpose housings for certain cameras such as the Rollei 6 × 6 and more economical universal housings. The most common materials used are plastic and Plexiglass. Spherical portholes can be used instead of flat ones for special shots and to eliminate the effect of refraction on the distance and focal length of the lens. It is impossible to read an exposure meter inside a watertight housing, so underwater exposure meters such as the Nikon Sekonic Auto Lumi L86 are necessary. Right: The Nikkor Calypso. Below: Discovering the silent world under water.

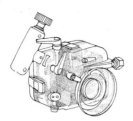

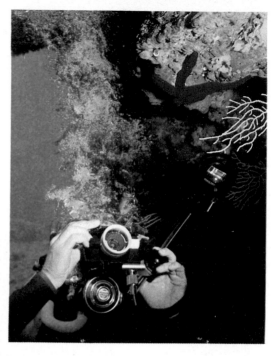

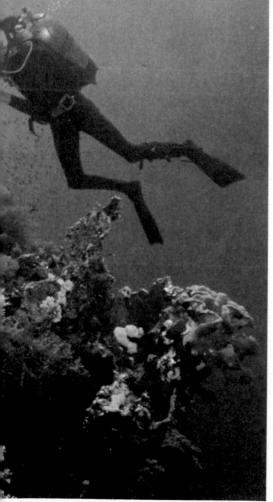

The Nikkor Calypso

This is an underwater camera made by Nikon that functions equally well above water. Its sturdiness and watertight casing make it the ideal camera for caving, climbing, sailing, and travelling in difficult conditions. The metal parts are given an anticorrosion treatment, and the camera itself has a three-part structure sealed with rubber O-rings, which protect it from water up to fifty meters (165 feet) below the surface. It uses normal 35mm film and interchangeable lenses—the 35mm f/2.5 and 80mm f/4 for use above and below water level and the 28mm f/3.5 and 15mm f/2.8 for use under water. The camera has a simple connection for flash, rubber controls, and an external viewfinder for underwater use. The internal viewfinder is Galilean (not reflex), the shutter speeds range from 1/500 to 1/30 second, and there is no exposure meter.

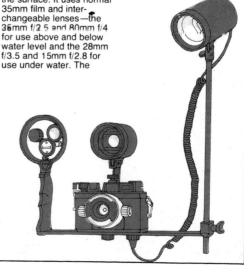

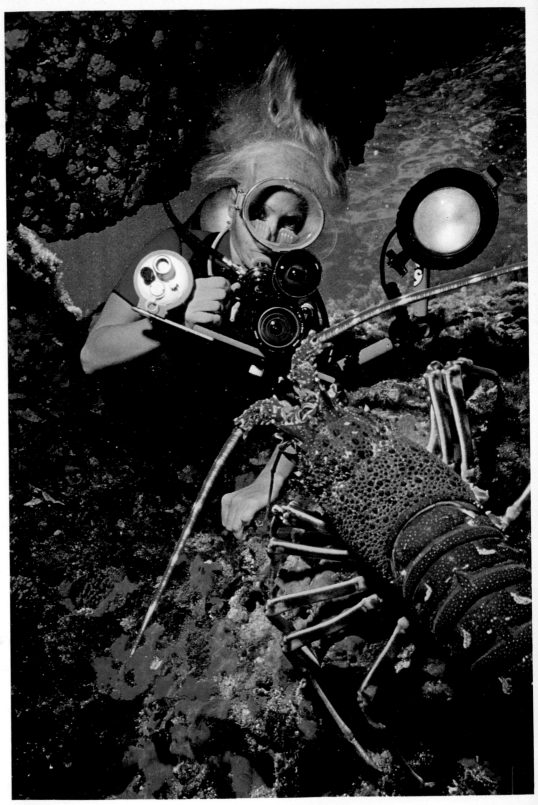

water also alters the focal length, making a 35mm a normal 46mm under water. As a result, it is better to use a powerful wide-angle lens such as the excellent Nikonos 15mm f/2.8, which was specifically designed for use under water, and take the subjects from a close range to maintain an acceptable contrast. External viewfinder sights are produced to overcome the problems of framing while wearing a mask. In order to get good results in ambient light, you should not go below 5 or 6 meters (15 or 20 feet), or you can use back lighting by pointing the camera toward the surface, though this does show the subjects in silhouette. High sensitivity film can be used to extend the depth of field to the maximum. A flash or electronic flash, of which there are various types and strengths, is

essential to give a true reproduction of the colors. The guide numbers can be reduced to a third of their value below water, and the direction of the flash should be angled away from the subject to avoid clouding it by illumination of all the suspended particles in between. The useful distance of the flash will be no more than 3 meters (10 feet); beyond this limit, the blue filter of the water will also absorb the light. White light works better under water, but before you can use a flash with confidence, you will have to try various test shots in the widest range of conditions possible. If the camera gets wet despite its waterproof casing, you should soak it immediately in fresh water and take it to the nearest laboratory to prevent salt from corroding the internal mechanisms.

The drawing shows the effect of water on light, with its progressive absorption of the different wavelengths. The first color to disappear is red.

Opposite: A good underwater close-up from an original angle. The photograph

won the first prize in the world underwater photography competition in Cala'mpiso in 1979.

Top: The back light has dramatized this exciting meeting between the diver and the enormous sperm whale.

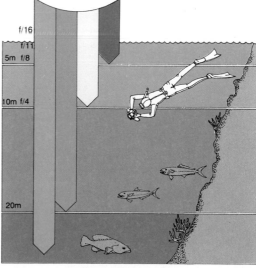

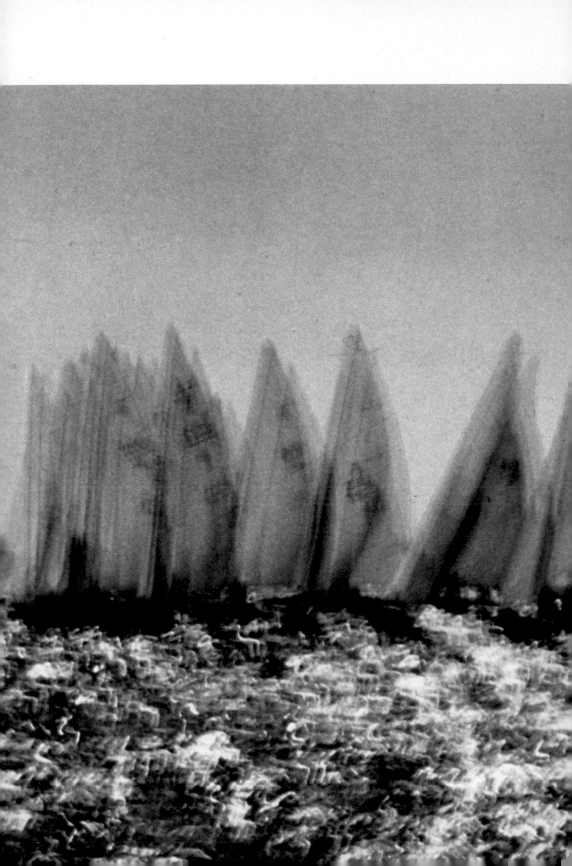

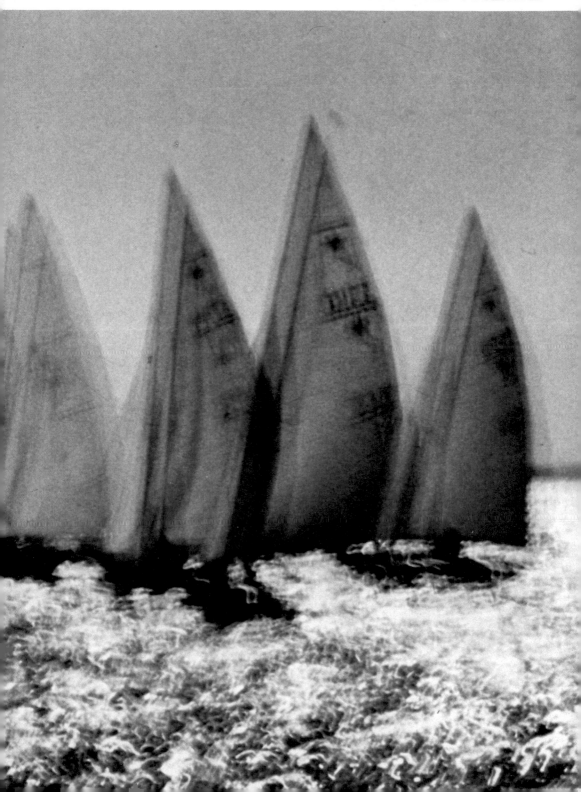

SPORT AS A CREATIVE THEME

The search for the original

Photography is usually divided into two categories, the "documentary" and the "creative," to show that even the apparently cold, mechanical, and reproductive techniques of photography allow those who have the gift to create unique artistic expressions.

Although this distinction is convenient for explaining in broad terms the aesthetic possibilities of the camera, it underscores a nonexistent barrier between documentation and creativity. Only one common denominator exists between photographs of any kind, and it is determined by the techniques and language that any photographer can use to create images suggesting a variety of things, while still effectively imparting information. In fact, a photograph can be both documentary and creative at the same time. An original photograph can only show certain features and aspects (otherwise it is impossible to create), but it can often explain and illustrate an event much more successfully than a general, clear, and traditional "postcard" type of photo, which claims to include everything, but really says nothing of any interest.

There are no rules: a photograph can put forward an infinite variety of stimuli and expressions to whomever has the sensitivity, taste, and intelligence to interpret them to the full, yet it can still avoid run-of-the-mill visual effects. It is not only the 1/1000 second photograph with everything in focus that can capture a suggestive interpretation and analysis of reality: a blurred, streaked, out-of-focus, grainy, distorted, or elaborate photograph can sometimes capture and characterize a situation more clearly. The creativity of these pictures lies mainly in their being different, for their difference fascinates the observer and arouses his curiosity, suggesting all kinds of hidden mysteries. Yet even the most extravagant and abstract photographs are produced from a direct view of reality and are the result of a process of visualization that can be successful only if you know all the techniques and can use them effectively. Imagination and ideas are not sufficient in themselves to enable you to escape the conventionality of the déjà vu.

The most basic (yet interesting) possibilities of a subjective approach lie in getting inside the mind of the athlete and picking out an expression, grimace, gesture, or action that would normally escape the spectator's eye. Such an approach can effectively convey the feel of the event, such as prematch nerves, the stress and fatigue on the face of a competitor, the sudden elation that erupts after a victory, or the very human dissatisfaction at being beaten. These can produce a lively and surprising account built up through a series of close-ups that stand out from the normal chaos of the whole. Alternating panoramic shots with detailed pictures by using a second camera or changing the lens enables you to build up the whole story in a sequence of relevant episodes. Or you can point the lens at the public, the other face of the competition or event, to complete an amusing, provocative, or simply original report.

Those who are more creative can experiment with the techniques of streaking, blurring, or exploding by using slow shutter speeds (up to 1/15 or 1/8 second), which do not arrest the action but allow the film to retain its traces, either longer or shorter depending on the speed and direction of the subject in frame. Very evocative pictures can be created in this way, particularly with color film, and these can often express the concept of movement more successfully than a frozen shot. Using a zoom lens, you can increase the possibilities of interpretation by altering the focal length during exposure to achieve the characteristic exploded effect. But these are not the only photographic tricks you can use: you can turn the camera around while taking the shot (with 1/15 second or slower, you can get some very strange effects), or you can use special lenses such as prismatics, distorting, or fisheyes, or color filters, to produce unique and improbable results. It is better not to overdo this though, if there is no real expressive, representative, or aesthetic need.

Further effects can be created in the laboratory, from simple partial enlargement to solarization, color keying, or chromatic effects. Surrealistic pictures can be created with photomontage, by superimposition, and by sandwiching negatives; but fortunately, you can be creative without having to resort to artificial techniques and tricks, for if you know how to "see" reality and take just the most useful elements, you can create your own pictures in a very original way.

The photographer's eye finds an infinite variety of stimuli and inspiration in sport, and even an original and at times very personal expressive language. The previous page shows the start of a sailing race. The photographer used a 1/5 second exposure to create out of the conventional elegance of the sails against the light an original visual study. The result is an image steeped in the magical atmosphere of a dream.
Opposite: A different way of looking at sports photography, that is, as a documentary vehicle. In this case, the Engadin Skimarathon has been photographed from a helicopter to reveal a new effect.

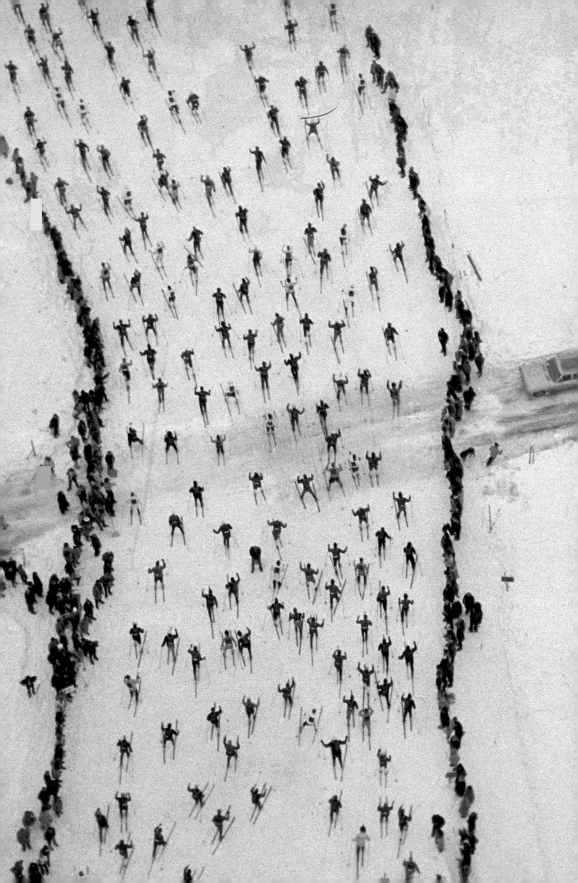

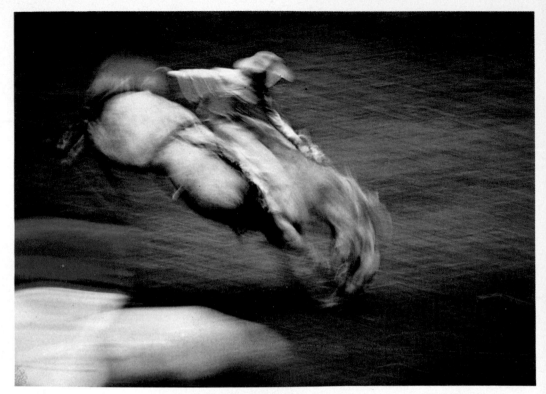

Special photographic techniques

The creative photographer is constantly on the lookout for new possibilities. The professional rarely ever uses these techniques to bring new life to old newspaper stereotypes, but the amateur is more attracted by special effects because of their fascination, magic, and mystery, as well as by the subconscious desire to be "artistic." The results can, however, often be rather strange and consequently uninspiring, so the photographic trick becomes nothing more than just that, though it does give some useful experience. One of the many possible effects is deliberate blurring, which has already been discussed. It was Anton Giulio Bragaglia who said in 1912 that instantaneousness kills the act, when he exhibited his futuristic collection of

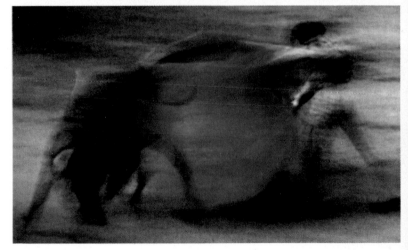

"photodynamics." These were actually blurred photographs which conveyed the movement by a trace on the film. The technique of blurring lends itself to an infinite series of variations. By changing your speeds and shooting techniques, moving the

camera or turning it when you take the shot, you can still respect the rules of "documentary" photography by keeping the main subjects clear, or you can convert the picture into an abstract, impressionistic composition. A photograph that is deliberately

Top: Ernst Haas, photographing the horse and cowboy at 1/10 second, has expressed all the energy and excitement of a rodeo in this picture. Above: The same technique has transformed the elegant "veronica" of the matador into a colorful impressionist picture.

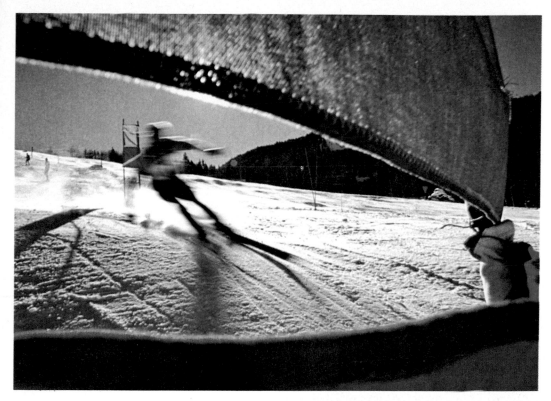

blurred, not by accident or mistake, can be very aesthetically suggestive, particularly if in color, as it spreads into bands that look like brushwork. It is not difficult to produce this kind of picture, but a lot of experience is needed to know in advance what the result will be like when using slow shutter speeds (varying generally from 1/8 to 1/30 second depending on the speed of the subject and its direction). Moving the camera should also be very

Deliberate mistakes

What would normally be a common mistake made by beginners can also be used deliberately and intelligently to create a personal and original visual effect.

Above: the arrival of the skier at a post in the giant slalom was taken at 1/60 second to transform him into a fleeting apparition. Right and below: Two possible interpretations of movement obtained by changing the focal length of a zoom lens during exposure. The motorcyclist at the bottom is in fact stationary.

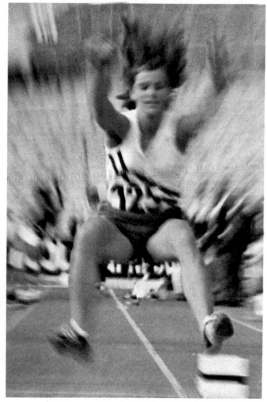

carefully planned and put into effect. A zoom lens increases the possibilities even further, for it enables you to create the exploded images that have made the fortune of many a poster just by rapidly altering the focal length while taking the shot. The shutter speeds must obviously be quite slow, no more than 1/60 second, and to capture the sensation of speed and movement fully, it is best to be in line with the direction of the subject, so as to give the picture a three-dimensional quality. Good zoom effects cannot be obtained from the side of the action, as it neutralizes the dynamism of the movement. Special filters and lenses give scope for the widest range of effects, though they are not always justified or justifiable. But it can be amusing to experiment with some of these accessories, from multiple prismatic lenses, which duplicate the figure, to color filters, even if only partial or homemade by greasing a transparent glass with Vaseline to correspond with the rim of the lens. Creating these effects is much easier in the darkroom,

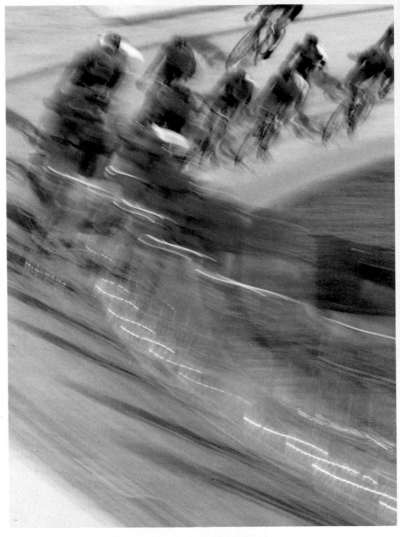

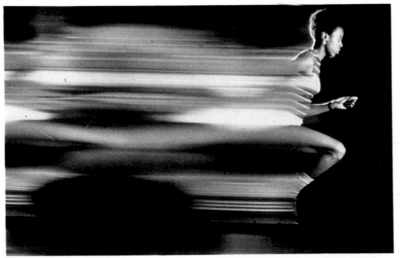

Special effects are not just the result of an accidental series of circumstances but require thorough knowledge of the subject and great technical and professional skill.

Top: This suggestive streak of cyclists was photographed at 1/30 second, taking advantage of the varying angular speeds of the subjects relative to the observer on the bend. Left: The athlete running was frozen by an electronic flash after having left a trace on the film with the shutter set on B.

but it is better to experiment on copies, so as to avoid ruining the original. One of the most famous effects that can be achieved in a darkroom is solarization, which is produced by subjecting the sensitive sheet (two-thirds of the way through development) to a dim light (a 25 watt bulb from a yard away for about a second) and then carrying on with normal procedure. In fact there are a thousand ways you can achieve different ef-

Below: The same technique as in the previous photos was used to take these two fencers in action. The blurred effects (which can be interpreted in countless ways just by setting different shutter speeds, varying the speed of the subjects, or panning the camera) are easier to get indoors because the weak ambient light allows you to use long exposure times without running the risk of overexposure.

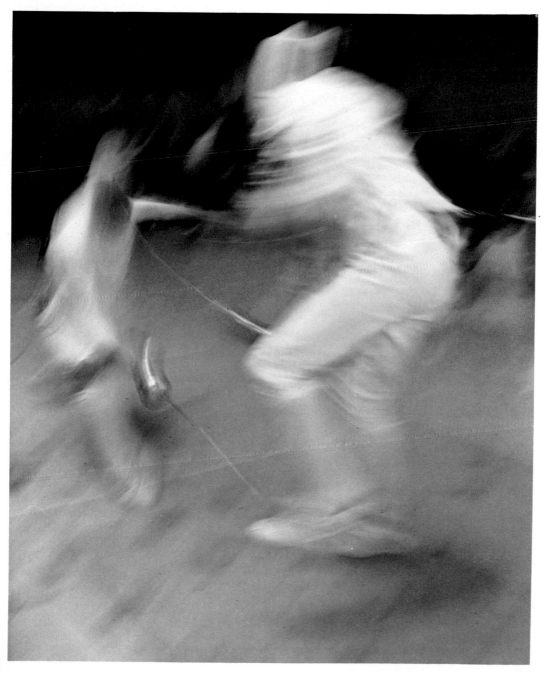

Above: This curious effect
was achieved very simply,
by placing a piece of frosted
glass in front of the lens to
transform the football play-
ers into a geometric patch of
color. Opposite, top: A
scrimmage taken from a
color TV screen. With

speeds over 1/30 second,
part of the screen would
remain in darkness (as it
would not yet have been
reached by the electronic
brush that recomposes the
image). Opposite, bottom:
Color processing during
printing.

fects in the darkroom. Agfacontour-Professional is a photomechanical film that creates interesting results, as the skeletal black and white images produced become new and curious figures when transferred onto commercial color-key material. Intelligent use of even the simplest flash opens up another whole new range of tricks, such as the dominants created by shooting the flash from behind a filter, double exposures in the dark, or movements frozen by a sudden flash after they have left their trace on the film in weak ambient light. Interesting color effects can also be obtained by using artificial light film in daylight without the recommended conversion filters, or infrared film in color. Infrared rays were among the first of those not included in the visi-

ble bands of the electromagnetic spectrum to be discovered in the early 1800s. Only in 1931 was it discovered that by adding certain colorants to the emulsions, infrared could be registered on a photograph, enabling you to see in the dark or in mist; and naturally, the first applications were of a military nature. Infrared color film allows any amateur to produce extraordinary effects with tones that are surprisingly different from those seen with the naked eye, the most curious being the transformation of green fields and leaves into a deep red. The use of filters spreads the colors in an infinite series of shades and tones, although focusing can be inaccurate because of a phenomenon of aberration which makes very small apertures essential.

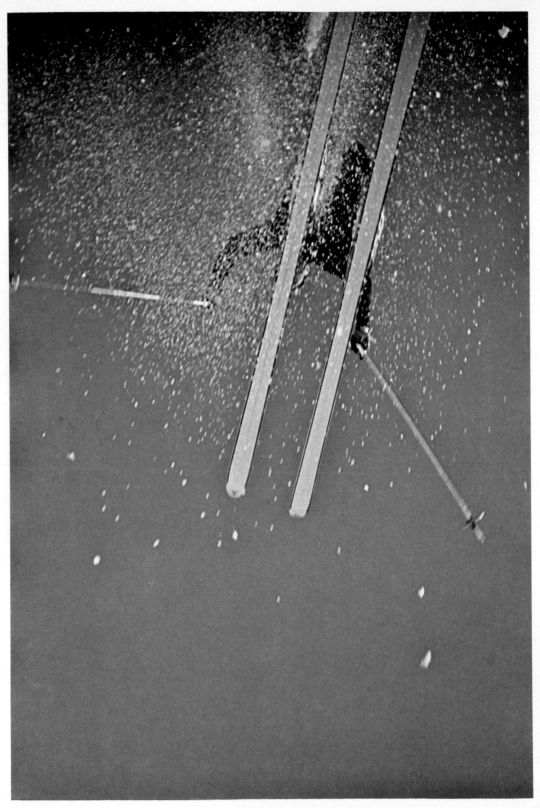

Effects without tricks

To get good special effects on a photograph, it is not absolutely necessary to resort to artificial devices. An original angle or viewpoint or just special shooting conditions can create a unique picture.

Opposite: The photographer stretched out on the snow on the far side of a jump to take this original picture with a 20mm lens. Below: The linear design of the scull was emphasized by the overhead shot taken against the light, which underlines its graphic elegance.

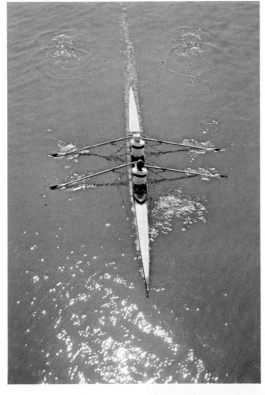

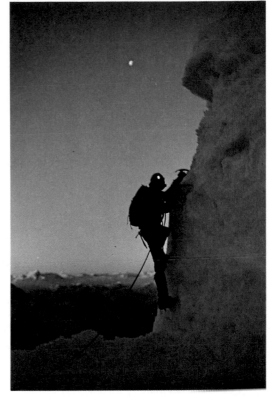

Back light

Most manuals warn against shooting against back lighting, but in certain cases it is precisely by picking out the dark shape of the main subject against a light background that the most dramatic and effective results are obtained.

Above: In the first light of dawn, a climber attacks a precipitous ice wall, still needing his helmet lamp. Different exposure, or even worse, a flash to illuminate the foreground would have "flattened" the image and destroyed its special atmosphere.

Sometimes just a reflection or flash of light is enough to bring out an atmosphere or situation and add value to an image by endowing it with a magical, timeless quality.

Right: The warm light of a sunset framing the rally car sets this picture apart from many others of its kind and has given it its own particular character.

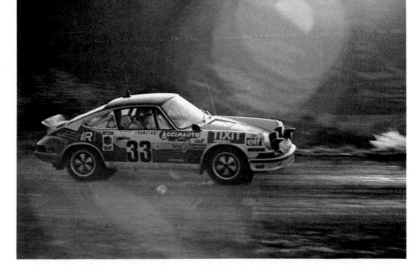

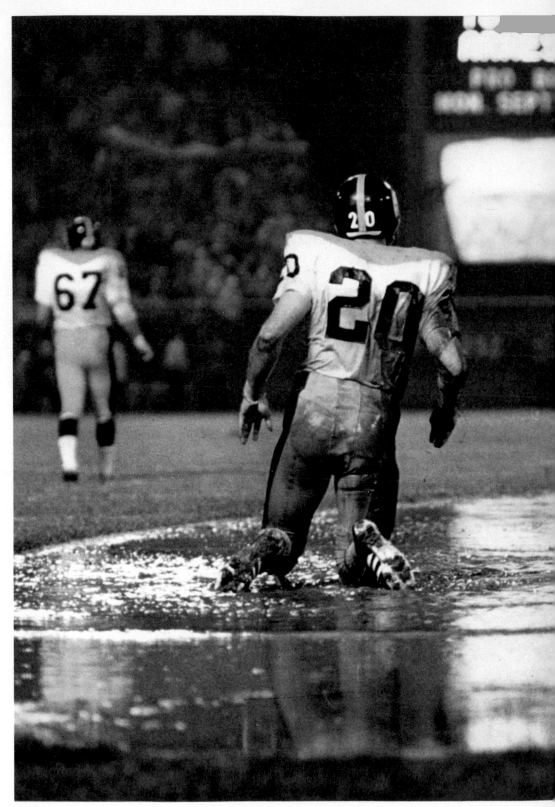

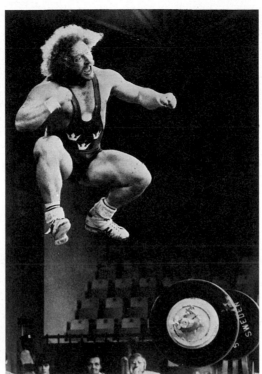

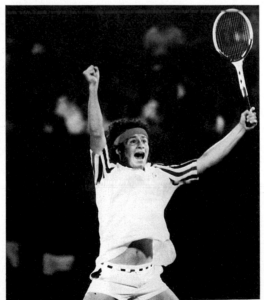

The play of emotions

Moments occur in every competition when the athletes depart from the strict rules and rituals of their events and react in the jubilation of triumph or the melancholy of defeat or failure. They are fleeting moments in which the emotions are difficult to hide, and the photographer must catch them as they occur, to add an extra human dimension to the competition. On these occasions, the athlete ceases to be a machine built of muscles and nerves and shows human emotion. When the strain of the competition is over, the athlete no longer needs total self-control, but can express joy, disappointment, anger, and pride through a gesture, a cry, an embrace, or a smile. This kind of subject is certainly less common than others and can be very stimulating for the observant photographer. The athletes' reactions are impulsive, but they are predictable to a certain extent if you know their characters, the importance of the prize, and their previous competitions. Following an athlete through the viewfinder with a telephoto lens powerful enough to bring the subject into close range, and filtering one gesture after another, tests the photographer's mental intui-

Victory and defeat

Opposite: The image of defeat—a player on his knees in the mud. A scoreboard in the background can be used to good effect by the photographer to explain the contrasting emotions. Top: The exultation of a weightlifter in Montreal in 1976, judged "the best sports photograph of the year."

Left: The triumphant gesture of tennis player John McEnroe.

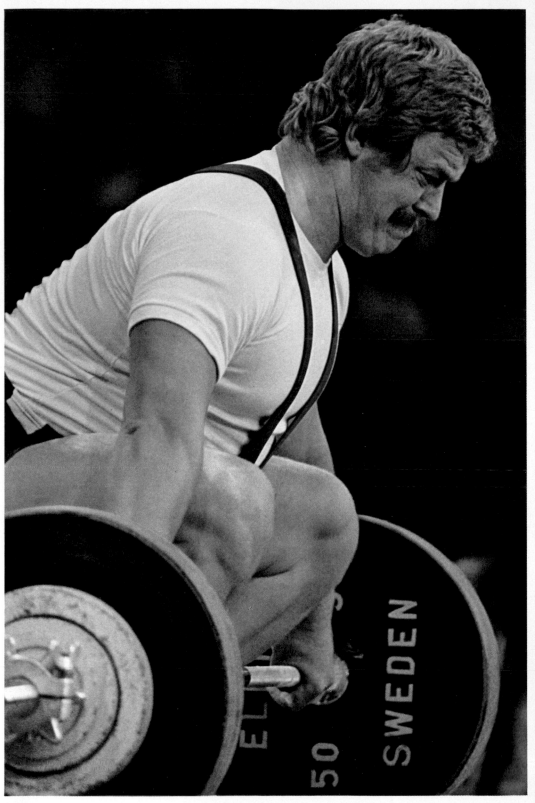

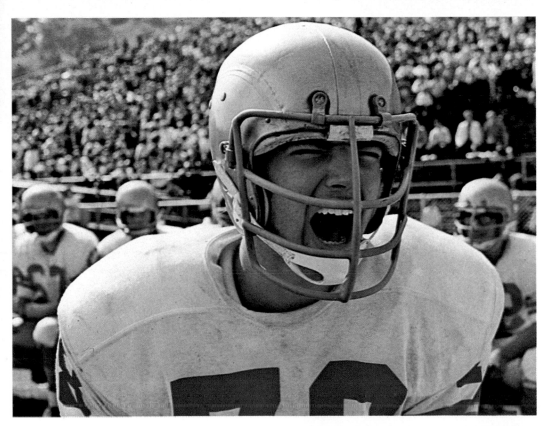

tion and reflexes. He or she must be selective, arresting the most meaningful, revealing, or simply amusing and curious moments. In fact the "moment of truth" is not always at victory or defeat: the moment before the match or immediately after it is over can be just as interesting. An athlete's character, anxieties, and superstitions, or sudden emotional reactions can often be captured in gestures, expressions, and spontaneous outbursts; and they are more successfully conveyed on photograph than on film, for they are then fixed for interpretation. A sequence of photographs of an athlete can bring out his or her personality in all its complexity, not just in the passing spectacle of the sport. In individual sports, it is the concentration before the event or the strain on the face at the moment of greatest effort that produces the best pictures; but in team sports, it can be interesting to capture the complex network of relationships between the team members or their changing emotions in the different stages of the game.

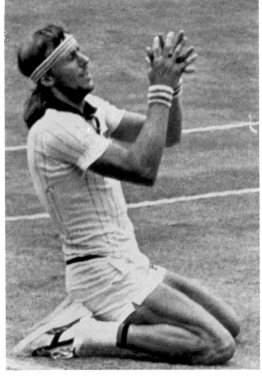

Faces betray emotions, and an observant photographer knows this.
Top: The captain of a football team spurring on his teammates. Opposite: Weightlifting offers excellent close-ups of the athletes making their greatest efforts. Right: Tennis player Bjorn Borg showing his great relief and satisfaction at winning his third Wimbledon singles title.

Composing a photo essay

Sporting action can give rise to interesting sequence shots organized logically into a report. In this way, the photographer is not limited to just the "decisive moment" or the "climax" of the game. The feel of the event can be expressed through a series of pictures that build up the full story of the whole match or of a single episode as the photographs follow and complement each other. But the sequence must not be haphazard, and so as the photographer you must decide in advance on what you want to take, picking out moments that you might not otherwise have photographed, but which are essential to the report. Basically, it is a question of following the event as if you were a reporter; this becomes a matter of habit for a professional, but it can be stimulating and challenging for anyone, even if your goal is only to show the pictures to friends or to compile a scrapbook. The photographic essay was developed with the earliest photographic journalism of the 1930s. Cartier-Bresson had his own theory of reporting and wrote among other things that you have to avoid firing volleys of shots and photographing

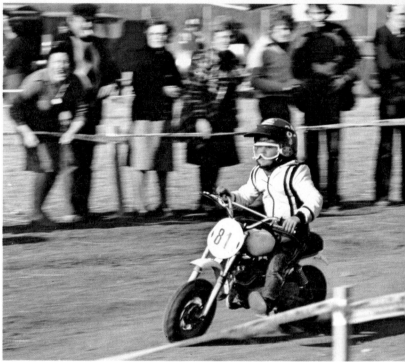

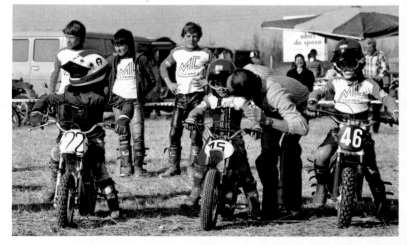

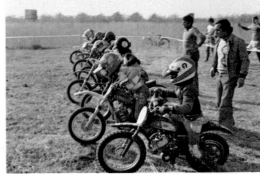

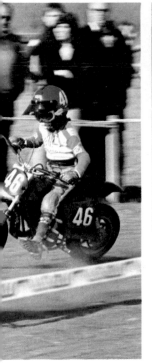

A day with the minichampions

It is mainly at less important events, where photographers are free to vary their angles and move wherever they like, that good photographic accounts can be taken. A high school football game, for example, can inspire magnificent reports. The photos on this page were taken at a motocross race for 4 to 6 year olds; note the enthusiasm of the parents, their anxious attention to the minibikes and their riders. There is also a certain degree of bitter irony for those who would transform their children into premature minichampions. All the photos were taken with a 35mm and 135mm lens.

automatically and in a hurry; otherwise you overload yourself with useless details that merely cloud the memory and spoil the clarity of the whole. It is, in fact, useless (and technically impossible) to photograph everything without having decided in advance on how to describe the event properly. A sequence is compiled by the photographer both in the field and later on in the darkroom. The most basic type is organized in

chronological order, photographing the event at its salient moments and characterizing the game or competition most effectively; but, since you cannot always do this, it helps to work with a colleague or a friend to get a fuller and more vivid account. An auto race is a good example, for you can organize it among three of you: two at the most difficult and interesting points of the track and one in the pits to get the "other side" of the event and to photograph details from close range. This is what the photographers from agencies and magazines do. To cover the Liston-Patterson fight, for example, four photographers from the Associated Press were positioned around the ring with three remote-controlled cameras above it. But even a single photographer can compile an account by getting a sequence from various viewpoints and using his equipment to the full, for example, by bringing the elements of a scene either closer or further away to isolate an athlete, then to merge the subject with the rest or with the public in a panoramic shot. Two lenses such as the 35mm and the 135mm give good alternatives on the field of view. Other interesting variations can

be made by placing different pictures alongside one another to bring out details that the spectators may have missed or by assembling a series of events that took place over various times and places. The order of the photographs can give an indication of the final sequence, but it can also be structured intelligently to bring out analogies, contrasts, and references between the pictures, whether showing them on a home projector or putting them in the papers. The relative size and position of each of the photographs in this case then come into consideration and enable you to bring out one element over another by organizing smaller photographs around a few larger ones to convey the feeling of the whole event.

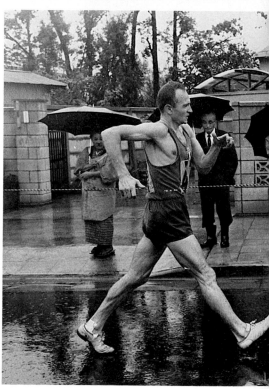

The cavalcade of Pamich
This interesting series of pictures shows all the stages of the victorious cavalcade of the Italian Abdon Pamich in the 50km (31 mile) walk in the Tokyo Olympics. The account is also an example of the inventiveness and intuition needed to photograph such a long and far-ranging event. After having taken a shot of the start with a 400mm lens from the stands, the photographer had to rush out of the stadium to a side street where a good tip paid a few hours before had persuaded a taxi driver to wait (the route of the race was obvi-

ously closed to traffic). The driver conveyed him some six miles further along the route ahead of the racers, where he was able to take a good close-up as they passed by (center). Another two flying stops (which let the racer know how far he was ahead of the others), and then off again to be there to photograph the winner crossing the finish line.

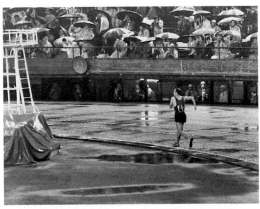

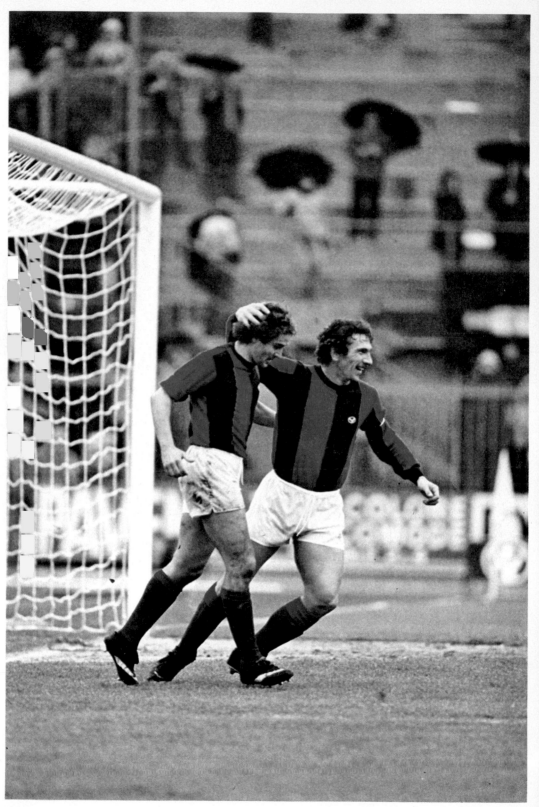

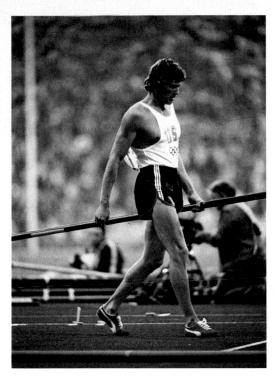

The most interesting and unusual photographs which reveal the character and personality of the athletes are often taken during the breaks before or after the event.

Opposite: A friendly hug between soccer players after a successful joint move ended in a goal. Left: A pole vaulter checks his equipment before the competition. Below: The camaraderie of two long distance runners after the race and a moment of relaxation along the track. Bottom: A competitor gloomily withdraws from the race with a damaged canoe.

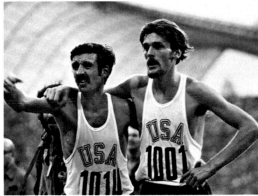

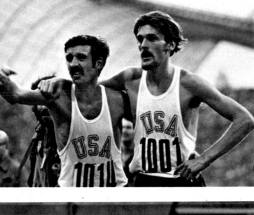

Moments of relaxation

There is a personality behind every athlete in the gym or on the field that is hidden when the challenge of the sport and the desire to win or at least to better the last result is what counts. After all, that is what all the sacrifices, the long hours of training, trials, and meticulous preparation are for. But the competitions last longer than the time the athlete is directly involved, and it is in these remaining periods that they relax—on the benches at the edges of the field, the grass at the end of the track, and in the dressing rooms, where they also meet their teammates or their opponents and show a less official and rigid side of themselves. These are also the places the sports photographer can complete the report on the champion and capture expressions of feeling that vanish with the sound of the starting pistol. Everything is more serene, open, or argumentative during the breaks, so the photographer must look there for the best pictures. The story of a competition is also made up of these pauses when the athlete stops being a robot who concentrates mental and physical energies on the sporting action. Freed of the myth, the aura of perfection, and the image of the superhuman, the athlete can express the same reactions as everyone else.

Occupational hazards

On the track or in the stadium, athletes always run the risk of accident. Although falls or collisions on the field are relatively common and generally not serious, other accidents can be very dramatic. In some sports, the possibility of an accident is there at every moment and behind every bend, being almost part of the rules of the game. The

photographer must thus include some pictures of these as they form an essential part of the account and give meaning to the sport being documented. Anything that happens to break up the normal running of a competition is a good subject for original photography, bringing into focus emotions often hidden during routine play: rage, generosity, pride, or courage.

Top: An unfortunate player is carried off the field on a stretcher. Above: Aftermath of a collision on a soccer field. Left: An expressive detail. Opposite: The face of this injured cyclist expresses all his tenacious will.

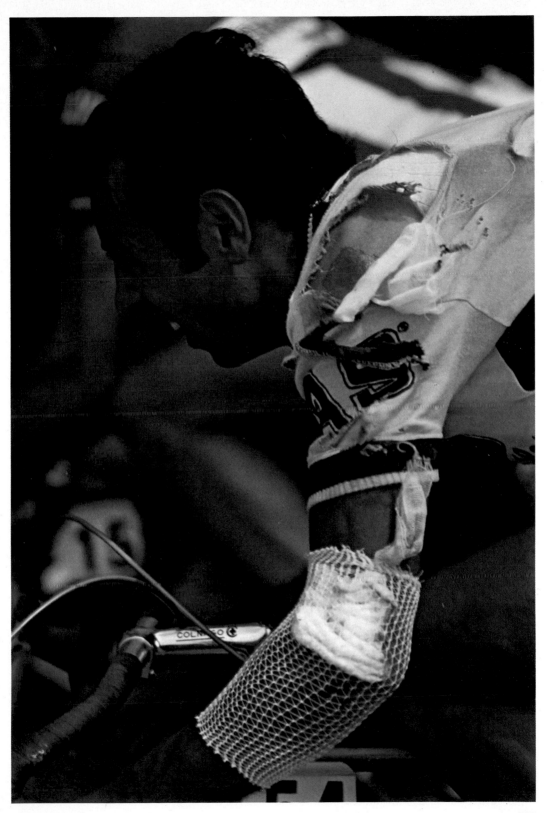

Attention to detail

The reality of sport embraces various dimensions, from the great to the very small, or from the general to the specific, in an endless visual journey in which the photographer must make choices. This is not always an easy task, as so many possibilities are presented through the viewfinder. Our minds and eyes move quickly over things, stopping only at those that are interesting or curious, and our cultural education governs how we see or understand reality. The photographer tries to express on film what

he or she has understood and wants to communicate to others, directing their attention to the elements singled out through the frame of the viewfinder. A close-up often has a greater visual impact than a wide-lens shot, in which the "action" may be lost to the background. Close-ups can be most effective in expressing the human element of victory and defeat, as well as in capturing the "essence" of the sport. Expensive accessories are not necessary in most cases, and an ordinary camera with a couple of lenses is all

you need. Often, a telephoto lens will produce a prize-winning shot. This uncovers a new world, a more unusual dimension discovered just by getting closer to people and machines. The face of a motocross driver covered with mud, or a boxer's, battered and unrecognizable or a still life of sports gear, can say much more about these sports than a whole sequence of actions. Attention to detail also adds a new dimension to the report, through pictures that can continually and effectively be alternated from the panoramic to the detailed.

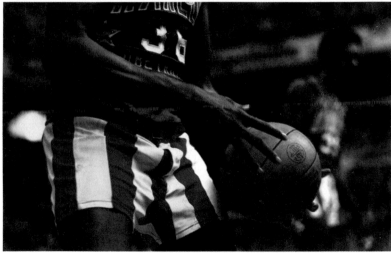

Detail can add a new dimension to any sport.
 Opposite, top: The protective mask of a Japanese kendo contestant. Left: After a motocross race.
 Top: The enthusiasm of a local is expressed in his emotional embrace of the winning horse in the Palio race in Siena, Italy. Above: A close-up of basketball action. Right: The footrest of a rowing scull can also serve as inspiration for an impromptu still life.

The other face of sports

The athletes are not the only ones who participate in a sporting event. The spectators and the public also take part from the stands or the sides of the track, with a fervor and attention that give the competition much of its meaning. Sport is also a spectacle and, as such, takes place in stadiums, tracks, or gymnasiums where the public comes with various interests and curiosities, but sharing a common feeling. This at times can be loaded with tension and provides psychologists and sociologists with a lot of ground for study. The photographer is also a curious onlooker by definition and is easily caught up in the happenings in the stands, for the expressions and gestures of the public reflect developments on the field as if in a mirror. Public behavior at sports events is a relatively old subject for photography, as can be seen, for example, in the vivid sequences taken in the Capannelle race course in Rome by Count Primoli, a highly original Italian amateur photographer of the late 1800s. His photos illustrate poses, gestures, and expressions of Roman high society, noblewomen and gentlemen following the races with bated breath. Comparing this kind of picture with others of the athletes in action, which can often be more stereotyped, the photographer can build up an intelligent account that can become a serious or amusing sociological analysis. Observing others through the camera also involves examining yourself, for the photographer must inevitably take part in the

Above: The aristocratic public at the famous Derby at Ascot, which is a ritual for English high society, makes an amusing photograph. Below: An exuberant spectator at a soccer game. Opposite: The Brazilian player Rivelino on the ground, knocked down by fans after the final with Italy in the 1970 World Cup.

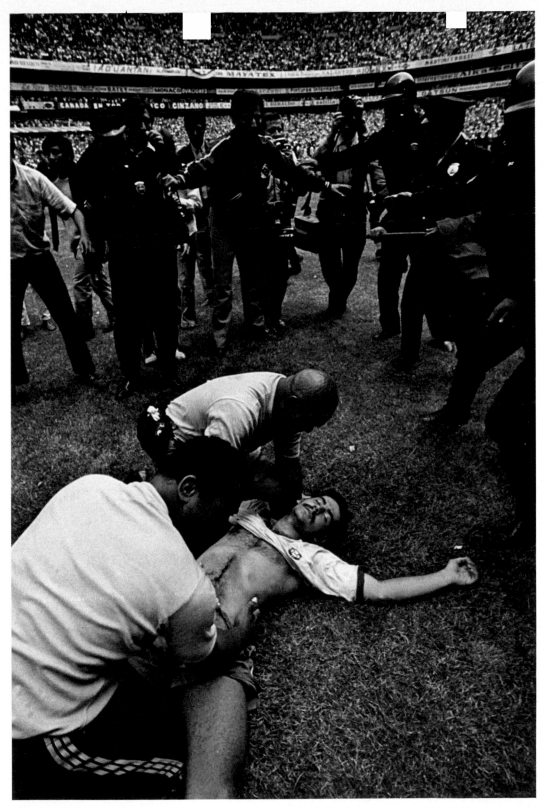

Below: Soccer fans during the decisive days of the championship. The stands vanish beneath a fluttering of flags, streamers, smoke, and firecrackers. Right: The wide-angle lens captures the incredible following at the Brazilian Maracanã stadium in Rio de Janeiro during a South American national soccer match.

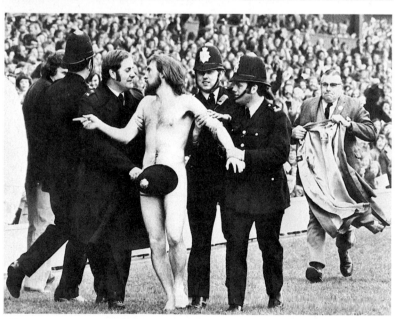

picture. The setting of sporting events all over the world offers an infinite variety of photographic themes, from the tradition of the rowdy and gooticulative fans in the stadiums, who are capable of vivid and unexpected exhibitions and incidents; to the deliberate aristocratic snobbery of thoroughbred racing; the highly colorful "white circus" following skiing events; and the equally extravagant followers of grand prix racing. Even with limited equipment such as a 35mm and a 135mm and nothing else, the observant photographer can produce very effective reports on the world of sport.

Near left: Gatecrashers climbing the barriers in the San Siro stadium in Milan before the start of the Milan-Inter derby. Opposite: An amusing photo taken in 1974 of a "streaker" who broke onto the field at Twickenham just before the start of the French-English international soccer match. Photographer Jan Bradshaw of the Sunday *Mirror* took the photo with a zoom lens.

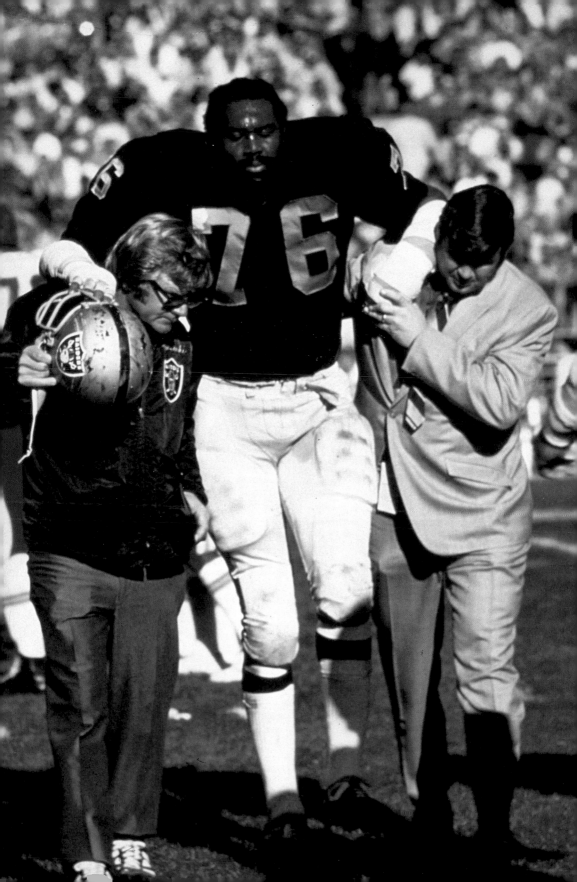

PHOTO CREDITS